Reading into Cultural Studies

Recent developments in the field of cultural studies have tended to focus on issues of subjectivity, audience power, cultural activity and the enduring power of ordinary culture. In the process the concerns of earlier texts, such as power, ideology and the possibilities and limits of resistance, have been marginalised. By revisiting some of the key early texts, this book aims to foreground the approaches and concerns of these earlier texts – texts which were central to the formation of cultural studies as a discipline, and as a project.

Each of the eleven chapters takes one of these key texts, revisits and re-evaluates it with the benefit of hindsight. Each study is critically examined in a number of ways, for its research strategy, its implicit theories of power and ideology, for the empirical evidence it draws on and its conceptual framework. But most importantly, the contributors draw attention to the implications for action and the possibilities for change.

Reading into Cultural Studies shows how the history of cultural studies can now be explored through a critique of its founding texts. It provides a useful introduction to the central debates and issues, demonstrating how the discipline has changed and developed over the years.

Reading into Cultural Studies

Edited by
Martin Barker and Anne Beezer

London and New York

First published 1992
by Routledge
11 New Fetter Lane, London EC4P 4EE

Simultaneously published in the USA and Canada by Routledge
a division of Routledge, Chapman and Hall Inc.
29 West 35th Street, New York, NY 10001

Typeset in 10 on 12 point Bembo by Witwell Ltd, Southport
Printed in Great Britain by Clays Ltd, St Ives plc

British Library Cataloguing in Publication Data
Reading into Cultural Studies
 I. Barker, Martin II. Beezer, Anne
 306

Library of Congress Cataloging in Publication Data

ISBN 0-415-06376-0 ISBN 0-415-06377-9 (pbk)

Contents

Notes on contributors

Martin Barker teaches cultural studies in the Humanities Department of Bristol Polytechnic.

John Baxendale teaches social and cultural history in the Department of Historical and Critical Studies at Sheffield City Polytechnic.

Anne Beezer teaches cultural studies in the Humanities Department of Bristol Polytechnic.

Andrew Blake teaches cultural studies at the Polytechnic of East London.

Kim Clancy is currently researching British culture in the 1960s, and the construction of gender and disorder, at the University of Sussex. She also teaches women's studies at the Open University and cultural studies in adult education.

Jeff Collins teaches art history and cultural studies in the Faculty of Arts at the Polytechnic South West.

Susan Emanuel is a former television producer and university lecturer who writes on cross-cultural issues in media studies.

Mark Jancovich teaches American studies in the Department of American Studies at the University of Manchester.

Susan Purdie teaches theatre arts in the Faculty of Arts at the Polytechnic South West.

Beverley Skeggs teaches research methodology in education and women's studies in the Department of Education at York University.

Liz Wells teaches photography and media studies in the Faculty of Art, Media and Design at Bristol Polytechnic.

Introduction: What's in a text?

Martin Barker and Anne Beezer

Learning about cultural studies in the 1990s is a very different enterprise from what it was to learn about it in the 1970s when the bulk of its current lecturers took it up, often with a touch of missionary enthusiasm. This may sound a terribly obvious thing to say, but it is worth charting some of the differences between now and then – because perhaps they are not all as obvious as might seem. In no particular order, we offer some of the changes that strike us as significant.

First, there was a sheer sense of being explorers. Whole new areas and arenas of popular culture and the mass media were being opened up, and methods of exploring them tried out. Who would be the first to have a go at, say, soap operas, or sitcoms, or music papers, or fashions? What would they draw on? What connections would they suggest?

It wasn't that we were the first to take popular culture seriously – the critics and moralists had done that for years. It wasn't being celebratory, either – there were deep suspicions of the ideological role and implications of most kinds of popular culture. It was, more, believing that they deserved systematic scrutiny, that we could only understand their political significance if we had systematic ways of looking at them.

Inevitably that sense of newness has declined. Of course there are many phenomena and kinds of culture still unstudied, but for most things there are now good precedents. Students coming into cultural studies now will always find dauntingly large reading lists awaiting them, and they are proliferating amazingly fast at the moment. But what about that sense of 'systems of looking' – what has happened to that? The answer to that, we think, is more complicated.

Second, in those tentative early days, in most places cultural studies

set its face against being a 'discipline', a closed, internally validated body of knowledge and ideas. Cultural studies was a street urchin of a subject area, nicking other people's handkerchiefs when it suited – but using them to shine shoes or patch clothes, thumbing its nose at academic manners, being cheeky to everyone. English, sociology, film studies, later psychology and especially psychoanalysis, bits of political (and especially state) theory, and so on – all were plundered for whatever we needed, at the same time as we challenged their status as 'disciplines'. At the same time, relations of other but equally important kinds went on with a variety of radical political movements: socialist organisations from time to time, the women's movement, anti-racist organisations, local culture and arts organisations.

Relations with these were, to use the jargon of the time, 'uneven', ranging from outright involvement in campaigns to engaging in debates about their significance for us. (A notable absence: with the exception of the 1984–5 miners' strike, which did engage the energies, both political and intellectual, of very many people within cultural studies, the truth is that there has been only marginal engagement with trade union activities. Even the lecturers' unions, both NATFHE and the AUT, have not 'engaged' much cultural studies activism.)

What is important here is not that these involvements have just declined, though they have obviously not gone away. No, what matters is that in the 1970s it was almost a sine qua non of being involved in cultural studies that we should also be involved within this spectrum of radical–political initiatives. That just isn't true in the same way in the 1990s, and certainly not for many of our students.

And that points to a third changed component: that in the 1970s there was in many ways a sense of a shared project: debated, but none the less shared. Of course that is easier to maintain when things are small – though there was very little in the way of a national network of people in the field until well into the 1980s. The Cultural Studies Network, founded between Birmingham, London and Bristol in the late 1970s, had only very patchy connections with other places; and despite its best intentions the Association for Cultural Studies which followed it, apart from organising some very useful conferences, did not consolidate the links very much. Still, with all its limits, the agenda of issues debated at the Network meetings is revealing. It ranged across how courses could be developed, the politics of different teaching styles and methods, the politics of cultural investigation, the meaning of cultural studies becoming a 'subject' with syllabus, assessment, etc., how to intervene

with the critical tools at our disposal in various cultural and political issues of the time, and so on.

All this, in a real sense, is now history. For students and others encountering cultural studies for the first time in the 1990s, how should they learn about it? In one sense, it is all too easy. For cultural studies, rather like a football star at 25, is busy writing its autobiography. Histories of cultural studies are becoming common, either as whole books or as brief sketches.

WRITING HISTORIES AND MAKING 'TRADITIONS'

If the publication of histories of a discipline is a sign of its coming of age, then cultural studies has undoubtedly emerged from adolescence into maturity. When Richard Johnson attempted to chart the nexus of issues and theoretical crosscurrents which had given rise to cultural studies, there was an ambivalence built into his title 'What is Cultural Studies Anyway?'[1] This has been replaced by a clearer sense of identity, albeit one that is fragmented. Take Graeme Turner's and Patrick Brantlinger's histories of British cultural studies as examples.[2] They both locate its beginnings in the post-war breakdown of the consensus about the direction and value of British cultural life. The critique of ideas of 'mass culture', and the re-evaluation of 'ordinary culture' which characterised the work of Raymond Williams, Richard Hoggart and E. P. Thompson, emerged from this broken consensus. *Culture and Society*, *The Uses of Literacy* and *The Making of the English Working Class* became the foundational texts of an interdisciplinary cultural studies.[3]

Both histories identify *Culture and Society* as the key text which 'set the agenda for cultural studies' (Brantlinger, p. 38) and whose influence 'has arguably been more profound than any other' (Turner, p. 52). Brantlinger maintains that its significance is due to the way it demonstrated 'how the multiple concepts signified by the key word "culture" arise in key debates about industrialization and democratization'; and Turner is largely in agreement that the book's strength and singularity was its pursuit of the connections between cultural products and cultural relations.

Accounts like these of the emergence of cultural studies, which give texts such as *Culture and Society* a foundational status, prompted Raymond Williams to recount a more 'hidden history' of cultural studies.[4] He argued that the publication of *Culture and Society* was the outcome of his and others' engagement in the various adult education

movements of the 1930s and 1940s. Williams insists that to privilege key
texts in an account of the emergence of cultural studies is to construct
an idealist history which misleads because it breaks the connection
between the social formation which gave rise to cultural studies and the
project that resulted from that formation. This formation, Williams
argues, was made up of the self-educating organisations of working
people whose project was to make institutionally-derived knowledge
relevant to their own experience and activities. And in this context,
Williams stresses that 'making relevant' was not a matter of 'enlighten-
ing the masses' but the much more radical project of building an open-
access democratic culture of an educated kind. In other words, cultural
studies was not a detached body of knowledge which could 'do good' to
people. It could only exist and grow through its dependence on the
'common people' whom it served.

It seems to us that there are a number of problems in Williams's
account, though it is surely an important corrective to any primarily
text-centred history. The first problem is his picture of post-war adult
education. His depiction of this as simply working-class self-education,
somehow indicative of a wider political objective of democratisation of
power, is a romanticised one – and that has wider implications for how
we should see cultural studies. For in his picture, 'education' – of the
right kind – takes on an heroic role in empowering working-class
people.[5] (By implication also, education of the wrong kind is particu-
larly deceitful and dangerous.) Something of the same 'heroic' role is
given in some cases today to ACCESS – as though getting more black,
or working-class, or other 'underprivileged' individuals into higher
education ought somehow to alter the position of the groups from
which they come.

The second problem is in Williams's account of who controlled the
curriculum of adult education. In his view, what was important was the
way in which the working-class 'clients' for their courses made
demands of their tutors: in particular, demands for relevance to their
lives. We are not saying this was untrue, or wrong; but implicit in
Williams's account is a claim that this demanding relationship thereby
made the resultant courses somehow liberatory. That could only be
certainly so on three conditions: first, that the shop stewards etc. who
came to those courses came knowing what kinds of knowledge they
'needed' in order to strengthen their own democratic participation in
their culture (and of course, what would count as democratic participa-
tion is not easy to say). Second, that in some meaningful sense they
came as 'representatives' of their class – but especially in the 1950s,

with the fragmentation and depoliticisation of class struggle that was gaining ground, that is hard to conceive. Third, that the courses offered could somehow be cut off from the institutional framework, and become and remain relatively free from the demands that being-an-adult-education-course carries with it. That last was the most likely in the 1950s. It is the least likely now, given the way successive Conservative governments have put the control of all forms of education centre-stage, politically. And were by the early 1990s well on the way to abolishing all but vocational adult education.

None the less, it is this project which Williams believed was in danger of being forgotten as cultural studies moves from the margins of educational provision into the more mainstream academic culture of higher education institutions. Williams warned that this is not just a matter of restricting access to cultural studies approaches to those who have followed the predominantly middle-class educational path of school and college or university education, but also involves pushing cultural studies into an academic enclave where institutional pressures force the setting up of discipline boundaries. Such a move will reinstate the conditions which cultural studies originally worked to transform.

On the face of it, a book of readings such as this, which revisits key texts in the emergence of cultural studies, appears to embody those very tendencies which Williams opposed. To locate cultural studies in 'canonical texts' runs the very real risk of effacing the links between the social formations which brought about the making of cultural studies. However, our intention is not to raise the texts we examine in this reader to canonical status. We think they are worth revisiting – and we think *students* should visit them – because, despite differences of emphasis and issue, they shared a common project which connects with the most valuable part of Williams's argument, and one which we think is now, unfortunately, in retreat. It is a project of thinking through the implications of extending the term 'culture' to include activities and meanings of ordinary people, precisely those constituencies excluded from participation in culture when its elitist definition holds sway. To return to this history and to reappraise the directions proposed for understanding the relations between power, ideology and resistance is not, therefore, an academicist exercise. Rather, we want it to be seen as a means of taking stock of the project of cultural studies and, with the benefit of hindsight, re-evaluating those directions.

Why have we repeatedly called this a 'project'? Because always implicit in early analyses was the question: what can be done about the oppressive relations we are revealing? What forces are there, even if

only potentially, that could lead to liberation? What strategies suggest themselves for supporting emancipatory forces? And, in consequence, what will count as liberation and emancipation? In short, there was a fundamental agenda in early cultural studies which set up broad oppositions between the concepts of power/ideology and culture/participation. However crude and unsatisfactory these terms may be (as a number of the essays in this volume themselves effectively show), that agenda was very different from the one which we see emergent in cultural studies now.

RE-EVALUATING TEXTS

How does this relate to the question of 'texts'? An odd process seems to us to be under way at the moment – a process of shucking off the past, even at the same time as 'histories' of that are being written – histories which seem to justify the new agendas in cultural studies. But what is being shucked off is just what we feel should be rescued. Putting it crudely, the texts of the past need a different kind of critique than the ones which they are mainly currently getting.

The publication of histories of cultural studies is just one indication of the current re-evaluation of the project of cultural studies. Many of the authors whose work is examined in this reader, together with others such as Angela McRobbie, have been engaged in this re-evaluation. And as part of this, the 'authority' of all texts, and the centrality that was once accorded to them in cultural studies, has been questioned. People whose work was pretty central to the early development of cultural studies have one after another been offering self-critiques resulting in the shedding of chunks of their past thinking. In no particular order: David Morley, Ien Ang, Paul Willis, Janice Radway, Angela McRobbie, John Fiske and Dick Hebdige have all in recent work shed some of their previous ideas. And there are common threads to these self-critiques. Angela McRobbie, for example, argues that 'gradually there has been a marginalization of narrow text-based analyses in place of a more contextualised approach which recognises the multiplicity of meanings and readings which any one text or image is capable of generating'. The critique of text-based approaches indicates, she argues, 'a movement away from the text in all its ideological glory, and a recognition of the fact that texts do not simply assert their meanings on "unsuspecting" readers and viewers'.[6]

This movement away from the 'Althusserian moment' in cultural studies, in which ideology was conceived in monolithic terms, is also

evident in the audience and reader research of David Morley and Janice Radway, in Ien Ang's reassessment of ethnographic approaches to the study of audiences, and in Paul Willis's celebration of the symbolic creativity inherent in the ordinary culture of young people.[7] Typical of this movement is the insistence by David Morley that production-oriented studies of the mass media remain incomplete without an equal and extended attention to the moment of consumption. Talking of television, Morley argues that questions of textual power must be contextualised within an approach which addresses the whole system of family dynamics and gender relations which govern television viewing. This, then, is a shift away from an approach which focuses on the class- and gender-based 'decodings' of television programmes towards an analysis of television viewing within the context of domestic leisure, a context where, Morley believes, gender relations are primary. As Morley notes, 'this perspective involves us in considering the ways in which familial relations, like any other social relations, are also and inevitably power relations'.[8]

Similarly, Janice Radway has returned to the question of the gendered pleasures of reading romance, and has distanced her present concerns from her previous research. She now sees romance as engaging 'nomadic subjects' caught up in shifting systems of pleasure.[9] This requires methods of investigation such as ethnography which are sensitive to the complexities of these shifts. And while Ien Ang is careful to distinguish the 'critical' element inherent in the movement of cultural studies' appropriations of ethnography from the positivism of a 'uses and gratifications' approach, she too acknowledges that textual analysis must give way to a reflexive ethnography of audiences.[10]

In the earlier work of these authors there was attention to the moment of 'resistance'. But this moment was conceived as something partial, wrested from the various systems of power relations. Thus, in Ien Ang's study of a small group of Dutch viewers of *Dallas*, she provides a symptomatic reading of her respondents' letters. Through this, she identified the organising presence of ideologies, such as the 'ideology of mass culture'.[11] And while Morley's concern was to give sociological substance to textual decodings of the sample of *Nationwide* viewers he investigated, the moment of 'encoding' still remained an important focus of study.[12] Radway similarly argued that women readers of romance exerted only momentary cultural power in the face of the fiction industry and patriarchal control.[13]

This 'moment' of resistance was given wider class significance in Paul Willis's *Learning to Labour*. The 'lads'' 'penetration' of the official

educational ideology, which posits qualifications as the means of achieving individual class mobility while leaving the class system *per se* intact, is a 'partial' one. The limitations of this resistance are argued to derive from the lads' refusal to extend their understanding of power relations to other groups, and from the way they collapse together cultural choice and collective class determination.[14] In each of these cases, in other words, early cultural studies work was exploring the potential for resistance and revolt against determinate dominatory forces.

It is interesting to note that where once Willis referred to the 'limitations' of these rejections of official ideology, he now seeks to develop an approach to 'ordinary' culture which defines it in terms of 'grounded aesthetics'. He proposes that commerce and consumerism cannot be understood as a reduction of the real to a semiotic chimera, as a postmodernist demonology would claim, but have in fact 'helped to release a profane explosion of everyday symbolic life and activity'.[15] Television, once seen as the ultimate pacifier, is used by young people who are television-literate and who 'actively control where and how TV functions in their own landscape' (p. 32). And so, too, with other media, such as film, video and microcomputers, all emblems of an electronic, information-based society. For Willis, these are not the hidden manipulators of a gullible and passive youth but the means by which new meanings and practices are circulated. They are 'usable resources' creatively appropriated by young people, and the material basis of their grounded aesthetics.

We can decipher, then, in a number of authors a deepening concern to understand the values and strengths of the sense-making strategies used by ordinary people. The focus on 'resistance', with its implication of a momentary or strategic opposition, has been replaced by an emphasis on the exertion of cultural power as a continuing feature of everyday life. Within the language of postmodernism, we might suggest that a concern to understand the 'master narratives' of political refusal has been replaced by a commitment to explore those less evident, and on the surface less heroic, stories of ordinary meaning-making.

In this movement there has been a tendency to reject previous theorisations of ideological and cultural domination, not as inadequate or partial accounts but as mistaken, even elitist in the direction implicit in their conceptual frameworks. This movement, we suggest, constitutes the emergence of a new 'paradigm' in cultural studies. A glimpse of this new paradigm is provided by Willis in the 'Afterword'

to *Common Culture*. He argues that previous Gramscian theorisations of popular culture focus on the larger context at the expense of examining 'identity from "below" and "horizontally" '. Willis maintains that 'hegemonic perspectives seem to be deeply uninterested in these actual practices (of fun, joy and meaning-making) and recoup "popular cultural" contents too quickly into the politics of people/power block relations' (p. 157).

The direction proposed by Willis seems to us more than a response to the 'post-Fordist' configurations of power in social-democratic societies, and to the consequent redefinitions of socialist–feminist politics which may have to be made because of this. It is not simply a case of a 'paradise postponed' or re-imagined in the light of these changes in the west and the more momentous ones occurring in eastern Europe. Rather, this direction seems to be premised on a loss of faith: cultural studies is no longer able to examine contemporary cultural formations while still keeping at least one eye to possible futures, and to groups-in-formation who might inherit those futures. This growing reluctance to imagine possible futures has also involved a change in the relationship between cultural studies and the research undertaken within its broad framework. Cultural studies research is now less a matter of 'decoding' the operations of power and resistance, with an eye to where we might go next. Instead, it has taken on the status of a 'witness', giving voice to the meanings that are made in the here and now. What those meanings amount to, where they might lead, what possibilities they might contain: to ask those things is to be unjustifiably judgemental, and elitist.

Cultural studies is, in Raymond Williams's apt phrase, a 'baggy monster', and some of what we say here, slightly accusingly, will not fit everyone. In truth, what we very often sense is an unhappy move in these directions, endlessly qualified by statements like 'we mustn't lose the dimensions of power/ideology . . .' – but without a conceptual apparatus on which they can any longer be hooked. And with all the qualifications that are necessary, some characteristic directions and emphases in cultural studies research of the late 1980s and 1990s can be discerned. One of these is the move from notions of textual power to an appreciation of the interpretative strategies of readers and audiences.

Ethnography is now widely held to be the only sure method of catching hold of the full meanings of people's activities, including their activities as audiences. But there are problems in this. First, it is difficult now to maintain any notion of textual power. Yet other approaches to audiences, including those using forms of discourse

analysis, have shown that it is possible to remain sensitive to audiences' interpretations but as a means to deepening our understanding of textual ideologies.[16]

Second, as Ang notes, the move towards ethnography is more than a change of methodological procedure; it amounts to a changed 'attitude' towards the 'objects' of research. It appears that cultural studies research is replacing concern for the power relations between texts and audiences, with concern for the power relations embodied in the research process itself. For example, Ellen Seiter et al. have criticised 'traditional ethnography's implicit insistence on scholarly experience as an unproblematic source and ultimate guarantee of knowledge about a specific culture or cultural process'.[17] But since all methodological procedures, including ethnography, necessarily involve the researchers' own interpretative strategies, it is not easy to see in what ways ethnography is 'privileged' just because it worries about this problem. Ethnography seems to be making a virtue of its own confessional status – as if confession of the problem would somehow eliminate it.

Third, we would contend that 'audiences' are in part the outcome of the research questions and strategies which constitute them. Thus, in *Seeing and Believing*, Greg Philo's concern was to discover the extent to which television news's organising concepts influenced viewers' memories of key political events such as the miners' strike. This concern with historical memory and the reconstruction of political narratives 'produces' a different audience from approaches which focus on pleasures and their relation to the family dynamics of television watching. In Philo's research the audience was located in relation to configurations of power external to the family, although impinging on it. And although historical memory may in part be a function of gendered viewing practices, this is unlikely to be revealed by ethnographic methodologies.[18]

Staying a little longer with Philo's work, this underscores something quite significant. What does he do? Very provocatively, and developing innovative research methods, he re-confronts the issue of media influence. Not interested in the areas that have come to the fore in cultural studies – the areas of pleasure, of domestic fiction, of gendered audiences – he returns to news, and the way news mediates our understanding of the organisation of major forces in the world. Philo claims to show that television provided 'templates' around which historical memory of the miners' strike was triggered, even two years after the event. Whether adequate or inadequate, this is a subtle

argument, aware of the complexities of viewing; yet gives the most persuasive picture we know of the ways in which television makes an ideological difference. What has been the response to Philo's study within cultural studies? The truth is that, by and large, the book has been either ignored or marginalised as 'media studies'. 'We don't deal with news any more.' 'The Glasgow Group are a bit out-of-date.' These are the stereotypical responses we have met with when asking around. Twenty, no, ten years ago it would have been met with an intense debate. We believe that an obsession with the family dynamics of viewing is precluding an engagement with the issues of textual power, and how families understand their place within larger social frameworks.

Another direction characteristic of current work in cultural studies, and connecting to the move towards ethnographies, is an understanding of almost all cultural activity as a form of resistance to inequalities of power and possession. Understandable as this is as a reaction to cruder theories of textual power and cultural domination, which see the 'subject' as the product of these intersecting forces, the activity which is now posited as the basis of making meanings becomes something of an undifferentiated umbrella term. A term that can include informally organised subcultural activity, the responses we make to the urban landscape, and the young unemployed's use of shopping malls, as well as the various relations between audiences and texts, is actually in danger of *inhibiting* our understanding of cultural processes. Similarly, the sometimes over-easy mapping of resistance on to ideas of *activity* produces an over-generalised, non-specific understanding of opposition. It is not a matter of positing an unreflexive socialist rectitude which is dismissive of anything that is politically 'incorrect' to suggest that some kinds of 'resistance' are more effective than others. Willis asserts that 'it must now be recognised that the coming together of coherence and identity in common culture occurs in surprising, blasphemous and alienated ways seen from old-fashioned Marxist rectitudes – in leisure not work, through commodities not political parties, privately not collectively'.[19] And John Fiske has also suggested that visits to shopping malls provide the opportunity for the young unemployed to carry out 'tactical raids on the rich and powerful'.[20] Here, the once-contested division between work and leisure is now taken as an unproblematic given, even a source of celebration. But also, political differentiation within forms of work and leisure has simply been lost. Refusing to buy South African fruit is now no different from gazing through the shopping mall window. A focus on the act

of consumption and not the social formations which lead to patterns of consumption will not reveal what kind of activity is embedded within those choices.

People may say we are being unfair. After all, open season has been declared on some of John Fiske's sillier claims – a hunting party in which we have ourselves joyously joined. The point we are making is that even those who would disagree with the outright statements of Fiske or Willis in this regard may none the less be caught uneasily within the same conceptual apparatus and unspoken agenda which Fiske et al. congratulate themselves on. And at the same time there is a marginalisation, or virtual disappearance, of alternative modes of thinking. For the kind of discriminations that cultural studies work has drawn in the past, between alternative, oppositional and conformist or consensual cultural formations, were ultimately dependent on a sense of social class, gender and 'racial' groups as collectivities in the making, fashioning their histories and consciousness through their activities.

WHATEVER HAPPENED TO 'CLASS'?

The place where all these changes show, more than anywhere else, is in how 'class' is talked about. Or, often, isn't. It is not possible, in this introductory essay, to survey all that should be looked at of recent cultural studies work, to see how 'class' has been redefined. But the following seem to us to typify the directions being taken.

Take, first, Willis's *Common Culture*. Willis celebrates the creativeness of ordinary people, their 'profane' cultural activities and how they take and make use of the most unpromising cultural materials. As a critique (yet again) of any surviving thesis that sees people as simply drugged by mass culture, a good deal of this is fine, if not very deep. But the conceptualisation offered in its place can't pass unremarked. In an early section, 'Work and play', Willis notes that for the majority of people work is deeply dull and undemanding.[21] Therefore, he says, 'free time' becomes the focus of their lives. But that is coupled with an unspoken assertion that that is all that needs to be said about work as the social relations of production. Work is boring, so it has no impact on people's lives – or even on their identities. For 'symbolic work', which is characteristic essentially of the things done for pleasure and leisure, is exclusively the maker of our identities (p. 11).

This cutting off of work-relations from leisure, this exclusive interest in cultural activity outside work, then enables him to say disastrous things such as: that common culture – the collation of

informal practices which now includes everything from listening to music, to shopping, to fighting after the pubs close – is 'inherently democratic' (p. 140), and that simply more resources can lead to 'cultural emancipation' (p. 131).

Willis has so thrown in his lot with whatever activities young people engage in, that he can have no stance even for thinking about the consequences of what they do and don't do. So, the idea that 'politics bores them' once upon a time would have been the stepping off point for a critique of politics, how and why it is so irrelevant to young people, and to discussion of how far projects like Rock Against Racism, or limited tactics like the Live Aid concerts, might change this. Now their rejection is accepted with something like equanimity – after all, to their common culture belongs the 'coming dominance' (p. 129). The unclarity and the vacuousness of this is well highlighted for us by the current (September 1991) wave of random estate riots by bored, disaffected young people. We should reassert the necessity of some notion of class which can combine social relations and lived experience, if we are to understand these outbreaks. Once, Willis himself thought so. Now he appears to have abandoned this project.

In many ways comparable to Willis, if a more rewarding book, is Jim Collins's *Uncommon Cultures*.[22] On the basis of a full-frontal assault on mass-culture theses (among which, interestingly, he groups a lot of *Screen* film theory) which are linked by their belief in some kind of 'unified control culture', he builds his case around a subtle reading of a variety of popular cultural forms, notably detective fiction, but also popular films, comics and some television shows. In this negative critique his aim is to show – and to delight in – difference: that all these genres display diverse political attitudes; all are intertextual in playful ways; that there are no grand schemes or continuities; and all define themselves by their difference from other competing forms and genres.

But his positive account is much more troubling. It has a number of strands, which seem to us quite typical of postmodern thinking. First is the bizarre tendency to reduce everything to discourse. One of his objections to any kind of class or ideological determinism is its positing of something extra-discursive. This is surely unsatisfactory. To use a hatchet-like example: the fact that AIDS is the topic of a huge amount of discourse, is the site of such overwhelming representations, does not reduce its material effectiveness. Indeed, part of the argument of those who challenged the discursive panics about AIDS is precisely that those panics have interfered with the possibilities of rational responses.[23]

Then, Collins like many postmodern critics has very little interest in

how culture is produced, and the way that this might link to material interests. Only the fact that it *is* produced in variety interests him – and that, to him, is enough to disprove any ideas of class determination. That can only be because of a very narrow view of what is meant by determination. Taking an example of his that we happen to know something about, he cites (pp. 33ff.) the example of Frank Miller's bleak version of the Batman story *The Dark Knight Returns*. His description of this is surely right – it is a sophisticated reworking of the Batman myth, walking a difficult line between vigilante politics and a radical critique of city life.

But that complexity has determinate origins, in the interaction of a series of material and political factors. First, the lasting impact on comics of the underground artists, whose project was to criticise city politics, but whom the major companies were forced to try to recruit because of their own falling sales. Then, the struggles over intellectual property rights, following a generation of 'industrially'-produced superhero comics which were the companies' safe response to the campaigns against the crime and horror comics of the 1950s. The struggles over ownership of characters and rights intersected with a number of other processes: the shift to multimedia ownership (Warner Bros bought DC Comics, for instance, and wanted marketable properties), the rise of fandom, and changes in the system of distribution. Together, these created a dynamic in which there was pressure on writers to produce repeated-but-every-time-unique demolitions of the superhero mythos. A consideration of the specific relations within which such comic books are produced can well account for work such as Miller's. The very vacillation can be seen as negotiating the interests of the multimedia corporation, the authors struggling for control, and the fans seeking sense and involvement. This is what we would understand by a class analysis of such a production system, and it is this kind of perspective which is lost in his utopian celebration of 'difference'.

Consider next David Morley's highly regarded *Family Television*.[24] In his studies of *Nationwide* Morley felt impelled to use a concept of 'class' to explore audience relations with television – albeit this was limited by tying that to the idea of 'encoding/decoding'. But in *Family Television*, the concept of 'gender' has become the central critical concept. One of us, perhaps provocatively, referred to this as part of a tendency to the 'domestication' of cultural studies. What we intended to point out by this was the tendency for cultural studies to shift focus from areas of television programming such as news, current affairs and

documentaries to fictional areas such as soap opera – and then even to address those primarily for their gender/youth dimensions, as if these could be studied independently of their class significance. We think this leads to a loss of context for understanding how and why television is so much used as a 'private' resource. Surely a comprehensive understanding of the political and social functions of gendered pleasures, and the use of news to frame public understandings, cannot be grasped outside this context.[25]

Finally, consider Angela McRobbie's reconsiderations in her *Feminism and Youth Culture*.[26] The issue of 'class' comes to the fore in her (reprinted) essay 'The Politics of Feminist Research'. There, she argues that early feminist work, under the joint influence of the left legacy in the women's movement, and the Marxist connections of social science, felt impelled to bring in 'class' to all its accounts. Yet it did not seem a 'natural category' to her subjects:

> [T]here certainly was a disparity between my 'wheeling in' class in my report and its almost complete absence from the girls' talk and general discourse. And this was something I did not really query. I felt that somehow my 'data' was refusing to do what I thought it should do. Being working class meant little or nothing to these girls – but being a girl over-determined their every moment. . . . If I had to go back and consider this problem now, I would go about it in a very different fashion. I would not harbour such a monolithic notion of class, and instead I would investigate how relations of power and powerlessness permeated the girls' lives – in the context of school, authority, language, job opportunities, the family, the community and sexuality. (pp. 64–5)

This is remarkably revealing. She has adopted a criterion that explanations can only have force if they are found within the discourse of the people whom we are studying. This is in fact an impossible intention. For to propose that her working-class girls should be studied for the operation of 'unequal sexualities' is every bit as much to impose a category on them – we very much doubt that they would have used this concept either. But the key point is that adopting such a criterion makes it impossible for the theorist to have any critical position independent of the people s/he is studying. Or to put it another way, the fact that McRobbie's girls at this time in their lives view their own situation through categories of gender does not mean that class has no shaping power on this.

But just as interesting is the way McRobbie's reconsideration

disables what is in our view the best essay in the book. This is her study of teenage mothers. Based on getting to know a number of young women in Birmingham, McRobbie first answers the likes of right-wing politician Rhodes Boyson who tried to start a 'panic' about girls deliberately getting pregnant in order to live off social security. She then explores the dynamics of their lives, and of their relationships with their boyfriends/children's fathers. Often violent towards the girls, these young men drifted between the British Movement, petty crime and glue-sniffing. And frequently, she notes, they drift back to living with their girls when they have part-time jobs and therefore money, leaving them when that is gone. During the course of the essay, she touches on some really important issues, such as the way that youth unemployment fractures the life-cycle from childhood to adulthood. But in the end, she collapses back on to a solution that is much weaker: in terms of 'poverty'. The young women need more resources, many more. Of course that is true, but we would maintain that there is a difference between giving an account of their situation in terms of 'poverty' and in terms of 'class'. For the 'poor' are a category of victims, who 'deserve better'. 'Class' we understand as a category for understanding social relations and systems of activity. The first leads us to ask questions about the failures of welfare systems; the second leads us to ask what other forms of empowerment besides the choice of motherhood could free these young women from the alienations of home, school and unemployment. What social movements might re-empower them, but in ways that will not lead them back into situations of subordination?

If these four books are in any way representative of the kinds of trends emerging, then we can tentatively tie together a number of their strands. Cultural studies has shifted ground so that the concept of 'class' has ceased to be the central critical concept. At best, it has become one 'variable' among many – but now frequently understood as just a mode of oppression, of poverty; at worst, it has dissolved away altogether. At the same time the primary focus has shifted to issues of subjectivity and identity, and to those cultural and media texts which inhabit and address the private and domestic domains. Simultaneously there has been a shift to a methodology which restricts interpretation to those offered by participants, sees them as empowered, and draws attention away from structures. Meanwhile 'histories' of cultural studies are being written – not just of the Turner and Brantlinger varieties, but more importantly by early 'actors' in the subject's field who are now revising their views on the direction that cultural studies should be

going. All this has coupled with seeing texts in all forms as slightly dubious. Texts, in the sense of media forms once thought to have ideological power; texts, in the sense of cultural studies books which may perhaps seem to empower our interpretations over participants.

One of the links that ties these together, and which has been part of our motivation for this book, is an attitude to teaching. We sense an increasingly self-negating attitude among many of our colleagues to their own role, or better to their right to teach the analysis of culture. Our students are now, according to our own dominant theories, coming to us with an already-accomplished valuable cultural repertoire. There are supposed to be no grand narratives within which we can invite them to place their own selves. So just what is the purpose of teaching them about a culture of which they are at least as much possessors as us?

We do not agree with these trends, which amount to a 'retreat from texts'. Far from giving excessive power to texts or to the role of the lecturer, it seems to us that the disappearance of such texts gives *us* too much control. We were formed, and our reasons for being involved in cultural studies were by and large formed, by and through response to these texts, and the events and arguments which they sedimented. We carry the clobber of those around with us. Our students do not. It can give students greater freedom from us if they can see how and under what conditions our projects were formed, and thus interrogate *our* histories.

We also believe that it is empowering for students to revisit texts that were important in the history of cultural studies, in order to ask themselves: what project did they participate in? What proposals were they making? How do we – not just as 'given' culturally formed individuals, but as people who will have to make social and political choices – now feel about these projects and proposals? What equivalents are open to us, and where might they take us?

To select and revisit certain texts need not raise them to some canonical status. Texts all too easily appear to students as archaeological deposits, a past that is entirely set. We want to propose instead that texts such as the ones focused on in this book are best revisited as 'experience in solution' (Raymond Williams), that is, as holding within them the traces of a variety of problems and possible solutions, and different groups in formation. Our intention in inviting the essays in this volume was to show how it is possible to see these texts in this way.

Finally – and this returns us to our earlier comments on Raymond Williams, and to his views on adult education – we think it is unfair to

students to deny that any formal education has its own imperatives and demands that just must be met. Learning in an academic institution just does demand a coming-to-terms with ideas which is different from any other kind of learning. It is like the difference between learning to drive to pass the driving test, and learning to drive a dumper truck, or a taxi. Our hope is that this reader will enable students to acquire at least a provisional licence!

This introduction is entirely the responsibility of Anne Beezer and Martin Barker. We don't know how far, if at all, our contributors would agree with it. When we conceived this book, we drew up a preliminary list of the major texts that we felt needed re-evaluation; and colleagues – most from among those involved with us in the *Magazine of Cultural Studies* – volunteered to take on one. We didn't say what kind of critical evaluation we felt was needed. We only asked that they write an account of the formative influences on their chosen text, of its main claims and arguments, of its contribution and the responses to it, and how they would now assess its continuing importance. This was a recipe for eleven unrelated essays. But it is striking, to us at any rate, that among the essays there are common themes, recurrent worries, common regrets. There is an unease that something is being lost in the contemporary movement of cultural studies. However colleagues may phrase it, it is a worry about the disappearance of power as a central concept within cultural studies. That is what we want to recover.

September 1991

NOTES

1 Richard Johnson, 'What is Cultural Studies Anyway?', originally Occasional Paper 74, CCCS, University of Birmingham 1983.
2 Graeme Turner, *British Cultural Studies: an Introduction*, London: Unwin Hyman 1990; Patrick Brantlinger, *Crusoe's Footprints: Cultural Studies in Britain and America*, London: Routledge 1990.
3 Raymond Williams, *Culture and Society 1780–1950*, London: Chatto & Windus 1958; Richard Hoggart, *The Uses of Literacy*, Harmondsworth: Penguin 1958; E. P. Thompson, *The Making of the English Working Class*, Harmondsworth: Penguin 1968.
4 Raymond Williams, 'The Future of Cultural Studies', in his *The Politics of Modernism: Against the New Conformists*, ed. Tony Pinkney, London: Verso 1989.
5 This connects back to the more general argument that Williams was making at an earlier stage, in for example *The Long Revolution*

(Harmondsworth: Penguin 1961), that the achievement of democracy would be the outcome of two associated processes: a gradual but even increase in public involvement in institutions like the mass media and education; and secondly, the empowering of that involvement by the spread of a kind of social and political literacy. This view was ably criticised by, among others, E. P. Thompson, in his review of *The Long Revolution*.

6 Angela McRobbie, *Feminism and Youth Culture: From Jackie to Just Seventeen*, London: Macmillan 1990, p. 138.

7 David Morley, *Family Television: Cultural Power and Domestic Leisure*, London: Comedia 1986; Janice Radway, 'Reception Study: Ethnography and the Problem of Dispersed Audiences, and Nomadic Subjects', *Cultural Studies*, vol. 2, no. 3 (1988); Paul Willis, *Common Culture*, Milton Keynes: Open University Press 1990.

8 David Morley, 'Changing Paradigms in Audience Studies', in Ellen Seiter, Hans Borchers, Gabriele Kreutzner and Eva-Maria Warth (eds), *Remote Control: Television, Audiences and Cultural Power*, London: Routledge 1989, p. 37.

9 Janice Radway, op. cit.

10 Ien Ang, 'Wanted: Audiences. On the Politics of Empirical Audience Studies', in Ellen Seiter et al., op. cit.

11 Ien Ang, *Watching Dallas: Soap Opera and the Melodramatic Imagination*, London: Methuen 1985.

12 David Morley, *The Nationwide Audience: Structure and Decoding*, London: BFI 1980.

13 Janice Radway, *Reading the Romance*, London: Verso 1987.

14 Paul Willis, *Learning to Labour: How Working class Boys get Working class Jobs*, London: Saxon House 1977.

15 Paul Willis, *Common Culture*, p. 27.

16 For example, John Corner, Kay Richardson and Natalie Fenton, *Nuclear Reactions: Form and Response in Public Issue Television*, London: John Libbey 1990.

17 Ellen Seiter, ' "Don't treat us like we're so stupid and naive": Toward an Ethnography of Soap Opera Viewers', in Ellen Seiter et al., op. cit., p. 227.

18 Greg Philo, *Seeing and Believing: the Influence of Television*, London: Routledge 1990.

19 Paul Willis, *Common Culture*, p. 159.

20 John Fiske, *Reading the Popular*, London: Unwin Hyman 1989, p. 18.

21 Paul Willis, *Common Culture*, pp. 14–17.

22 Jim Collins, *Uncommon Cultures: Popular Culture and Postmodernism*, London: Routledge 1989.

23 For a further discussion which develops a critique of postmodernism along lines which we would broadly sympathise with, see Christopher Norris, *What's Wrong With Postmodernism: Critical Theory and the Ends of Philosophy*, Hemel Hempstead: Harvester Wheatsheaf 1990.

24 David Morley, *Family Television*.

25 It is interesting in the light of this to look at the valuable evidence from Andrea Press who, in her recent study, showed that there are structured differences in the relations to television of middle-class and working-class women. Middle-class women tended to relate to programmes like *I Love*

Lucy through the category of gender; whereas working-class women related to them along class dimensions. The importance of this is that, according to her evidence, the *kinds* of impact of class and gender are different. See Andrea Press, 'Class and Gender in the Hegemonic Process', *Media, Culture & Society*, vol. 11, no. 2 (April 1989).

26　Angela McRobbie, *Feminism and Youth Culture*.

Chapter 1

Ien Ang, *Watching Dallas: Soap Opera and the Melodramatic Imagination*

Susan Emanuel

Into the midst of the 1980s academic debate about popular media forms and the concurrent political debate about American cultural imperialism came a book from Holland about the paradigmatic series in both discourses, *Dallas*, which was by then successfully exported to ninety countries, and on its way to becoming the common currency of global television. In fact some would say that familiarity with the Ewings was virtually the only thing that viewers round the world had in common. But how could something so quintessentially American cross wide cultural chasms? While American communications experts used a content analysis of *Dallas* to take the temperature of the contemporary United States, others began to investigate how non-American viewers made sense of it.

Ien Ang, a lecturer in the Department of Political Science at the University of Amsterdam, has close ties to British cultural studies, and also affinity with both continental theory and American research in communications. Her study, published in Britain in 1985, was seminal in combining empirical work on viewer responses to the series with theoretical analyses grounded in key debates in cultural studies, keyworded in the titles of her four chapters: (1) reality and fiction; (2) the melodramatic imagination; (3) the ideology of mass culture; (4) feminism.

The preoccupation with television fiction succeeded an earlier period in cultural studies in which informational television was the object of study; news, current affairs, documentary are the objects of earlier publications by the Centre for Contemporary Cultural Studies and the Glasgow Media Group. There was a sense, by the early 1980s, that cultural studies scholars were finally acknowledging their own participation in the pleasures offered by the mass media; the issue became whether such forms could be studied by scholars without

turning into rationalisations of their own guilty pleasures. There was a swing from the disdain of mass culture which had coloured the Frankfurt School position to its opposite, the populism of a 'semiotic democracy'.

The empirical base of Ang's book are the 42 letters she received in response to a small advertisement placed in a Dutch women's magazine: 'I like watching the TV serial *Dallas*, but often get odd reactions to it. Would anyone like to write and tell me why you like watching it too, or dislike it? I should like to assimilate these reactions in my university thesis. Please write to . . .' (p. 10). Ang did not claim that this small sample was representative of even Dutch women's reaction to this 'present from a distant uncle in America' (p. 24). Her sights are trained on the relation between pleasure and ideology, a topic long repressed in leftist thought. Her book more than any other signalled an important shift in critical theory from analysis of texts to a study of the audience, a shift in the intellectual paradigm away from a functionalist approach towards pleasure and towards an analysis of why and how audiences take pleasure from popular culture, and how that pleasure relates to ideology.

Like David Morley's study of groups watching the BBC current affairs magazine *Nationwide* (see Chapter 8), *Watching Dallas* attempts to reconcile a structuralist perspective with the 'uses and gratifications' school of communications studies. As she put it in her Introduction: '. . . Pleasure must be conceived of as not so much the automatic result of some "satisfaction of needs", but rather as the effect of a certain productivity of a cultural artefact' (pp. 10–11). What makes *Watching Dallas* a key text in cultural studies is her success in rescuing critical theory from various impasses it had reached in the preceding decade – for example, the idea that mass culture merely mystifies, that texts determine their readings, that popular fictions aimed at female audiences are irredeemably patriarchal, and so forth – while remaining aware of her own status as a feminist and an intellectual, and of the political context of television studies.

What I propose to do is to look at Ang's sources, her key concepts, and her influences on later work in the light of the four chapter headings she uses. I will go on to comment on her methodology, and on critiques of reception studies, a field which her book helped to inaugurate.

REALITY AND FICTION

In this section, which considers *Dallas* as television entertainment and as a text with identificatory mechanisms which obviously succeed in binding Dutch (and even more sociologically remote) viewers into the world of J. R. and Sue Ellen, Pamela and Bobby Ewing, Ang poses the question of how a serial which is on so many levels patently fantastic can nevertheless maintain the realistic illusion. Film theory had for years been elaborating a theory of classical realism (derived from the narrational paradigm of the novel) to show how spectators are bound into, and manipulated by, texts. The construction of an illusory reality, this theory argued, produced a comfortable, transparent access for the viewer into the narrative. S/he would be borne away on the ideological stream through which the narrative craft moved – in the case of *Dallas*, presumably, the white waters of capitalist relations. By the time of Ang's book, the notion of an all-embracing classical realism had been discredited. (In one of many useful footnotes, she refers to the most trenchant critiques of that theory.)

The world of *Dallas* is patently not realistic to its viewers; they are well aware of its fictional excesses. But does that mean they are distanced from the values and ideas embedded in it? Ang cuts through this contradiction between reality and fiction, using the analytic distinction between denotation and connotation to demonstrate that *Dallas* does not have empirical but has *psychological* reality. One of her breakthroughs is to identify a level of understanding she calls 'emotional realism', a subjective experience of the world which may be more akin to the effect of myth. She then turns to Raymond Williams's idea of a 'structure of feeling', but now applied not to a society but to a genre, and concludes that 'at least for *these* fans, it is a sense of emotional realism that appeals to them. More specifically, this realism has to do with the recognition of a tragic structure of feeling, which is felt as "real" and which makes sense for these viewers' (p. 87). It arouses our awareness that happiness is precarious, that even the most perfect romance will end in tears. But Ang believes that our indulgence in over-sized feelings is a game played with reality, not an escape into fantasy. Her application of the slippery idea of structure of feeling to a television genre became one of the more controversial aspects of her book, because of the essentialism it implies.

A number of cross-cultural audience studies have since been done comparing *Dallas* with domestically produced serials, which find that audiences tend to judge the latter more in terms of realism. What the

Dallas formula offers, then, is perhaps primordial story material which is articulated in such a way as to be open to multiple levels of understanding and emotionality (cf. Katz and Liebes).

THE MELODRAMATIC IMAGINATION

Ang classifies *Dallas* generically as a 'prime time soap opera': like the daytime serials in its open-ended narrative, but like film melodrama (the woman's picture of the 1940s and 1950s) in its glossy visual style and sensational plot developments. Ang's book is part of the critical rehabilitation of melodrama as a mode of popular fiction which in its strong emotional appeal and moral dualism often underlies seemingly masculine genres like the Western and adventure films. It is the principal vehicle for the tragic structure of feeling in contemporary culture.

The theoretical analysis of film melodrama in Britain was substantial in the 1970s, notable for seminal essays by Laura Mulvey and Thomas Elsaesser, originally printed in *Movie* and *Monogram* respectively. Melodrama was the genre in which the crossover from film to television was most closely examined, and became a test case for the applicability of film theory to television studies. (Work on film melodrama would later be collected by Christine Gledhill in *Home is Where the Heart Is*, and she consistently argues for the different specificities of film and television melodrama.)

Soap opera was quickly 'colonised' by feminist critics moving into the study of popular television. In the USA and France there had been little-known pioneering essays on television melodrama, by David Thorburn and Jean-Marie Piemme respectively. A number of British serials beginning with *Coronation Street* had been the subject of monographs by people in the cultural studies movement, but much of the work did not specify the differences in form between these serials and prime-time soaps.

Ang takes from film analysis of melodrama such features of her discussion of *Dallas* as the use of metaphor (alcoholism, illness), the centrality of family relationships (Gillian Swanson's Lévi-Straussian analysis of *Dallas* made the family a key binary term), and the ironic use of *mise-en-scène*. 'The sun-drenched prairie around Southfork, the luxurious swimming pool, the tall, spacious office buildings, the chic restaurants and the elegant women and handsome men – they seem rather to belong to the optimistic image world of advertising, an optimism that does not fit in with the pessimistic world of soap opera, so that the *mise-en-scène* in itself produces a chronic contradiction'

(p. 78). A similar claim has been made for Hollywood directors of 1950s melodrama like Douglas Sirk.

From Tania Modleski, who studied women's fantasies in fiction, Ang takes the prominence of the hermeneutic code in soap operas, with their deferral of meaning from episode to episode (*Dallas* turned the cliffhanger into a cliché), and their invitation to the viewer to shift identification from character to character. But Ang parts company with Modleski's verdict (and that of others who have been depressed by women's taste for melodrama) that this mode ends up belittling the significance of the individual life. Counters Ang: 'The melodramatic imagination is therefore the expression of a refusal, or inability, to accept insignificant everyday life as banal and meaningless, and is born of a vague, inarticulate, dissatisfaction with existence here and now' (p. 79). Her humility in explaining the affirmation it does offer is founded in her respondents' own hesitant statements, such as 'I find it really difficult to state exactly why I like *Dallas*.' It may be difficult to account rationally for why you watch it, but that does not make it an escape from daily life, but the exercise of the 'melodramatic imagination', a term first used by the literary critic Peter Brooks (1976). Unlike him – and most of the film theorists I have mentioned – Ang does not draw on psychoanalysis to explain pleasure.

THE IDEOLOGY OF MASS CULTURE

Ang's approach to her respondents' letters is that of a 'symptomatic reading', meaning she treats their responses as symptoms of underlying ideologies. In a symptomatic reading, therefore, she must also account for some viewers' vehement *dislike* for the series. She ascribes this boredom and/or irritation to the prevalence of an ideology of mass culture (particularly in Europe) which alleges that national cultures are being swamped by commercial American 'trash'. In a section called 'Hating *Dallas*', she quotes responses like 'I find it a typical American programme, simple and commercial, role-affirming, deceitful. The thing so many American programmes revolve around is money and sensation' (p. 91). Commercial series like *Dallas* get labelled as 'bad objects', in comparison to which respectable, and supposedly more artistic, culture seems reassuringly superior. In a notorious speech to a gathering of intellectuals in Paris in 1983, the French culture minister made *Dallas* the Medusa's head of American media imperialism; the television critic of the *Financial Times* put 'wall-to-wall *Dallas*' in the subtitle of a glum book on the future of television. The premise was

that *Dallas* was carrying American and capitalist ideology into societies whose indigenous values bore no relation to those of mythological Texas.

There are a variety of defences against the threat perceived in mass culture. Ang was one of the first to note that it became socially acceptable to view 'bad objects' if one maintained a suitably ironical attitude to them. (This irony was later associated with *Dynasty*, which seemed to invite it.) As a person of taste, you can feel superior to other people who fall for them. A second defence is populism, the appeal to common-sense ideas like the arbitrariness of taste, which thumbs its nose at the ideology of mass culture. As she later noted in an article with Morley: 'If Hollywood ever colonized the subconscious of postwar Europe then it was with the knowing complicity of a large number of Europeans' (Ang and Morley 1989: 140). She finds that hierarchies of taste had been so internalised that even those who liked *Dallas* apologised for the fact. High and popular art are in a dialectical relation with each other. Although insufficiently developed, her defence of the popular aesthetic (inspired by Pierre Bourdieu) is that it is more pluralist and open than the high art aesthetic. It also puts pleasure – not some formal or moral purity – at the centre. This line of thought has been taken even further in the work of John Fiske, who argues that people re-shape mass media materials to resist dominant ideology with almost unlimited latitude.

Ang cautions against this ideology of mass culture as an ivory tower disposition, as have many European media scholars who have taken up her work, looking at the dissemination of American serials in their native countries. Kim Schrøder, who has studied the reception of *Dynasty* in Denmark, is one of a number of scholars trying to redefine aesthetic quality in a non-hierarchical way, in order for television studies to have an impact on both schooling (where the curriculum is still dominated by high culture criteria) and on government policy ('Quality' appears in the title of the British White Paper on broadcasting, where it is assumed to mean diversity of provision). Schrøder's model uses taste-related categories, intrinsic not to the text but to the experience of it, and which are relative, avoiding the pitfalls of either snobbery or populism. The three dimensions of quality in experience of popular culture he elaborates are the ethical, the aesthetic and the ecstatic, and he argues that any fictional text that actualises all three of these dimensions can be termed to have quality. Even *Dallas*.

Another offshoot of Ang's work is the study of transnational attempts to copy what is perceived as the *Dallas* formula. In 1986, the

British Film Institute published *East of Dallas*, in which contributors from various European countries analysed indigenous serial television fiction traditions, and the fate of the national attempts to produce a successful prime-time soap. Not only programmes but audiences are becoming internationalised too, as the big budget American production model is emulated for circulation within the European community.

FEMINISM

The evidence shows that *Dallas* is watched and appreciated more by women than by men. Ang's respondents debate the relative merits of Pamela and Sue Ellen, the two main feminine subject-positions the series offers, but she notes that neither offers a shred of hope for feminists. How can patriarchal fantasies be mobilised for a feminist politics?

Methuen published the year before Ang's book the study by Tania Modleski, *Loving with a Vengeance: Mass-Produced Fantasies for Women*, which had come out in the USA two years previously. As Ang points out, much of the early work by feminist scholars on soaps – the archetypal women's genre and one long degraded as the lowest form of television – is motivated by dismay at its patriarchal ideology. Feminists wanted to distance themselves from 'anti-emancipatory' feminine texts. This 'monstrous alliance' between feminists and the ideology of mass culture was gradually overtaken by later (often British) audience research which called attention to the skills necessary to follow a serial: series memory, the ability to juggle domestic labour, to reinterpret plot developments in gossip, and so on. Although monographs from the British Film Institute had disseminated some of the work being done by feminists on British soap operas such as *Coronation Street* and *Crossroads* (Dyer et al., Hobson, Brunsdon), Ang's study, in taking on an American and internationally distributed serial, drew these debates to the attention of a much wider audience.

While Ang argues that *Dallas* can be open to feminist readings, she finds that there may be an irreconcilability between a tragic structure of feeling and a feminist sensibility. And while it is impossible to say whether this structure of feeling is conservative or progressive, the critic must always be aware of the political effectivity of her own work. Later research into predominantly female audiences which is indebted to Ang includes Janice Radway's study of romance fiction (1984) and Helen Taylor's *Scarlett's Women: Gone With The Wind and its Female Fans* (London: Virago, 1990).

METHODOLOGY

Ang was not the first to gather qualitative material on audiences. The sparsity of the replies, their unstructured nature, the self-selection of the sample – all mean that her study lacks the depth and demographic context that quantitative surveys have. Nor did she have any personal interaction with her respondents, which means that this qualitative study lacks the ethnograpic dimension that some media scholars strived for. But her work is free of one common weakness of such research: a tendency for the scholar to write from a position superior to her respondents. Ang does not imply that intellectuals stand in a vanguard relation to popular culture because of their ironic detachment from it. Her methodology offers an alternative model to the empiricism of American communication studies.

Serious treatment of popular culture, and attention to the ways in which ordinary people make sense of television programmes is still relatively new in countries like France. In the autumn of 1990, Ang and other practitioners of reception studies presented an overview of their field to an audience at the Georges Pompidou Centre. She sketched two traditions: effects *on* the audience, and functions *for* the audience. The general trend has been from the former to the latter, from a social-psychological perception to a socio-cultural perception of the audience. Marx's famous phrase about 'circumstances not of their own making' may not be forgotten by researchers unless they work in an historical vacuum.

Ideas of perception have been considerably refined since the 'hypodermic' model of communication: meaning is actively produced by the viewer, and due weight must be given by the researcher to the context of reception (beginning with whether we watch alone, or with family members or friends, and whose finger is on the remote control), to demographic factors of nation, class, age and gender, as well as more amorphous determinants like cultural capital. With respect to the latter, Ang noted how often the condemnation of soaps changes to cult admiration when intellectuals start watching them in an ironic mode!

Discourse theory has made a big impact on cultural studies. Among the discursive contexts relevant to studies of the television audience is the fact that viewers do not relate in a neat way to a television 'text'; they are 'nomadic subjects' engaged simultaneously in household routines and woven into webs of personal and family relationships. Television's intertextuality – programmes' reference to other series or

cultural icons outside television itself – is another context which is receiving widespread attention, even in daily journalism. More elusive is what is called 'tertiary reception', that is, how television helps construct national and historical consciousness, how we all draw on the cultural memory bank accessed by the television screen.

Nowadays reception researchers engaged in 'micro studies' of the reception of individual programmes or series are questioning for various reasons their own methods and even objectives. The previously secure boundaries of television genres and texts are dissolving; ethnographic surveys challenge the very notion of 'watching television' as a concentrated activity; responses to individual programmes are shaped much more than was previously thought by secondary factors like press publicity and tertiary ones, like popular memory. A question mark has been hung over the various forms of decoding models. Some media scholars are worried about the gap between the study of popular drama, driven by models of pleasure, and study of news and current affairs, driven by models of knowledge acquisition. And what validity do microstudies have unless they are buttressed by larger scale quantitative surveys?

Tamar Liebes from Israel represents a more structuralist kind of media scholarship. She and her collaborator Elihu Katz are trying to answer the two questions of why people keep watching soaps, and why so many different kinds of people watch them. Their structuralist method fuses aspects of various decoding models, almost all of which use dichotomies: closed/open, hegemonic/oppositional, preferred/aberrant, etc. Katz and Liebes have designed a matrix in which those models intersect with two types of involvement in television texts (referential as opposed to constructional). Liebes concludes that the main reason people keep watching serials like *Dallas* is that the locus of dramatic tension shifts from plots to the personalities of the characters, who in turn shift among moral positions, producing ambivalent feelings in viewers with floating allegiances to different characters.

Dallas has generated particularly rich comparative audience research, most notably Katz's and Liebes's 1989 *The Export of Meaning: Cross-Cultural Readings of Dallas* which uses focus group interviews with couples from a range of different ethnic communities, to show the radically different range of meanings the serial carried, and the reasons for its failure in certain countries like Japan and Brazil. (They note that even within Europe, a study of German audiences turns up signs of Oedipal appreciation of J.R.'s rebellion against the conscience embodied in Miss Ellie, very different from the disapproving stance

taken by Ang's Dutch viewers.) One of the reasons *Dallas* has been
studied by so many communications scholars, they argue, is that it came
along at the moment of convergence between critical theory, which
was at last taking note of the existence of alternative readings amongst
ordinary viewers, and the gratifications school, which was at last
returning to the text to see what ideas were being communicated. Ang,
on the other hand, doubts that there has been any real convergence
between the two schools.

A concentration on the range of viewer decodings has changed the
agenda of cultural studies. New research questions include institutional
definitions of audiences (for example in the broadcasters' departments
of audience research); the emergence of new genres (which specify
their own epistemological and communicative frames); the need to
transcend binary ways of conceiving texts and viewer involvement (for
example, as open versus closed); the effort to integrate new work on
cognition; and the reformulation of the old question of the power and
influence of the mass media (questioning, for example, the assumption
that casual viewing is more resistant to effects than is concentration).

Audience research has blossomed with a strong impetus from
ethnographic work like James Lull's *Inside Family Viewing*, although as
Seiter et al. note (1989) relatively few academics actually engage in
study of the audience. Recent examples of the new importance of
everyday life and how people make use of media texts and artefacts are
a collection of essays on Batman culture (one-third of which involve
audience research), and a book by Henry Jenkins on television fan
subcultures (*Textual Poachers: TV Fans and Participatory Culture*).

THE POLITICS OF THE AUDIENCE

Modleski has been one of the most vociferous critics of ethnographic
research, on the grounds that it risks validating the dominant ideology.
Scholars like Ang, she says in her introduction to *Studies in Entertainment*
may end up 'writing apologias for mass culture' and 'reproducing in
their methodologies the very strategies by which consumer society
measures and constructs its audiences' (1986, p. xii). On somewhat
different grounds, Charlotte Brunsdon finds that this type of cultural
studies has often replaced the bad old text with the good new audience,
and argues that analysis of individual television texts must remain
central. Others feel that the pendulum has swung too far in the
direction of consumption and away from production.

Ang herself has since re-evaluated her work, and the place of

audience research within cultural studies. In her essay in the collection *Remote Control* she takes some audience researchers to task for the academicism of their approach: 'One essential theoretical point of the cultural studies approach to the television audience is its foregrounding of the notion that the dynamics of watching television, no matter how heterogeneous and seemingly free it is, is always related to the operations of forms of social power' (1989, pp. 101–2). She has more recently written a study (1991) of professional broadcasters' discourses of the audience grounded in an ethnographic approach.

In a joint article, Ien Ang and David Morley wryly note that while cultural studies can be seen as an export industry, it is certainly not an intellectual movement, or very influential on socialist thought about culture. 'What is sadly missing in north-west European public discourse is any sustained, Left intellectual interest in discussing matters of contemporary culture in a critical yet open-minded way' (p. 136). This, they say, is due to:

> the dominance in spirit if not in practice, of a social democratic vision of culture in post-war western Europe. For social democracy, with its concept of the welfare state, to be built up through rational institutional reform and planning, cultural politics becomes a matter of cultural policy, a set of state-directed practices, guided by pedagogical aims presented as democracy . . . This conception is notably manifested in policies for cultural education and distribution, in which culture (generally still defined in high cultural terms) is seen as a fixed value that needs to be disseminated throughout the whole population. As a result, the role assigned to 'the people' is exclusively that of receivers, not of producers of culture . . . (1989: 136–7)

Cultural policy has been determined by political forces with scant regard for academic research on popular cultural practices.

I write this during the week in spring 1991 when CBS broadcast the final episode of *Dallas*'s thirteen-year run to an audience of 41 million Americans. Its re-working of the premise of the 1940s film *It's a Wonderful Life*, but with a devil showing J. R. what might have happened if he had not lived, will presumably be shown round the world, where that Jimmy Stewart film is not part of the national popular memory, and so for that reason, among many others, it will produce very different resonances. Though the popularity of this series and its spin-offs may have waned, there is no sign that serial fiction's importance in world television culture is declining, from the Latin

telenovelas to the high gloss of *L. A. LAW*. For anyone who takes their popularity – and their own pleasure in them – seriously, Ien Ang's book on *Dallas* will remain a key text.

SELECT BIBLIOGRAPHY

Allen, Robert C. (1987) 'Reader-Oriented Criticism and Television' in Robert Allen (ed.) *Channels of Discourse* London: Methuen.

Ang, Ien (1985) *Watching Dallas: Soap Opera and the Melodramatic Imagination*, London: Methuen.

Ang, Ien (1989) 'Wanted: Audiences. On the Politics of Empirical Audience Studies' in Ellen Seiter et al. (eds), op. cit.

Ang, Ien (1991) *Desperately Seeking the Audience*, London: Routledge.

Ang, I. and Morley, D. (1989) 'Mayonnaise Culture and other European Follies', *Cultural Studies*, vol. 3, no. 2, pp. 133–44.

Brooks, Peter (1976) *The Melodramatic Imagination*, New Haven: Yale University Press.

Brunsdon, Charlotte (1989) 'Text and Audience' in Ellen Seiter et al. (eds), op. cit.

Dyer, Richard, C. Geraghty, M. Jordan, T. Lovell, R. Patterson and J. Stewart (1981) *Coronation Street*, London: BFI.

Elsaesser, Thomas (1972) 'Tales of Sound and Fury', *Monogram*, no. 4.

Feuer, Jane (1984) 'Melodrama, Serial Form and Television Today', *Screen*, vol. 25, no. 1, pp. 4–16.

Geraghty, Christine (1991) *Women and Soap Opera*, London: Polity Press.

Gledhill, Christine (1987) *Home Is Where the Heart Is: Studies in Melodrama and the Women's Film*, London: BFI.

Hobson, Dorothy (1982) *Crossroads: the Drama of a Soap Opera*, London: Methuen.

Jenkins, Henry (1992) *Textual Poachers: TV Fans and Participatory Culture*, London: Routledge.

Katz, E. and Liebes, T. (1989) *The Export of Meaning: Cross-Cultural Readings of Dallas*, Oxford: Oxford University Press.

Lull, James (1990) *Inside Family Viewing: Ethnographic Research on Television's Audiences*, London: Routledge.

Modleski, Tania (1982) *Loving with a Vengeance: Mass-Produced Fantasies for Women*, Hamden, Conn.: Archon. British publication: London: Methuen 1984.

Modleski, Tania (ed.) (1986) *Studies in Entertainment: Critical Approaches to Mass Culture*, Bloomington, Ind.: Indiana University Press.

Morley, David (1986) *Family Television: Cultural Power and Domestic Leisure*, London: Comedia.

Morley, David (1989) 'Changing Paradigms in Audience Studies' in Ellen Seiter et al. (eds), op. cit.

Piemme, Jean-Marie (1975) *La Propagande Inavoué*, Paris: UGE.

Radway, Janice (1984) *Reading the Romance: Women, Patriarchy and Popular Literature*, Chapel Hill: University of North Carolina Press and London: Verso.

Schrøder, Kim (1987) 'Convergence of Antagonistic Traditions? The Case of Audience Research', *European Journal of Communication*, vol. 2, pp. 7–31.

Seiter, Ellen, Hans Borchers, Gabriele Kreutzner and Eva-Maria Warth (eds) (1989) *Remote Control: Television, Audiences and Cultural Power*, London and New York: Routledge.

Silj, A. (ed.) (1988) *East of Dallas: the European Challenge to American Television*, London: BFI.

Swanson, Gillian (1985) '*Dallas*. Parts One and Two', *Framework*, nos 14 and 15.

Thorburn, David (1976) 'Television Melodrama' in R. P. Adler (ed.) *Television as a Cultural Force*, New York: Praeger.

Tulloch, John (1990) *Television Drama: Agency, Audience and Myth*, London: Routledge.

Chapter 2

Peter Bailey, *Leisure and Class in Victorian England*

John Baxendale

I

In the late 1970s, when Peter Bailey's book was published, cultural studies and social history seemed for a time to march together. Cultural studies was formed in a critical relationship to Marxism (itself a theory of history) and its founding texts included the essentially historical works of Raymond Williams and Edward Thompson.[1] A lot of people think history is about 'the facts' – what actually happened: but anyone with a rudimentary grasp of cultural theory can see that history is also a work of construction and representation, in which 'the facts' mean nothing without theories and concepts. History in the 1970s was turning away from blind empiricism to a more conscious engagement with theory and method: much of that theory, as we shall see, was held in common with cultural studies. So, there was a convergence, and this book has to be understood in terms of that convergence: but also in terms of the ways in which history and cultural studies remained, and remain, separate.

It seems to me, as a rough rule of thumb, that there are three kinds of things a student of cultural studies might expect to learn from a history book. First, historical research can be a unique kind of ethnography. Obviously, some techniques, such as participant observation, are not available, but there are compensating gains: the historian has hindsight, can see a number of times and places simultaneously, has access to documentary records. From this detailed (re)construction, we get a sense, more difficult to convey in contemporary studies, of the multidimensionality and dense texture of cultural life, and the multiplicity of forces which make it what it is. We also get a sense of difference, as we do when reading about an alien culture, but at the same time of connection and recognition, all of which sharpens our

perception of what is specific and different about our own time and culture.

Second, history is a testbed for theories and concepts. Do notions like 'class', 'hegemony', 'ideology' actually work – do they help us to understand the world? Many of our common concepts were developed in order to explain historical change, and despite historians' traditional scepticism, much historical debate is still about their explanatory value. Bailey's book, explicitly foregrounding class, as did much historical writing of the time, invites us to test the strengths and limitations of the concept in a way that no philosophical debate could match.

Finally, history gives us ideas about epochal change – about the grand temporal sweep of human society. Grand narratives are said to be unfashionable at the moment, and most historians have never liked them. But all the same, only from history can we get a large-scale sense of structural change in society, and the part played in that by different forces and agencies – production, culture, the state.

All these things can help us to understand culture, drawing us away from the eternal present and the textual obsessions to which some kinds of cultural analysis are prone. But it has to be understood at the same time that history as an intellectual practice has its own obsessions, and that a book like this springs primarily from those. British social history in the mid-1970s was preoccupied as it had always been with one dominant theme: the transition to an urban, industrial society during the late eighteenth and nineteenth centuries. Out of this theme, depending on your point of view, could be spun a number of different historical narratives, and the disputes between these set the agenda for historical research. Drastically oversimplifying rival points of view, and exaggerating their coherence and fixity, let us say that by the 1970s there were two rival 'grand narratives' of the great story of industrialisation. One was based on conflict, exploitation and class struggle; the other on consensus, correctable grievances and social stabilisation.

The first – broadly derived from Marxism – held that conflict was not merely inevitable but actually built in to the foundations of capitalist society, the motor by which history moved. Social harmony was therefore something the ruling class had to achieve, overriding by coercion or persuasion the interests of the classes they exploit. According to the second narrative, capitalist society was (or could) be run for the benefit of all its members: social harmony developing through non-coercive acceptance and the fair treatment of grievances – a rarely fully-achieved, always fragile, liberal ideal, towards which British society is said at times to have tended. In their different ways,

both narratives put class at the centre of the stage.

So historians' views about popular culture have to be understood by asking what larger questions, what hidden agenda they are addressing. Rival historians would probably agree on the underlying theme of Bailey's period: the intensification, and then (after the 1840s) a diminution of social conflict. But they would disagree profoundly on how to describe this process – the achievement of consensus, a stable class society, a new phase of bourgeois dominance – and to describe it was to explain it. In the 1970s, they were starting to think that popular culture, related as it was to class, power and ideology, might have some bearing on the issue: perhaps as an instrument of control, perhaps a means of class expression, perhaps a site where social conflicts were resolved. But to come to this view required some shift away from orthodox Marxist and liberal positions.

As Bailey points out in his Introduction, an 'elementary schema' of the history of popular leisure was already in existence at his time of writing (p. 2).[2] This received story is of a 'traditional' rural culture, wiped out in the early nineteenth century by industrialisation, urbanisation and the work ethic. The resulting vacuum was eventually filled by new urban recreations – football, music hall, Blackpool – displaced in their turn by 'modern' mass communication and the leisure industries of our own century. This bald historical framework, which has been the basis of several conflicting theories of culture, could accommodate both major historical narratives – Marxist and liberal. But in both cases, popular culture tended to be marginalised.

For orthodox Marxist historians, what mattered was class struggle; class struggle was about production and politics, and this meant trade unionism and political organisation, and class-consciousness gained in the direct experience of capitalism and of the struggle against it. Only genuinely class-expressive forms of popular culture (either explicitly political, or 'authentically' folk) could be seen as consciousness-raising. Leisure time was something to be struggled for, not with, in the fight to reduce working hours. The forms in which it was actually used when it had been won were at best irrelevant; worse, an opiate; worst of all a weapon of the enemy, transmitting 'false consciousness' and bourgeois ideology. Orthodox Marxists therefore did not deal with nineteenth-century popular culture very much at all.

Liberal historians, on the other hand, stressed the emergence of cross-class consensus and shared social values, in the 'age of equipoise' which succeeded the stormy 1840s. Popular culture was sometimes used to exemplify this equipoise, to show the shared values at work, and

how things were improving for the majority; but it could not be portrayed as an active force or instrument in bringing these things about, without falling back into Marxist ways.

II

So, in a typical text, Geoffrey Best's book *Mid-Victorian Britain*, published in 1971, common values of respectability and independence are seen not as middle-class values transmitted 'downwards' but as genuinely shared by people of all social classes.[3] Popular recreation 'for the most part seems to defy strict presentation in terms of social or economic class'. Rather, 'it must have functioned to some extent as yet another of those common grounds for members of different social and economic groups which characterised social relations during our period and helped to keep them, relatively speaking, sweet'.[4] Though Best is writing at a time when little research on the history of popular culture had been done, his book contains a lot of information about it. But in the use he makes of it shows the place which the liberal schema reserves for popular culture: expressing, rather than generating, social harmony, and while interesting in itself, not an important field of historical change.[5]

This survey of the territory explains why the historical study of popular culture before the 1970s was largely left to the amateur enthusiast, the antiquarian and the folklorist.[6] Yet, by the end of the decade it was rapidly becoming one of the growth-areas of historical research.[7] Much of the theoretical debate which convulsed historical studies in this period focused on questions of culture and ideology.[8] Moreover, social history was seen as a major contributor to the new discipline (or 'convergence of interests' (Bailey, p. 13)) of cultural studies, some of whose most important debates were conducted around historical themes; and in the avalanche of new non-historical work on popular culture, a historical perspective of some kind was a sine qua non.[9] What had happened?

Briefly, history was affected by political and intellectual changes similar to those which gave rise to cultural studies itself in the post-1960s era. Thompson's *The Making of the English Working Class* (1963) was one of the first of a whole string of histories which took as their object popular behaviour, experience and belief: not, any longer, seen through the narrow frame of political and economic organisation but as something which working-class people created and shared themselves.[10] The working class, Thompson famously insisted, was not

'made' by external forces of the factory and the steam-engine: in an important sense it made itself. But what did it make? Enter Raymond Williams: a culture, a 'whole way of life'.[11] Williams defined what a culture was; Richard Hoggart, in *The Uses of Literacy*, described, partly from within, what the components of an actually-existing working-class culture might be, in the Hunslet of his boyhood.

It was no coincidence that Hoggart and Williams both had working-class roots: a rarity among intellectuals of earlier generations. Nor was it a coincidence that Thompson had been among those leaving the Communist Party in the 1950s, in the disintegration of Stalinist certainties – including 'orthodox Marxist' 'grand narratives'. The history of the working class was no longer the history of its institutions, movements and activists (though for many Marxists it never had been). The complexities and contradictions of the popular culture that most working people actually lived in could, and must be, faced.

So, was Bailey a part and product of these stirring intellectual developments? From his stylish condensed intellectual autobiography written in 1986 (pp. 18–20), it seems not. Returning to England from Canada as a graduate student at the height of these 'political and theoretical fermentations', he was largely unaware of them – 'more likely to have mistaken the *New Left Review* for a cabaret act than the broadsheet of a reinvigorated intellectual radicalism'. He began his research on recreational reform from a liberal standpoint, in 'the respectable tradition of studies of the reformer and reform institutions in "the age of improvement" ': recreational reform being, like housing, sanitary or educational reform, a mark of progress. But his attention – and sympathy – was pulled from the reformers to the reformed. It was not, therefore, orthodox Marxism which proved inadequate to his purpose, but liberalism. This he explains (most appealingly) in personal terms. The déclassé working-class Oxford student, boozy poseur and academic failure, redeemed by emigration to the colonies, was now a semi-detached observer of the social system in which once he had been a minor combatant and would-be 'improvee'. Hence, he was inclined to side with the working people who, like himself, had to win 'small but relishable gains in a class war gone underground', rather than with the middle-class reformers who sought to 'improve' them from above.

This is plausible and engaging autobiography: and one with more general application. Social and cultural change had undermined the certainties of liberalism. Intellectuals no longer occupied the assured social position of their nineteenth-century forebears, outside and above

the masses, from which they could safely be observed and/or 'improved'. Today's 'lumpen professoriat' (p. 20) has had more in common with the 'improvees' than with the 'improvers'.

So for Bailey, while industrialisation and urbanisation did indeed call forth a 'new leisure world', the working class were neither the passive victims of social disruption nor passive recipients of a reformed culture imposed 'from above'. Nor – classic leftist cop-out – were they active only in politically radical ways. As 'one of the major frontiers of social change in the nineteenth century', leisure was 'disputed territory': an area of exchange between social classes, and not a vehicle for social control, or for unambiguous class expression.[12] The book therefore takes as its theme the interplay between 'the middle-class activists who sought to shape working-class choice', and 'the indigenous process of renewal in popular culture' – with the familiar shape of the publican, along with other commercial providers, looming increasingly large as the century wore on.[13]

In adopting this more interactive approach to class and culture, Bailey was, despite his disclaimers, very much of his time. The work of Gramsci was attracting a great deal of interest as a way out of the impasse of classic Marxism.[14] For Gramsci, hegemony is a process of interaction, and (unequal) exchange between classes and fractions, in which stable dominance is achieved by negotiating consent, rather than simply by force or the imposition of a dominant ideology. In this process, culture and ideas become disputed territory, in which ruling groups are obviously powerful, but in which their power is not unquestioned or their dominance guaranteed. Culture is clearly a lot more interesting and important from this standpoint than it was for either orthodox Marxist or liberal.

Though Bailey says a lot about Gramsci in the 1986 Introduction, he hardly mentioned him in 1978: however, Gramsci's spirit haunts the pages. In this Gramscian mode, and against the received view that urbanisation crushed the popular spirit, Bailey points to the immense vitality of life in the early Victorian town. Popular recreation adapted, rather than succumbed to, the new constraints of time and space. Fairs, wakes and race meetings flourished. In the form of 'Saint Monday', traditional transgressions of the work/leisure boundary persisted, to the despair of employers. Street life was crude, noisy and drunken. The middle classes saw this culture as a hangover from earlier, less rational times, and a threat to the values they wished to carry through: work-discipline, respectability, progress and rationality. Through moral exhortation, the law and the police, they sought to curb it.

To some extent, they succeeded, often against sharp resistance – although, as we know, struggles over the use of public space are never finally resolved.[15] But in fact, working-class people were never wholehearted about defending 'traditional' pastimes. New recreational opportunities emerged which were, to the poor, among the benefits of urban civilisation. But to be properly enjoyed, they had to become more orderly and organised. Traditional agencies were ready to adapt. Pubs grew bigger and better, and host to a wider programme of activities and entertainments – particularly music, whose tone could be boisterous or intellectual, or both. From the pub grew the singing saloons – 'called into being by the working classes [who] asserted a remarkable degree of popular control over them' (p. 42). Bailey's case study of the Star in Bolton (opened in 1840) shows an extraordinary variety of entertainment on offer, from the self-improving to the frankly vulgar. In short, popular leisure refused to go away, but expanded and became more 'modern'. But it stubbornly refused to conform to the ideals of middle-class reformers, and seemed more dangerous than ever as leisure-time expanded. What was to be done about it?

If popular leisure could not be abolished, it must be 'improved' like everything else in this 'age of improvement'. Leisure which coarsened taste, debilitated the body and disrupted social harmony must be replaced with leisure that was a positive force for moral education. But how? The middle class must set the standards and set the example. Under their tutelage, 'rational recreation' would be achieved by the voluntary and fraternal association of classes. Only thus would the workers learn from their betters, class hostility be assuaged and a sense of community restored. So the future of recreation must lie not in the pub and the music hall but in the Working Men's Club, with its lectures and library; in horticultural shows and brass band contests; in the museum, the gymnasium and the playing-field: all with their list of middle-class patrons, subscribers – and, ideally, participants. This cross-class ideal of 'rational recreation' inspired recreational reformers for much of the nineteenth century, and its failure is the central focus of Bailey's book.

Why did 'rational recreation' fail, and what have we to learn from it? It would be a simple matter to say that it failed because it was not market-driven, and so did not give people what they wanted. This would be to ignore real needs which were not met by the pub, and perhaps could not be met commercially at all, but only by the voluntary work of, for instance, members and patrons of 'improving' Working

Men's Clubs. Much the same goes for the football club, fostered at first no doubt by some paternalistic employer or do-gooding curate, and requiring their help to buy kit and find somewhere to play, but soon gaining its independence and its paying spectators. Of course, 'rational recreation' was patronising. But so, in a different way, was the 'give 'em what they want', beer and skittles, philosophy, frequently applied by aristocratic landlords or Tory millowners, expecting the workers to get loyally drunk celebrating the heir's coming of age.[16] The mistake in both cases is to judge the recipients according to the motives of the providers – a mistake we are still inclined to make. People with cultural needs would turn to whichever agency, commercial, voluntary or charitable, would provide for them. Sometimes there was a price to be paid for these 'small but relishable gains', in acknowledgement of the hegemony of your 'betters' – tugging the forelock, or adopting a 'respectable' mien. This, for Bailey, was not the deferential submission which some historians see, but simply playing the system.

III

Rational recreation failed, says Bailey, because contemporary middle-class people made the same mistakes that historians have made. They had two stereotypes of working-class behaviour: 'rough' and 'respectable'. Working people were either threatening and violent, or they accepted the status quo. The aim of 'rational recreation' was to move people from one condition to the other. But these ideological categories, often applied by historians, had less to do with working-class behaviour than with middle-class preoccupations. Bailey shows that they simply do not work. 'Bill Banks', the railwayman whose fictional excursion to Hampton Court, by turns sedate, self-improving, drunken and unruly, Bailey analyses with wit and precision (pp. 100–1), is neither rough nor respectable; or, if you like, is both.[17] The fact is that these were not the categories by which most people lived: rather than distinct, separate and exclusive kinds of people or activity, they were, Bailey argues, social roles, which they understood, and could adopt at will. People did not judge their own recreation by the 'improving' or 'degenerate' categories of the rational recreation theory, so they could not be induced to choose one over the other.

All Bailey's case studies illustrate this theme, but in different ways. Thus, Working Men's Clubs (see chapter 5) were promoted by the philanthropist Henry Solly to provide an improving and socially harmonious alternative to the pub. Their middle- and upper-class

patrons therefore sought to control behaviour and activities – in particular, politics and the sale of beer. Resentment of this patronage led to most of the clubs becoming self-governing by the 1880s, supported financially by beer sales, and engaged in a wide range of educational, recreational and political activities. Orderly, well-run and certainly bent on Improvement, 'though they moved up Solly's inclined plane they were bound for a different destination' (p. 132) – an independent, working-class culture without the guiding hand of social superiors. Here, self-improvement, respectability, independence – the great aims of middle-class reformers – were indeed achieved, but in a different form from that envisaged by the reformers. This idea of a 'negotiated', working-class version of the great shibboleth of 'respectability' is straight out of the Gramscian repertoire.[18]

Sport (chapter 6) was originally highly suspect in the eyes of the moral reformer, exercising the body, not the mind, and providing the occasion for vulgarity, drunkenness and gambling among spectators. Its adoption by the revived public schools as a vehicle for moral virtues and physical fitness rehabilitated it for more general 'improving' use. But while reformers may have believed that with the rules of association football they were spreading team-work, sportsmanship and health to the masses, their missionary efforts were in fact grafted on to a long-standing popular appetite for sport, which could now benefit from the more organised framework which the public schools had developed. Once set free, football would veer towards the plebeian traditions of professional athletics, with its gambling and rowdy partisanship, rather than the gentlemanly world of amateur sport where its rules and organisations originally came from. As with the Working Men's Clubs, patronage was accepted only for as long as was necessary to get things off the ground. By the time of the 'football mania' of the 1880s and 1890s, the game was not a rational recreation but a professional spectator sport, a cause of moral panic, and the supposed harbinger of a new wave of atavistic barbarism.

Professional sport fulfilled one set of needs: those of the spectators, who gave it a central role in urban culture. But amateur sport also met popular needs: those of participation. Here, a different story unfolds, one which casts interesting light on middle-class motives. Professionalism – competing for money, or as a job – was of course banned by the amateur organisations. But also banned from sports like athletics, rowing and cycling until the 1870s were 'mechanics, artisans and labourers'. Working-class amateurs were not allowed to compete with their middle-class counterparts. Not only did social mixing threaten

the respectable tone of amateur athletics, but most middle-class people found it uncomfortable. Just as working-class men preferred to run their clubs under their own steam, and along their own lines, so the bulk of the middle class also used recreation not to 'improve' other people but to seek their own separate identity and status. Resenting the expansion of working-class leisure, and often finding the company of even respectable working men distasteful, the middle class developed their own holiday resorts, their own clubs, sports and pastimes, such as yachting, tennis and golf, which had precisely the advantage of the first-class railway carriage: the plebs could be kept out (chapter 3).

A proper attention to the actions and motives of middle- and working-class people alike therefore tells us a different story from the rhetoric of the reformers. Recreations can indeed be a vehicle for social values – but exactly which social values cannot be controlled in advance. Not just for the working class, but for the middle class too, recreation carried meanings: not common, cross-class meanings but meanings of class identity and class separation. Thus did the class-divided society undermine the rational recreationists' purpose.

The failure of middle-class reformers to penetrate working-class culture had already been pointed out by Gareth Stedman Jones, in a seminal article published in 1974. But for him, it was not all good news. Late nineteenth-century working-class culture became impervious to all outside influences or ambitions, an inward-looking 'culture of consolation', addicted to small pleasures, which turned its back on class-assertive political activity.[19] Bailey finds this picture too bleak. 'The cultural politics of the 1880s', he argues, 'indicate a capacity for collective assertiveness among working people that goes beyond the simply conservative and defensive' (p. 186). Workers showed in their various conflicts over leisure that they could manipulate the rules of the social order to their advantage, and emerge with the cultural forms which satisfied their own needs.

Stedman Jones may lead us into a dead end where nothing counts except 'the set pieces of collective class expression and encounter' (p. 17), and Bailey's formulation suggests a more open and cautiously optimistic view, in which culture can still be a field of resistance and popular creativity. However, it still leaves a lot unresolved. This stylistic ducking and diving is attractive, but what does it really have to do with class? Are we to understand that class is primarily a matter of recreational identity, of style? Or are classes formed 'somewhere else', such as the factory, and then brought into cultural relationships? Class plays an important role in Bailey's argument, but so does the notion of

social role-playing: to see the relationship between the two, we need a more complex and theorised account of the relationship between culture and class than Bailey delivers.

A similar problem is the relationship of class to other collectivities which have cultural importance – race, gender, generation, or simply sub-cultures and taste-publics. Bailey says little in 1978 about any identity save that of class, and this typifies the time. But two of his three case studies – Working Men's Clubs and sport – were almost exclusively male preoccupations. The fact is mentioned only in passing: indeed, we are almost invited to sympathise with the workman's desire to get away from the wife (p. 130). There is no systematic attempt to analyse how these activities helped to construct gender-identities and gender-relations. In 1978, perhaps, the facts and theories were simply not there for such an analysis. We have more theory now, but still a shortage of hard knowledge about women's recreations. But the absence of gender from the analysis – and of youth cultures (which did exist then), ethnic cultures (where are the Irish?), regional and local identities, the culture of the workplace – renders Bailey's conception of class somewhat simplistic. If class deserves the centrality he gives it, we would today look for an analysis of how it articulated – spoke for or linked together – the needs of these different collectivities.

Perhaps because of the class problem, historians seem curiously unsure in their approach to twentieth-century popular culture. Bailey, Stedman Jones and Cunningham all take us up to the climacteric of the 1890s, with the popular daily press and the cinema more or less upon us, and radio not far ahead. We long to know what happens next. How do these new media impact upon the complex interplay of class and culture that we have been reading about? Do they come to manipulate a largely passive audience – so that, in effect, the complex interplay is lost? Early critics such as the Leavisites and the Frankfurt School thought (more or less) that they did. Cultural studies work on the post-war period – most famously that on youth sub-cultures – has sought with some success to rebut this 'mass culture' pessimism.[20] But curiously, most of the history written about twentieth-century popular culture seems to ignore not only these cultural studies arguments but even the questions and answers set up by historians of the nineteenth century, such as Bailey himself.[21]

Bailey's chapter on music hall is where he deals with the embryonic entertainment industry. How does it foreshadow the next 'new leisure world'? Music hall, like the other forms Bailey examines, receives the attentions of reformers, who dislike its association with drink, prosti-

tution and vulgarity. But this time it is the entrepreneurs, partly seeking to defend their business and their personal status against moral reproach, but mainly looking for more efficient and profitable management methods, who hasten what Bailey somewhat rashly calls 'the modernisation of popular entertainment'. The result: the gradual replacement of tables with fixed seating, the separation of drinking areas from the auditorium, a more rigid timetable of acts, and less dialogue between performer and audience: and eventually, 'a clientèle more passive, more predictable and more numerous' (p. 174). Thus, declares Bailey, 'big business had succeeded where the social reformers of recreation had failed', and 'the emergent mass entertainment industry [became] a conscious and effective agency of rational re-creation' (pp. 174–5). This verdict is echoed in Bailey's Conclusion:

> the eventual success of the reformed music hall in turning its customers into disciplined consumers adumbrated a new formula for capitalist growth which was to make the mass leisure industries of the present century more formidable agents of social control than anything experienced in Victorian society. (p. 188)

Coming at the end of a book whose unique selling proposition is the power of ordinary punters to fight back, this is a startlingly pessimistic verdict – and one which seems to yield too much ground to Stedman Jones, the Frankfurt School and F. R. Leavis. Yet it finds echoes in other work on the late nineteenth century. Hugh Cunningham's excellent *Leisure in the Industrial Revolution*, after a subtle exploration of the complexities of class and cultural power, concludes that

> The outcome of a century of battles over the problem of leisure was that for the dominant culture leisure was safely residual, unconnected with and possibly a counterweight to new and socialist challenges to hegemony . . . both tamed and legitimate because separated from the other concerns of people's lives.[22]

Well, we await further research, and meantime the reader must make up his or her own mind. This reader finds it hard to envisage a world in which culture is totally separated from 'the other concerns of people's lives', and certainly doesn't agree that he lives in such a world. The gap between the 1890s and the 1960s cries out to be filled.

The most attractive thing about Bailey's work, though, is that he engages with these problems. His 1987 Introduction is the most provocative and incisive survey of the field, because he has taken on board the theoretical advances of a decade. His later work, for example

on music hall, seeks to combine the imaginative and the theoretical, an experiential understanding of popular culture going hand in hand with hard-headed business history. His theoretical approach may not suit everyone: but he keeps his eye on 'the bigger questions of culture and ideology, agency and structure in a modern capitalist society'.[23] At a time when most historians still scorn such grand ambitions, and cultural studies still lurches into theoreticism at the least excuse, preferring textual to social-historical analysis (and too often mistaking the one for the other), we can perhaps learn something from the intellectual convergences of the 1970s: not least that our hard-won theoretical instruments are there to help us understand the life of society, and that it cannot be understood without them.

NOTES

1 Raymond Williams, *Culture and Society 1780–1950*, London: Chatto & Windus 1958 and *The Long Revolution*, London: Chatto & Windus 1961; E. P. Thompson, *The Making of the English Working Class*, London: Victor Gollancz 1963. We could also see Richard Hoggart, *The Uses of Literacy*, London: Chatto & Windus 1957 as essentially historical in its approach to working-class culture.

2 Peter Bailey, *Leisure and Class in Victorian England: Rational Recreation and the Contest for Control, 1830–1885*, London: Routledge 1978. Page references are to the 1987 University Paperback version.

3 Geoffrey Best, *Mid-Victorian Britain 1851–1875*, London: Weidenfeld and Nicolson 1971.

4 Ibid, pp. 200–1.

5 For example, Harold Perkin's ambitious account of *The Origins of Modern English Society 1780–1880*, London: Routledge 1969, gives no role to any form of popular culture, except religion. For a later 'liberal' analysis, see J. M. Golby and A. W. Purdue, 'The Emergence of an Urban Popular Culture', Open University *Popular Culture* course U203, Unit 4, Milton Keynes: Open University Press 1981; and the same authors' *The Civilisation of the Crowd: Popular Culture in England 1750–1900*, London: Batsford 1984.

6 The earliest notable exception is R. W. Malcomson, *Popular Recreations in English Society, 1700–1850*, Cambridge: Cambridge University Press 1973.

7 See the Further Reading list for evidence of this.

8 For example, Raphael Samuel (ed.), *People's History and Socialist Theory*, London: Routledge 1978; J. Clarke et al. (eds), *Working Class Culture: Studies in History and Theory*, London: Hutchinson 1979; R. Samuel and G. Stedman Jones (eds), *Culture, Ideology and Politics: Essays for Eric Hobsbawm*, London: Routledge 1982.

9 For example, an interpretation of history lay at the heart of S. Hall, Chas Critcher, Tony Jefferson, John Clarke and Brian Roberts (eds), *Policing the Crisis*, London: Macmillan 1978, and other productions of the Birmingham Centre for Contemporary Cultural Studies; and history was an important

component in the Open University *Popular Culture* (U203) course units, Milton Keynes: Open University Press 1981.

10 For an early account of the changes in historiography in this period, see Richard Johnson, 'Culture and the historians', in J. Clarke et al. (eds), op. cit., especially pp. 58–65.

11 Raymond Williams, *The Long Revolution*, paperback edition, Harmondsworth: Penguin 1965, p. 63.

12 Compare Gareth Stedman Jones, 'Class Expression versus Social Control? A Critique of Recent Trends in the Social History of "Leisure" ', *History Workshop Journal*, vol. 4 (autumn 1977).

13 The quotations in this paragraph are all taken from pp. 4–5 of the original (1978) 'Introduction'.

14 Amongst historians, R. Q. Gray was a notable Gramscian pioneer: see his *The Labour Aristocracy in Victorian Edinburgh*, Oxford: Clarendon Press 1976; and 'Bourgeois Hegemony in Victorian Britain', in Jon Bloomfield (ed.), *Class, Hegemony and Party*, London: Lawrence & Wishart 1977.

15 For a case study in suppression and resistance, see A. Delves, 'Popular Recreation and Social Conflict in Derby, 1800–1850', in E. and S. Yeo (eds), *Popular Culture and Class Conflict 1590–1914: Explorations in the History of Labour and Leisure*, Brighton: Harvester 1981.

16 For an outstanding account of the two styles of 'factory paternalism', see Patrick Joyce, *Work, Society and Politics: the Culture of the Factory in Later Victorian England*, Brighton: Harvester 1980.

17 See also P. Bailey, ' "Will the real Bill Banks please stand up?" A Role Analysis of mid-Victorian Working-class Respectability', *Journal of Social History*, vol. xii (1979), pp. 336–53.

18 Similar accounts of artisan 'respectability' are given by G. Crossick, *An Artisan Elite in Victorian Society: Kentish London 1840-1880*, London: Croom Helm 1978; and R. Q. Gray, op. cit.

19 G. Stedman Jones, 'Working-class Culture and Working-class Politics in London 1870–1900: Notes on the Remaking of a Working Class', *Journal of Social History*, vol. vii (1974), pp. 460–508; reprinted in his *Languages of Class*, Cambridge: Cambridge University Press 1983.

20 See, for example, S. Hall and T. Jefferson, *Resistance Through Rituals*, London: Hutchinson 1976; and D. Hebdige, *Subculture: the Meaning of Style*, London: Routledge 1979.

21 See, for example, Jeffrey Richards, *The Age of the Dream Palace: Cinema and Society in Britain 1930–39*, London: Routledge 1984; and Stephen G. Jones, *Workers at Play: a Social and Economic History of Leisure 1918–39*, London: Routledge 1986. Both are very useful and informative books, but neither has the theoretical engagement which I refer to.

22 Hugh Cunningham, *Leisure in the Industrial Revolution, c.1780–1880*, London: Croom Helm 1980. This excellent book is very much complementary to Bailey's, though more wide-ranging and more explicitly theorised. It was allowed to go out of print deplorably quickly, and deserves to be reprinted.

23 P. Bailey (ed.), *Music Hall: the Business of Pleasure*, Milton Keynes: Open University Press 1986, p. xix.

FURTHER READING

Bailey, P., ' "Will the real Bill Banks please stand up?" A Role Analysis of mid-Victorian Working-class Respectability', *Journal of Social History*, vol. xii (1979), pp. 336-53.

Bailey, P., 'Ally Sloper's Half Holiday: Comic Art in the 1880s', *History Workshop Journal*, no. 16 (1983), pp. 4-31.

Bailey, P. (ed.), *Music Hall: the Business of Pleasure*, Milton Keynes: Open University Press 1986.

Bratton, J. S. (ed.), *Music Hall: Performance and Style*, Milton Keynes: Open University Press 1986.

Clarke, J., C. Critcher and R. Johnson (eds), *Working Class Culture: Studies in History and Theory*, London: Hutchinson 1979.

Cunningham, Hugh, *Leisure in the Industrial Revolution, c.1780-1880*, London: Croom Helm 1980.

Jones, G. Stedman, 'Working-class Culture and Working-class Politics in London 1870-1900: Notes on the Remaking of a Working Class', *Journal of Social History*, vol. vii (1974), pp. 460-508; reprinted in his *Languages of Class*, Cambridge: Cambridge University Press 1983.

Jones, Stephen G., *Workers at Play: a Social and Economic History of Leisure 1918-39*, London: Routledge 1986.

Joyce, Patrick, *Work, Society and Politics: the Culture of the Factory in Later Victorian England*, Brighton: Harvester 1980.

Malcomson, R. W., *Popular Recreations in English Society, 1700-1850*, Cambridge: Cambridge University Press 1973.

Mason, A., *Association Football and English Society, 1863-1915*, Brighton: Harvester 1980.

Richards, Jeffrey, *The Age of the Dream Palace: Cinema and Society in Britain 1930-39*, London: Routledge 1984.

Storch, R. (ed.), *Popular Culture and Custom in Nineteenth Century England*, London: Croom Helm 1982.

Walton, J., *The English Seaside Resort: a Social History 1750-1914*, Leicester: Leicester University Press 1983.

Waters, Chris, *British Socialists and the Politics of Popular Culture 1884-1914*, Manchester: Manchester University Press 1990.

Yeo, E. and S. (eds), *Popular Culture and Class Conflict 1590-1914: Explorations in the History of Labour and Leisure*, Brighton: Harvester 1981.

Chapter 3

Tony Bennett and Janet Woollacott, *Bond and Beyond*

Andrew Blake

In early 1991 the credit card company Barclaycard ran a television advertising campaign in which comedy actor Rowan Atkinson starred as a British secret agent. One part of this mini-series in particular revolved around the clichés of the James Bond film. The relationship between Bond and the brusque establishment figure of the spymaster, 'M'; the films' reliance on high-tech spying gadgets; the extravagance of the Pinewood sets; all were parodied lovingly. The 'plot' of this episode, in which the Bond figure demanded a series of gadgets, only to be presented with a Barclaycard by the M figure and told that this was all he needed in the modern world, was a salutary reminder of the belief current at the time that the Cold War was over, and that it had been won by the values of democratic capitalism. And beyond this, that the figure of the fictional spy James Bond is still currently resonant within British culture nearly forty years after his first appearance, in Ian Fleming's novel *Casino Royale*.

The authors of *Bond and Beyond* were almost inclined to doubt this continued currency when their volume was published, in 1987 – surprisingly perhaps, in that one of the main arguments of their book is that the Bond phenomenon has been constantly re-presented to account for differing political actualities within British and indeed world political and economic history. James Bond is still the subject of new films, and new books, including fictions by various would-be inheritors of Fleming's mantle; but at least as importantly, as the Barclaycard campaign suggests, Bond has become a supra-fictional figure, a champion of mythical status. Like Sherlock Holmes, James Bond has transcended the limits of literature, cinema, and indeed critical discourse, and has become an independent commodity, part of the international cultural market.

This categorical transcendence is the starting point for *Bond and*

Beyond. 'The Bond phenomenon', the authors remark, 'raised a series of awkward problems which led us to question some of the customary assumptions and procedures of cultural analysis and, to a certain extent, to depart from them.'[1] Their task, as announced in the introduction, is first to provide a substantial cultural analysis of 'the Bond phenomenon', and second, through this work to establish a set of theoretical positions from which to understand the workings of popular cultural production. Eschewing the usual trawl through the deep waters of theoretical approaches to cultural texts, listing and then ticking off Marxism, psychoanalysis, semiotics and so on before proceeding to their empirical investigation, Bennett and Woollacott plunge straight into their historical and cultural analysis, calling on the various theoretical approaches wherever they think it necessary. It's an approach which helps to save a book loaded with academic verbiage from sinking incomprehensibly into those deep waters of theory.

This is an important point. Film criticism in particular had been sunk in the slough of theoretical despond during the high moment of hegemony enjoyed by the magazine *Screen* in the middle 1970s. *Screen's* contributors played a veritable Glass Bead Game of theoretical position-taking hardly troubled by the more plastic world of actual films, particularly those made outside a few obscure French and Italian studios. History itself was often bypassed in an attempt to encompass psychoanalytical and structuralist verities within critical discourse. One debate within *Screen* attempted to establish that 'realist' films, and by extension other realist fictions, were supportive of bourgeois ideology. By presenting an unproblematic 'reality', they mystified and concealed the real relationships of production, while non-realist cinema (films which drew attention to their own constructedness) was in some way subversive because it revealed the codes of ideology rather than concealing them as 'common sense'.[2] A related assumption was that all twentieth-century 'high art' fell into the subversive and anti-realist category, whereas popular fictions, being realist, merely parroted the prevailing dominant ideology. The audience for any popular film dutifully absorbed this message, left the cinema and returned to daily life as good little reactionaries.

One of the particular precursors of *Bond and Beyond*, the Open University course *Mass Communications and Society*, was heavily influenced by these theoretical approaches. The first work done by Bennett and Woollacott on 'the Bond phenomenon' was an analysis of the making of the 1976 Bond film *The Spy who Loved Me* for the *Mass Communications* course.[3] The approach here encompassed the isolation of

the film both as a capitalist product and as the bearer of a set of ideologies which it imposed on its audience, making that audience implicit with these positions. However, this argument, and the formalist and functionalist divisions between high and popular art, were not simply upheld by the *Mass Communications* course (partly because it had a far stronger and wider empirical base than the *Screen* debates), and both this and the more historically based *Popular Culture* course which followed it were the centres of new debate rather than purveyors of the established orthodoxy of the middle 1970s. But the opposite tendency within the *Popular Culture* course – the more or less uncritical celebration of the popular, merely because it *is* popular – finds no place in *Bond and Beyond*. The project of the text is to forge a path away from the patronising, theoretically-based refusal of popular cultural products, without treading the dangerous path of naïve and celebratory populism. It is an admirable project, summarised best in the authors' words:

> the ideological work effected by both the films and the novels, we suggest, is not that of imposing a range of dominant ideologies but that of articulating the relations between a series of ideologies (subordinate as well as dominant) overlapping them onto one another so as to bring about certain movements and reformations of subjectivity – movements whose direction has varied with different moments in Bond's career as a popular hero in response to broader cultural and ideological pressures.[4]

I

The opening chapter, 'The Bond Phenomenon', underlines the importance of James Bond, 'arguably the most popular – in the sense of widely known – figure of the post-war period'.[5] There were an estimated billion paid viewings (worldwide) of Bond films by 1971; by 1977 paperback sales of Fleming's novels totalled 27,863,500 *in Britain alone*. Immediate explanations are offered for this massive success. First that the fictions offer the (male) reader a series of pleasures centred on identification with the hero. Second that the films were exceptionally well marketed by the Salzman–Broccoli production team; in particular, the market was saturated with prints within weeks of the première, thus both maximising the immediate pre-release publicity and accelerating the repayment of production money. Third that there is a corpus of work, very unusual in the cinema, stretching over a

quarter of a century, with many audience-identifiable generic points. Fourth, that despite this generic similarity, the films have proved malleable in reworking a changing system of cultural and ideological concerns; they are always in some way contemporary: 'If Bond has functioned as a "sign of the times" it has been as a *moving sign of the times*'.[6]

In the second chapter, 'The Moments of Bond', Bennett and Woollacott examine the moving sign. They commence with the moment of Bond's appearance. Ian Fleming (1908–64), an Etonian former journalist, stockbroker and naval intelligence officer, wrote from 1953 a series of novels and short stories about James Bond, a member of the British secret service 'licensed to kill', and in background a figure not unlike Fleming himself. Fleming's literary models were John Buchan, Cyril McNeile, Graham Greene and Eric Ambler; he assumed at first that his readership shared his comparatively privileged background. The appearance of the novels in paperback from 1955, followed by the serialisation of *From Russia with Love* as a strip cartoon in the *Daily Express* in 1957, widened the readership and paved the way for the first film, *Dr No* (1962), whose success dramatically increased sales of the novels, and ended the first 'moment of Bond'. In two ways: from now on Fleming wrote with both a wide audience and eventual filming in mind – indeed, *Thunderball* (1961), written with John Wittingham and Kevin McLory, started as a film script. And the nature of the basic plot changed. Bond novels in the 1950s were Cold War novels, pitting the western secret agent against the Soviet Union and its employees. Almost from the start of his film career, however, James Bond became an opponent of SPECTRE, a criminal organisation which conspired against both 'sides' of the Cold War. The second film, *From Russia with Love* (1963), based on a Cold War novel published in 1957 (immediately after both Suez and Hungary), was actually re-written so as to involve confrontation with SPECTRE rather than directly between Russia and the west.

It is the early 1960s, in fact, which are 'the' moment of Bond, as exemplified by the success enjoyed in the film role by Sean Connery. Himself from outside Fleming's establishment world, Connery appealed to the 'classless' spirit of early-1960s England. Connery's rugged beauty, his rebellious one-liners, his very accent, signalled rebellion against the world of M. As did Bond's open sexual promiscuity; and here there was also something positive to be found in the figure of the 'Bond Girl', in this moment at least, in celebrating a personal sexuality free from the restrictions of domesticity and 'the

constraints and hypocrisies of gentlemanly chivalry'.[7] The films' portrayal of the Connery Bond as 'modern' is also emphasised by their use of high-technology spying and killing devices, such as the Aston Martin DB5 car in *Goldfinger* equipped with machine guns and an ejector seat among other optional extras. This is also the moment of maximum imitation; the authors cite the films based on Len Deighton's 'anti-Bond' figure, Harry Palmer, such as *The Ipcress File* and television series *The Avengers*, *The Man from UNCLE*, and even the Jon Pertwee *Doctor Who* (!) – and they could have added many others.[8] Spies and investigators, usually handsome and sexually successful, but almost always heavily self-parodic, were to be seen on both large and small screens throughout the 1960s.

Two later 'moments of Bond' are dealt with in less detail. The replacement of Sean Connery with George Lazenby and then Roger Moore led to an increase in the self-parody and comedy elements of the films. By now (the mid-1970s) they were appearing regularly on domestic television in the USA and in Britain, where they were screened to as wide an audience as possible, at Christmas time or on other bank holidays. The market was, by this time, assumed to be the family, with the stress on pre-adolescent children, especially boys; toys of the various gadgets were produced to coincide with the films' releases. During the heyday of east–west 'détente', the plot-basis remained that of the SPECTRE conspiracy, or a parody thereof, as in *The Spy who Loved Me*. At this point the playfulness underlines that this is make-believe, and to signal the end of British pretensions as an international power. The least playful and self-parodic elements of the films were in their portrayal of gender relations; where Bennett and Woollacott found these to be potentially liberating in the early 1960s, by the 1970s Bond's continual conquests of women, and the deaths of women characters, can only be seen as reinscribing the primacy of patriarchy. Then in the early 1980s there is a further 'moment', a down-playing of parody and a clear emergence, for the first time in the Bond films, of Cold War politics, in the aftermath of both the Russian invasion of Afghanistan, and the more positive view of Bond's Englishness and national worth in the aftermath of the post-Imperial war in the Falkland Islands.

II

We return to the novels, and here as elsewhere most discussion is of the Fleming novels. Two chapters, 'Reading Bond' and 'Bonded

Ideologies', discuss the ways in which meaning is constructed from the texts themselves and especially from 'intertextual' relations. This is a fundamental theoretical position for the authors; meaning is seen to reside in 'the social organisation of the relations between texts within specific conditions of reading'.[9] This means among other things that they do not themselves give primacy in meaning to any particular text(s), and try not to privilege any particular readings of them; they do not read the films as deviations from the novels, or vice versa, though they argue that the films 'have culturally activated the novels in particular ways, selectively cueing their reading . . . by inserting the novels within an expanded intertextual set'.[10] An example is the redesign of the Pan covers for the Fleming novels. From a set of designs in the late 1950s redolent of London clubland and the Cold War, through a brief period featuring Connery, to a set which privileged James Bond's name rather than Fleming's, and featured photographs of young women posing with, usually straddling, very large model handguns – designs whose excessive phallic emphasis reanimates the novels as pornography, in ways which the films of the 1970s, the 'third moment', also underlined. It's worth emphasising the point: that Fleming's words were not changed but that the struggle for their meaning went on outside them.

This assertion casts doubt, if any were needed, on the Leavisite notion of the absolute text, ultimate giver of meaning, which had been taken for granted in the *Screen* debates. But it leaves Bennett and Woollacott with an admitted problem. They argue convincingly that readers will come to the texts with very different textual capital; that they will therefore decode the texts in very different ways; and that major determinants on these intertextual pre-readings are class, ethnic and gender positions. The study of people's reading practices would therefore seem a prerequisite for the study of the social and intertextual creation of meanings. The authors have not carried out this admittedly very difficult and time-consuming work.

Instead, they have read the few academic approaches to Bond, in chapter three those of the historian David Cannadine and the structuralist Umberto Eco; here (and again in chapter eight, with a different group of authors) they read these approaches according to their authors' cultural capital.[11] They do their office fairly, criticising for instance Eco's arcane references and his absurd dismissal of the traces of popular culture in Fleming (even Etonians go to the movies, and Fleming refers to them at many points in the novels). However, they accept that there are levels of deliberate 'literariness' in the Fleming

novels, notably a consistent playing with the Oedipus drama. This is seen in the recurrence of father-figures from M, through the CIA agent Felix Leiter, to the various villains (almost all middle-aged men), and most obviously in the file on Scaramanga in *The Man with the Golden Gun*, and the torture/rebirth scene in *Dr No*. They also criticise Cannadine's argument that Bond is in some way a 'gentleman amateur', simply a representative of the establishment and its values, rather like John Buchan's hero Richard Hannay (Bond is in all respects a professional – including that of relying on his salary; he trains, rather than relying on 'natural' abilities, as the more gentlemanly Hannay does.[12]) But they take Cannadine's more general point that the various texts of Bond are closely related with the history of post-Imperial Britain in decline.

III

The third section examines the Bond films. Chapter five, 'The Transformations of James Bond', looks at the differences between the novels and the films. By this time in the book parts of the argument already stated are being fleshed out, somewhat repetitively; once again the emphasis is on the parodic excesses of the films, their reliance for instance on gadgets as jokes, which 'serve to open up contradictions in the image of patriotism, professionalism and sexuality established by the Bond of the novels'.[13] In this chapter they look at *Goldfinger* in particular, as an instance of the crucial 'second moment of Bond'.

Apart from the continuing incidence of parody (which is there right from the start: the pre-credit opening sequence of *Goldfinger* is a case in point), the films effected a transformation in the gender positioning of the Bond phenomenon. There soon evolved a 'three girl formula'; one woman in particular would be the centre of attraction for Bond in each of three parts of the film. Only the last would survive, to be bedded by Bond in the closing sequence. As well as this, there is a 'cornucopia' of women seemingly sexually available to Bond; all the young women he meets casually bestow frankly admiring glances in his direction, while the camera confirms their attractiveness to the (implicitly male heterosexual) audience. While agreeing that the place of women in the films is in many ways within the structured 'male gaze' of Laura Mulvey's approach, and indeed that the 'three girl formula' is disturbing (the Bond films are in effect serial killers of young women), once again Bennett and Woollacott find a positive emphasis in the place of 'the Bond girl' in the early films.[14] They analyse the free and

independent sexuality on offer from the Bond films in the context of the so-called progressive 'New Wave' films of the same period (*Room at the Top*, *A Kind of Loving*, *Look Back in Anger* etc.), in which unprocreative sexuality is punished as such, while marital and procreative sexuality is re-established. This comparative freedom may, they suggest, explain why Bond films were popular with women as well as men in the early 1960s.

This discussion is expanded in the seventh chapter, 'Pleasure and the Bond films', in which the various erotic pleasures on display are enumerated. Though this includes the 'male gaze', Bennett and Woollacott do not follow Mulvey's essentialist Freudianism. The gaze can, they say, be equally on the male, and narcissistic. Bond is a figure on the fringes of social acceptability, rejecting domestic sexuality, marriage, often indeed the very concept of the law itself, in a way open to the narcissistic identification of a 'liberated' masculinity obvious in Westerns. They also note the 'eroticisation' of the torture scenes featuring Bond as potential victim – again *Goldfinger* has a particular example, as Bond is tied to a slab and faced with a laser beam working towards his genitals. Quite why torture scenes involving potential castration (or any other scenes of violence) either are or should be erotic spectacles is not explained.

Another set of pleasures, for women, are identified through the intertextual reading of the Bond films as romances. The tall, dark, handsome Bond is eventually caught, after some false starts, by the heroine, the last of the three women in the 'three girl formula'. Several examples of the romantic formula are given, all from literature rather than film. Bennett and Woollacott also suggest that the Bond films can be read as soap opera, another 'female form' – as a long-running family drama in which the errant son Bond is controlled more or less effectively by the 'father' (M) and 'mother' (M's secretary, Miss Moneypenny) figures.

IV

The final two chapters discuss the status of the texts within the wider fields of cultural and political theory. (Again there is a lot of repetition here, and these would perhaps be the parts of the book to read for anyone wanting a conspectus of the argument with some but not all of the empirical detail.) One of Tony Bennett's continuing interests, figured in various articles and his book *Formalism and Marxism*, as well as in his contributions to the Open University courses, is the question of

the status of 'high' as opposed to 'popular' art, literature and so on. In particular, *Bond and Beyond* calls into question the formalist distinction between various cultural products. Extending the argument from the various discussions of the intertextually-formed reading of texts (such as the reading of Bond films as romances), Bennett and Woollacott insist that 'texts are not holders of determinate effects. They function differently within ideological contestations at different moments in time.'[15]

Furthermore, they argue, this applies to *all* texts. They refuse the commonly drawn distinction, implicit in their own construction of *The Spy who Loved Me* for the Open University *Mass Communications* course, between high-art forms which 'rupture' ideology and popular forms which merely reproduce it. Calling on Annette Kuhn, they claim that 'once the notion of reading as an active and situated practice is adopted, the distinction between films which embody an internal self-criticism and films which are completely ideologically complicit becomes redundant'.[16] This assertion is illustrated by the *Lady Chatterley's Lover* trial of 1963, in which a piece of 'pornographic fiction' was turned into a 'great novel' by the intervention of a few guardians of the definition of high-art culture, Oxbridge dons like Raymond Williams and E. M. Forster.

The *Lady Chatterley* trial took place during the period of the second 'moment of Bond', the moment of modernisation within the ideology of the 'classless society'. Not before time – in the final chapter of *Bond and Beyond* – the implications of this relationship for the historical process within British society are discussed. Finally then, the concept of 'hegemony' is revealed in all its explanatory glory. Hegemony describes the process through which 'the subordinate and allied classes consent to the rule of the dominant classes, and the whole process of constantly forming and reproducing that consent is vital to such a society'.[17] Popular fiction incorporates 'real concessions to popular tastes and sentiments' while then stitching ' "the people" back into a newly restructured place within the hegemony'.[18] The refiguring of Bond in each of their four 'moments' stands for successive moments of hegemony within the British state. In a closing passage written apparently without irony Bennett and Woollacott fantasise about a moment of left hegemony in which Bond would become a pacifist working for trade union and gay rights within the secret service.

An interesting postscript discusses the last of the Roger Moore Bond films, *A View to a Kill*, and especially the ambivalent place in the film of Grace Jones, who as the only black woman in the film triumphs easily

over both Bond and the older establishment figure Sir Godfrey Tibbet, and then destroys the ambivalent Aryan/Russian villain, Zorin – but only by blowing herself up. The authors conclude that this is, therefore, a racist and misogynist film, which is one of the many areas of the text where the comparative liberalism of the intertextual approach breaks down, and they privilege their own reading. In the specific instance of May Day's death, a reading informed by for example eighteenth-century English, classical Greek or Hindu constructions of heroic female sacrifice in the interests either of personal honour or of 'the greater good' might have led them to draw rather different conclusions about the hegemonic constructions offered by the film.[19]

V

It would be ungenerous to carp further at this level of detail. To expect omniscience from any critic(s) would be to place ourselves in the position of the court presiding over the *Lady Chatterley* trial, expecting definitive knowledge to spring from the mouths of experts. And Bennett and Woollacott consistently refuse this position themselves, stressing that their readings are as contingent as the others they discuss. Nevertheless, there are certain omissions within their text which should be addressed in the spirit of making this particular history more fully faceted.

One powerful presence within the Bond films, music, is hardly noticed by *Bond and Beyond*. Neither is there space here to do justice to this important topic; a few points will stand for all. The music has a resonance which can in some ways stand for everything else in the films. Another early 1991 television advertising campaign, for John Smith's bitter, featured John Barry's theme music to the early Bond films – accompanying an ironically presented 'action sequence' of an air bubble making its way slowly up a glass full of beer. The John Barry theme tune, with its Americanised, sophisticated big band sound *plus* the technological modernism of the lead (electric) guitar, its reverberant sound associated with early rock music, is important in helping to establish the parameters of the 'modernism' of the second 'moment of Bond'. The scores' increasing use of parody in the 1970s underlines the points made about changes within the 'moments of Bond'. Finally, as with scripts, camerawork and acting styles, intertextual relations within the musical content of the films help to produce the meanings of those films.[20]

Given the authors' laudable insistence on the intertextual relations between readings which form meaning, their list of television productions immediately influenced by the Bond films seems inadequate; I mention some obvious supplementary material in note 8. Discussion of Woody Allen's Bond film, *Casino Royale*, whose parodies predated their schematic division into 'moments', is left to a brief footnote. One other absence in particular seems surprising. Their discussion of the British spy thriller as a fictional genre makes no mention of the work of John Le Carré. *The Spy who Came in from the Cold* (1963), Le Carré's third novel, was reviewed in an intertextual context dominated by the Bond of the early films. The book was seen as a quite deliberately anti-Bondian gesture by one who wished to portray spying as essentially sordid and mean rather than heroic and luxurious. It was almost immediately filmed, with Richard Burton in the title role. Le Carré's further fictions have usually concerned themselves with the British secret service and its successes and failures. Two novels, *Tinker, Tailor, Soldier, Spy* and *Smiley's People*, were made into BBC serial dramas during the latter days of the 'third moment of Bond', 1980–1. Starring Alec Guinness as the bureaucratic hero George Smiley, they were successfully placed worldwide. The BBC went on to broadcast a version of *A Perfect Spy* in 1988 – arguably the last days of the Cold War.

Le Carré's work is important in the context of *Bond and Beyond* not simply because it is popular and usually about spying. It points to another surprising omission from *Bond and Beyond*. Most of Le Carré's novels are about treachery and the nature of treachery; they are about double agents, betrayal, counter-espionage, and the highly conditional nature of truths and ideals expressed by those working within the secret services. Though Le Carré shares something of Fleming's background – he is an Etonian and former intelligence officer – there is nothing in his work of the 1950s establishment, of M, clubland and an essentially cosy relationship with the political elite. This is partly because the Le Carré establishment contains the traitors. The enemy is not outside, an evil foreigner, whether communist or criminal; the enemy is also within.

There is a crucial history here which is part of the construction of Bond. Bennett and Woollacott say quite rightly that one of the conditions of the emergence of Bond as national hero was a national crisis. They point in particular to the Suez fiasco (1957), and quote at length Fleming's representation in *From Russia with Love* (also 1957) of a meeting of the governing council of the Russian spy organisation,

SMERSH, at which those present speak with admiration about the qualities of the British secret service they wish to undermine, while dismissing the equivalent American organisation as naïve and inefficient. This is not merely an assertion of British superiority over the wealthy ex-colonial upstarts who had domineered over Suez. It is also an assertion that despite the presence within the British secret service of known traitors, the enemy is still afraid of the British. Doubtless a ludicrous falsehood, this fiction was also doubtless very necessary both for public opinion and for self-confidence within the ruling classes, who in fact made very little attempt to cleanse the Augean stables of post-war 'Intelligence'. The stables stank. British information helped Stalin to build nuclear weapons and thereby commence the most dangerous years of the Cold War. Burgess and Maclean had decamped in 1951, and Philby, known to be under suspicion in 1957, left for Russia in 1963. Twenty years later Blunt was 'uncovered', and it was revealed that he had confessed in the 1960s and had since been protected by friends in high places to the extent of obtaining a knighthood for his work on the history of art. Controversy raged over the status of former MI5 chief Sir Roger Hollis, whose career was discussed in Peter Wright's book *Spycatcher*, which the British government was trying to ban from publication in Australia as *Bond and Beyond* was going to print.[21]

One reason for the presence of Bond, then, was that he reassured people at all levels of British society that the traitors had not in fact damaged the state. The immediacy of the crisis is apparent in *From Russia with Love*, the one Fleming novel which actually mentions Burgess and Maclean; it is the most defensive of all Fleming's Bond books. Throughout, identities and loyalties remain uncertain. The basic plot concerns a woman whom the Russians order to act as a double agent. She claims to have fallen in love with Bond's photograph, and to wish to defect with him; she offers to bring a stolen cipher machine as a love token. Then she really does fall for Bond and wishes to defect in earnest. Double agents ostensibly working for Britain are unthinkable (or at least unwriteable) in London, but appear in Turkey. And there is the curious figure of Red Grant, an English psychopath working for the Russians who takes on the role of an English spy he has killed in order to close the trap on Bond, managing before his eventual death at our hero's hands to launch into a long and angry denunciation of precisely the cosy establishment codes which had allowed Burgess and Maclean to spy away merrily because they acted like 'one of us'. Finally, Bond is (slightly ambivalently) killed at the end of the novel, having first *failed*

to recognise, and then adequately to disarm, his Russian opponent, Rosa Klebb.[22]

Like Conan Doyle with Sherlock Holmes, the success, the virtual necessity, of the character virtually forced Fleming to resurrect Bond. The post-Imperial crisis, and the continuing uncertainty over the efficacy of a secret service staffed largely by public school/Oxbridge products, demanded the continuing fictional presence of the increasingly 'modern' Bond. We should recognise that the modernising professional is one of the character's principal roles from the start in 1953, precisely because of this problem within the secret service. Thanks to the traitors, Bond could never be written as unproblematically 'one of us'. He *always was* a 'modernist' – a 'professional', a cocktail drinker, a drug user, who was prepared to cheat at cards, or golf. A 'gentleman' of the old school (a McNeile, Dornford Yates etc. character) simply could not have been called on as Britain's fictional saviour at this moment, arguably the worst crisis within the British state, so wedded to 'secrecy', since the Second World War. We should also remember that during the 1970s, the moment of the least 'political' and most overtly self-parodistic of the Bond films, the British secret service was spending much of its time trying to undermine an elected British (Labour) government.[23] Arguably, then, the Bond texts conceal political realities (in the way predicted by the *Screen*-debate model of 'realism') at least as much as they renegotiate hegemony. Lack of any discussion of this dimension of secret service politics within British political history seriously weakens *Bond and Beyond*, particularly since so much of the book concerns reformulations of the notion of 'Englishness'.

There is a related problem. Bennett and Woollacott make clear from the start that the 'Bond phenomenon' has had a worldwide impact; they argue that one of the reasons behind the changed emphasis of the early films (away from the Cold War) was a deliberate strategy by producers Salzman and Broccoli precisely to internationalise the appeal of the films. Again, the playing down of British 'success' in the later films as against the novels sought successfully to de-Anglicise the appeal. In other words, there is a great deal more to the Bond phenomenon than Englishness. Yet while Bennett and Woollacott acknowledge this from time to time – there is an interesting comparison of the intertextual preparation of American as opposed to English men in chapter three, for example – by and large the international dimension is left to its own devices. Perhaps this again was an impossible task; the pity is that it is so often not even acknowledged in a text which is elsewhere well

aware of its own shortcomings. Ironically, the authors completed the book from Australia and New York. The problem lies perhaps in the eagerness with which British historians and cultural analysts researched and reconstructed Englishness in the 1980s. Is it too much to hope that as that decade, with its very Little Englander political leadership, retreats into the softened glow of memory, the English can be brought once again to consider the rest of the world?

NOTES

1 Tony Bennett and Janet Woollacott, *Bond and Beyond: the Political Career of a Popular Hero*, London: Macmillan 1987, p. 2.
2 For samples of this debate see Bennett et al. (eds), *Popular Television and Film*, London: BFI 1981; Christopher Williams (ed.), *Realism and the Cinema*, London: Routledge 1980.
3 Open University Course Team, *Mass Communications and Society*, Milton Keynes: Open University Press 1976.
4 *Bond and Beyond*, pp. 5–6.
5 *Bond and Beyond*, p. 11.
6 *Bond and Beyond*, p. 18.
7 *Bond and Beyond*, p. 34.
8 Other extensions and parodies of Bond include 1960s television series *I Spy*, *Get Smart*, *Danger Man* and *The Saint* (starring Roger Moore); films include the three *Matt Helm* films starring Dean Martin, the 1964 film of Le Carré's *The Spy who Came in from the Cold*, and the late 1960s films in which black Americans are the almost superhuman heroes/heroines of investigation plots (such as *Shaft*, *Superfly* and *Cleopatra Jones*). The Bond film parodies *Our Man Flint* and *The Intelligence Men* (both 1966) are mentioned in *Bond and Beyond* footnote 14, p. 298 – but *Carry On Spying* (1964) is not. This footnote also refers without discussion to Woody Allen's 1967 James Bond film, *Casino Royale*, whose parodic excesses anticipate the Roger Moore films.
9 *Bond and Beyond*, p. 45.
10 *Bond and Beyond*, p. 55.
11 Umberto Eco, 'Narrative Structures in Fleming', in his *The Role of The Reader*, London: Hutchinson 1981; David Cannadine, 'James Bond and the Decline of England', *Encounter*, vol. 53, no. 3 (November 1979).
12 Like many cultural analysts of the left, Bennett and Woollacott have difficulty in analysing the complex layering of the ruling class. Hannay, like Sherlock Holmes, is not by origin an English gentleman but an outsider: a South African businessman of Scots descent. He is an amateur in the sense that he neither trains, nor is directly paid, for his service to the country. However, he is then rewarded, eventually with a knighthood – and, living in the country, *becomes* an English gentleman. No doubt even the Connery Bond would be so transformed in retirement.
13 *Bond and Beyond*, p. 165.
14 See Laura Mulvey, 'Visual Pleasure and Narrative Cinema', in Bennett et al. (eds), op. cit.

15 *Bond and Beyond*, p. 235.
16 *Bond and Beyond*, p. 235.
17 *Bond and Beyond*, p. 279.
18 *Bond and Beyond*, p. 282.
19 See in general M. F. C. Bourdillon and M. Fortes (eds), *Sacrifice*, London: Academic Press 1980; and in particular for eighteenth-century England, S. Richardson, *Clarissa Harlowe*, London: 7 vols, 1747–8; for the Classical world, I. Donaldson, *The Rapes of Lucretia*, Oxford: Clarendon Press 1982, and any version of the stories of Dido and Aeneas or Cupid and Psyche; for Hinduism, B. Walker, *Hindu World*, London: Allen & Unwin 1968, vol. 2, p. 375, G. Spivak, 'The Rani of Sirmur', and L. Mani, 'The Production of an Official Discourse on *sati* in Early Nineteenth Century Bengal', both in F. Barker, P. Hulme, M. Iverson and D. Loxley (eds), *Europe and Its Others*, Colchester: University of Essex 1985.
20 Music's contribution to meaning remains, depressingly, opaque to most cultural theorists. See in general on this A. Durant, *Conditions of Music*, London: Macmillan 1984. One impressive decoding of a short piece of theme music is P. Stagg, *Kojak . . . 50 Seconds of Television Music*, Gothenburg: University of Gothenburg Press 1979.
21 Peter Wright, *Spycatcher*, London: Heinemann 1987; Chapman Pincher, *Their Trade is Treachery*, London: Sidgwick & Jackson 1981; Andrew Boyle, *The Climate of Treason*, London: Hutchinson 1983.
22 The high moment of British Cold War fiction was in fact the early 1960s, the very moment at which the politics of Bond were moving away from the Cold War. Bennett and Woollacott make no mention of this. Other Cold War novels include D. G. Barron, *The Zilov Bombs*, London: André Deutsch 1962; C. Fitzgibbon, *When the Kissing Had to Stop*, London: Cassell 1961; E. Bordich and H. Wheeler, *Fail-Safe*, London: Pan 1962.
23 Wright, *Spycatcher*, throughout.

FURTHER READING

Bennett, Tony (ed.), *Popular Fiction: Technology, Ideology, Production, Reading*, London: Routledge 1990.
Bennett, Tony, Janet Woollacott, Chris Mercer and Susan Boyd-Bowman (eds), *Popular Television and Film*, London: BFI 1981.
Cannadine, David, 'James Bond and the Decline of England', *Encounter*, vol. 53, no. 3 (November 1979).
Denning, Michael, *Cover Stories: Narrative and Ideology in the British Spy Thriller*, London: Routledge 1987.
Eco, Umberto, 'Narrative Structures in Fleming' in his *The Role of the Reader*, London: Hutchinson 1981.
Freund, Elizabeth, *The Return of the Reader*, London: Routledge 1987.
Kuhn, Annette, *Women's Pictures: Feminism and Cinema*, London: Routledge 1982.
Longhurst, Derek (ed.), *Gender, Genre and Narrative Pleasure*, London: Unwin Hyman 1989.
Merry, Bruce, *Anatomy of the Spy Thriller*, Dublin: Gill & Macmillan 1977.
Pribram, E. Deirdre (ed.), *Female Spectators: Looking at Film and Television*, London: Verso 1988.

Radstone, Susannah (ed.), *Sweet Dreams: Sexuality, Gender and Popular Fiction*, London: Lawrence & Wishart 1989.

Tulloch, John and Manuel Alvorado, *Doctor Who, the Unfolding Text*, London: Macmillan 1983.

Williams, Christopher (ed.), *Realism and the Cinema*, London: Routledge 1980.

Chapter 4

Glasgow University Media Group, The *Bad News* Books

Jeff Collins

I

'Not for the beginner, but influential in challenging broadcasters' own beliefs.' This judgement from John Hartley on the *Bad News* books indicates both their campaigning stance and a sense of academic difficulties in the work.[1] Why not for 'the beginner'? Are they just too long, containing over six hundred pages of close empirical analysis of news output, and several hundred more of discussion? But the case study material is clearly presented, and there are many suggestions for analysis of news texts and practices which would alone make the books a good starting point. If there are problems, they lie in a contradiction in the project which has acted as a structuring influence throughout, governing the choice of methods, how 'news' is treated as a category, and the conclusions presented.

This contradiction is one of address. The *Bad News* books are academic studies, written by academics and addressed to students and researchers of media sociology. But they also address other constituencies: politicians and policy-makers, broadcasting professionals and managers, television regulatory bodies. And the work is not only a set of books. The Group have challenged broadcasting professionals and policy-makers in a government commission, public conferences, in newspaper and journal debates, with television lobbying groups, and in television programmes; and the results have been one of the most extensive campaigns to promote change in the nature of television news. Active political campaigning is not the norm for British academics. Is this, then, what 'beginners' should be protected from? Certainly the project has been marked by this contradictory address, and has drawn criticism from both broadcasters and academics.

Conservative critics have attempted to deny the work's 'academic

credibility'. They have done this sometimes by pointing to the work's left-radical political position, maintaining the mythology of their own work as disinterested, and sometimes by denying the statistical evidences of the work and presenting counter-statistics.[2] What has followed has been a set of quasi-legal arguments and counter-arguments about often very small details of the Group's empirical evidence. I think a good lawyer would have no difficulty resolving most of these arguments in the Group's favour; occasionally, perhaps, some points lost; sometimes an uneasy stalemate. But these arguments have tended to conceal another set of issues. Put briefly, conservative critics have largely avoided engagement with any of the Group's major arguments about power, control and influence in the production of news, and have offered defences of present practices which seem at times to be extraordinarily complacent: news professionals are excused on the grounds that they are short of time and have a hassling job; any criticisms should be based on the professionals' own criteria of what they do or aspire to do; instances of bias are infrequent or trivial; in short, news is fine as it is, or if there have been isolated instances of 'bad news', these can be corrected by minor reforms or a certain extra vigilance by the professionals themselves.[3]

That such defences are not adequate has been evidenced recently in the coverage of the Gulf War. In 1981, Edward Said concluded his study of the representations of 'Islam' with the following words:

> Underlying every interpretation of other cultures . . . is the choice facing the individual scholar or intellectual: whether to put intellect at the service of power or at the service of criticism, community, and moral sense If the history of knowledge about Islam in the West has been too closely tied to conquest and domination, the time has come for these ties to be severed completely For otherwise, we will not only face protracted tension and perhaps even war, but we will offer the Muslim world . . . the prospect of many wars, unimaginable suffering, and disastrous upheavals By even the most sanguine of standards, this is not a pleasant possibility.[4]

In an account usefully contrasted with the *Bad News* books, Said investigated how western media have constructed a discourse on Islam: the ascription of false unities, the explanatory assumption of religious essentialism, the elimination of the history of the Other, the systematic suppression of unflattering or contradictory aspects of the west's own history, the projection on to the Other of what is feared, disliked or troublesome in the self, and promoting confrontation as the only

possibility because, after all, you can't negotiate with irrationality, or trust the untrustworthy. The 'sanguine' defences of such discourses need to be challenged. It is precisely this kind of challenge that the Glasgow group offered, and which has not been prominent in cultural studies in the last decade.

II

The books to be considered here are *Bad News* (1976), *More Bad News* (1980), and *Really Bad News* (1982), cited in the text as *BN*, *MBN* and *RBN* respectively.[5] The Group's project was apparently simple: to take an extended sample of national daily news programmes, analysing content and textual devices. The three main conclusions were that television news violates its formal obligations to give a balanced account of events, that news institutions are extremely hierarchical and closely linked to official sources for news, and that this results in the presentation of 'preferred' ways of seeing the world (*RBN*, p. xi).

Bad News focused on industrial news, the BBC1, BBC2 and ITN reportage of trades unions, industrial disputes, business and economic affairs, and labour and economic legislation, between April and June 1974. News selection procedures, bulletin profiles and story categories were examined in detail. These established questionable priorities. For instance, certain economic areas, especially the motor industry, transport and public services, were reported at the expense of areas like engineering and the distributive trades which were arguably more important economically, and involved and influenced more people. This type of inaccuracy extended to industrial disputes: the 'principal disputes' in news were not the important disputes recognised by the Department of Employment. Selection priorities also affected news explanations of industrial processes. Wage levels, disputes and employment figures were reported, rather than investment, profits and other managerial issues (*BN*, p. 97). Industrial disputes were reported with an emphasis on inconvenienced consumers and on unscheduled interruptions to 'normal' production and consumption. Case studies of disputes in Glasgow and Birmingham in 1975 showed a systematic disadvantaging of trades unions in their relations to news. Most prominently, in *More Bad News*, coverage of the 'social contract' was shown to adopt only one of the available explanations of inflation, the Wilson government's preferred explanation which directly equated price rises only with wage increases. Industrial news, the Group conclude, is organised around the views of the dominant groups in

society: hence the unthinkability of headlines which could legitimately have read 'One million jobs threatened by huge dividends payouts' (*MBN*, p. 112). In subsequent sections of *More Bad News*, the Group took a sample of one week's news and analysed its uses of verbal language and visual representation across a wider range of news categories. This material too indicated that news accounts are limited and preferential (*MBN*, p. 119). For instance, verbal devices such as headlining and boundary markers reinforced and normalised the professionals' selection priorities. In reported speech, news gave people with higher status more direct, less mediated, positions of speaking. News vocabulary was restricted in many ways. For example, false communalities were constructed, such as 'us', the nation, against 'them', workers in dispute with managements; news consistently spoke of workers 'demanding' while managers 'offered'; there were few terms with which to describe industrial action by managements (*MBN*, p. 188). The Group approached visual representations in a similar way, though their key finding here was that news is governed by the demands of cohesive verbal narrative, with visual material often having little direct relation to this. The consequence is that news visuals often carry a falsely inflated sense of factuality and informativeness (*MBN*, p. 324).

III

Most of these arguments and evidences address the issue of news bias, and were offered in support of the Group's initial conclusion that television news is biased in its own terms. Arguments about bias are well known to media consumers because they are reported as news. However, what news media report are isolated incidents rather than argument about what bias might mean and in whose interests the term is operated. Media accounts of bias are usually couched in terms of personality attacks, declining programme standards and the rituals of party political debate, rather than the nature of news and its relations to the late twentieth-century capitalist state.

This public discourse on bias structures much of the Group's methods and conclusions. It has been a discourse organised mainly around two principles: a distinction of facts from values, and a notion of impartiality. Professionals and policy-makers have held firmly to a distinction of facts from values, of truth from opinions, using this to distinguish news from other genres such as current affairs and documentary, and as the basis of their claim that news is a discourse with special 'authority'.[6] Like most other academic researchers the

Glasgow group refused any absolute distinction of facts from values, given that any statements in language will be subject, to some extent, to the perspectives of both their producers and receivers. But this confronts only part of the problem. News professionals, recognising that news will inevitably have to report the views of others, have used the terms *impartiality*, *neutrality* and *balance* to organise and justify their procedures for doing this. Impartiality and neutrality are terms borrowed from the bourgeois management of conflict in law, military and diplomatic discourses. But in dealing with complex cultural texts like news bulletins, they suggest only the possibility of speaking from a position outside culture, effectively outside all representation. Underlying these terms is therefore again the notion of facticity, of ideal truth. Balance seems different in that it suggests an ideal pluralism of equally competing viewpoints, but the management of a regime of balance must still be conducted from positions which are assumed to be impartial or neutral.[7] Someone has to decide what constitutes a legitimate viewpoint, and how many viewpoints will be presented in a news item.

In entering this field of debate, the Glasgow group took a dual approach. They implicitly adopted some of its terms, especially balance, in order to offer evidence of the failure of news in those terms. But they also denied the adequacy of the bias debates and offered another way of explaining and discussing news. News was 'inevitably' biased, and discussion should centre on the nature and sources of the bias. The domination of certain sets of views was explained in terms of professional ideologies: the selection and presentation of news is governed by unquestioned attitudes and values which inevitably limit the nature of the resulting texts. It is these value systems which have to be challenged if news is to be reformed.

The Group were attempting to displace a public debate which had taken opinions and ideas to be the spontaneously-arising, freely-competing expressions of individuals, and replace this with questions about a systematic ordering of social power and control: what range of meanings are produced and available in a class-structured society, how are they produced, and whose interests are served? These questions go significantly beyond the simple assertion that all news is inevitably biased. This type of argument is now much more familiar in academic media research than in professional or policy-making circles. But the campaign project still seemed to demand an address to bias in its own terms, and this had important implications for both the methods of analysis and the picture of news which resulted.

IV

The Group's principal methods were content analysis, sociolinguistics and a range of descriptive textual formalisms. These methods stayed linked to the professional discourses on news, especially in their claims to objective or scientific status, and their emphasis on quantitative evidence. For instance, the content analysis used in *Bad News* retained some sense of the 'objective, systematic and quantitative description of manifest content' that Bernard Berelson proposed in 1952.[8] This derived from the origins of content analysis in newspaper journalism training in the USA in the 1920s, and its subsequent use in fields such as military intelligence and the study of propaganda and political discourses.

The Group's work was not however a simple frequency count. It was influenced by types of content analysis developed in communication and information studies in the 1960s, which recognised that content is not 'manifest' but produced, and that its identification relies on the inferences of researchers. Different characteristics of a discourse will therefore be revealed by different methods of conceiving content. The Group chose to see news content as a product of news institutions, arising from the professional ideologies of news practitioners.[9] However, this stress on 'content produced at source' eliminated other possibilities, especially the analysis of meanings as produced by historically-located readers within a culture. One simplified example: a certain sample of news may be analysed in terms of the number of, say, trade unionists mentioned, and that particular characteristic of a discourse might be important and useful to mark; but it may tell us little or nothing about what the words 'trade unionist' can mean, or for whom, nor how such meanings are produced in discourse and gain social currency. That such enquiries are important to a campaigning politics, and sometimes essential, is evidenced in Said's work, quoted above.

The Group's methodological complicity with the discourses of professionals and policy-makers must be questioned because it produces a limited and in some respects recuperable account of news. Are there other research methods which would serve both a campaigning politics and academic demands for a theorised account of news? This question can be explored by considering the Group's key term, ideology, and in particular the influence of Louis Althusser's theory of ideology on British cultural critics in the early 1970s.

V

'Ideology', in this context, seemed to invite a way of thinking the relationship of cultural production to economic and other social relations, without assuming that cultural production would simply reflect or express economic relations. One particular problem in Althusser's theory of ideology indicates also a problem in the *Bad News* books. This can best be indexed here through Michele Barrett's reading of Althusser's 1968 paper on ideology.[10] Barrett detects two distinct uses of the term 'ideology' in that paper: ideology as an agency of reproduction of capitalist class relations, and ideology as a mode of formation of subjectivity in language. In the first, ideology is necessarily 'class-partial'; but in the second it constitutes subjects whose class identities are not pre-specified. These two formulations, Barrett suggests, are indications of two subsequent directions for cultural criticism which have proved difficult to reconcile. In one, ideology has been analysed as a mechanism of reproduction of class relations, with an attendant assumption that language is a transparent vehicle for ideology. In the other, ideology has been analysed as a process of formation of individual consciousness, leading potentially to accounts of ideology outside history. This second direction has also tended to collapse any separation of ideology from language or discourse. The cultural studies work which took this second path will be familiar especially from the adoption of certain semiotic and psychoanalytic theories, offering as these did theories of language and subjectivity. These addressed questions of how textual meanings are produced, and also how those textual meanings might themselves be 'producing' a subject as the reader of the text.

This reference to Althusser is not made here to adjudicate the theories of ideology used in the *Bad News* books, still less to judge the Group as good or bad Althusserians.[11] Rather, it indicates different ways in which the *Bad News* books can be read. The Glasgow group's use of the term *ideology* is consonant with only a class-based theory of ideology, and this tends to eliminate questions of subjectivity. It also relegates to subsidiary status those politics of gender, sexuality and race which have taken subjectivity as a central issue. So I would like to suggest here two different possible readings of the *Bad News* books.

In the first reading, the Group undertake a discourse analysis of, primarily, industrial and economic news, demonstrating how television news systematically favoured certain discourses – for instance those that equated wage increases with inflation, or those which explained

economic processes only in terms of orthodox marginal economics – to the exclusion of others which were available. They show how this offered advantages to proponents of those views, including a right-wing Labour government, a range of centrist and conservative politicians, and also crucially to industrial investors, whose failure of investment was an alternative explanation of the 'problems of British industry' in the mid-1970s. But it is one thing to analyse a particular economic discourse in terms of specific aspects of news texts and specific production practices; it is another again to give an account of television news in terms of how power operates through its controls of language and discourse. In this second reading, the absence of now familiar territories of work on language and subjectivity is clearly marked. From this perspective, the work falls short on three counts. It cannot account for the mechanisms of production and reception of language within which meanings are produced. It cannot articulate a politics of subjectivity in relation to language-use. And it cannot formulate a better type of text to replace those now on offer.

I propose taking up this last issue. The Group's work can be tested against a question: if, from their picture, news is like that now, what could it be like in a better 'reformed' condition? Although the *Bad News* books suggest a far-reaching campaign programme for reforming news institutions, the lack of a sense of what future texts might be like is a major absence, with implications both for how news is currently analysed and for the strategies which might be used to reform it. To anticipate: Will this news be based on an assumption of naturalistic realism? Yes. Whom will it address and how, who might watch it and why, and what range of meanings might be constructed from it? Not specifiable. What genre characteristics will it have? It will be 'news': perhaps as at present.

VI

Take first the question of language and realism. One approach is to dismiss the problem of bias and call instead for an attention to the devices of news texts, and to the strategies and positionings of readers, which make news seem like a picturing of reality.[12] The assumption of realism in news language, and especially of naturalism in visual images, provides the institutions with a major defence.[13] Consider for instance ITN's remarks to the Annan committee in 1977:

The first priority of a television news programme is to present the

viewer with a plain unvarnished account of happenings, as free as humanly possible of bias, and making the maximum possible use of television's unique capacity to *show* these happenings.[14]

This assumption of a capacity to 'show' events is reproduced in the *Bad News* case studies, though with some qualifications. What emerges is a distortion account of news language. Texts can reflect the world, but the institutional biases of news selection and language-use distort that reflection.[15] The possibility of reflecting or imprinting the 'real' is retained not only in the Group's analysis but also in their programme of reform. Good news will be based on naturalistic assumptions.

Semiotically-informed approaches to media studies in the 1970s and 1980s have suggested that these assumptions are inadequate as an account of language and representation. They are also a means of operation of power – the power of persuasion towards a sense of truth – which should be subject to a political critique. However, semiotic approaches to television news are uncommon, and the Glasgow group explicitly rejected the 'full conceptual apparatus' of semiotics (*MBN*, p. 202). In the comparable field of film studies, semiotic theories were used extensively through the 1970s to examine 'commercial' cinema critically, to challenge the 'common-sense' notions of humanist criticism and to advance a radical counter-cinema. All three projects were linked through their critique of naturalistic realism. The counterparts of this analytical work were anti-naturalistic texts premised on the assumption that alternative forms of language and representation are necessary to represent real conditions of living adequately.[16] Such alternatives have not been suggested for television news. Given this absence, should we and can we consider an anti-naturalistic news?[17]

John Corner has argued against such a possibility in the related field of documentary:

> only the most committed of anti-realists could consider the abandonment of documentary to be desirable For the alternatives are too limited in range and in informational and connotational richness to satisfy by themselves the . . . paradoxical but strong and not necessarily at all conservative desire to 'see for ourselves' through images made by other people.[18]

My suggestion here is that news, as a genre, lacks alternatives from which to make such judgements. News has also lacked the types of critical attention which could promote such discussion. Moreover, in

the reformed conditions proposed by the *Bad News* books, the present kind of textual naturalism would be impossible to sustain.

VII

The second set of questions for this imaginary better news concerns audiences. Whom will it address, and how; who might want to watch it, and why; and what range of meanings might be available? In the *Bad News* books readers are largely absent. This tends to produce, by default, a notion of the viewing subject as de-historicised, outside specific material circumstances, making readings independent of class, race, gender, national or other identities. It suggests too a passive audience, unproblematically receptive of the views of news professionals.

The price that is paid for segregating textual analysis from audience analysis is a failure to see 'texts' as to some extent a result of readers' activity. Three kinds of audience analysis have prompted questions for the *Bad News* books.[19]

Reader-oriented semiotics has produced an extensive literature on codes and coding, terms which the Glasgow group use to link conventions of news production, textual features and professional ideologies.[20] Taking just one area, this suggests the need for close attention to narrative in news. The *Bad News* books list and measure stories, items, reports and bulletins, suggesting narrative features for analysis but not exploring them. It is however noticeable that although the instrumental terms in day-to-day studio organisation of news are 'items' and 'duration', the key term for journalists is still 'story'. What, for example, constitutes openings and closures for television news? How is the impulse to continue reading established? How are narrative continuities maintained, and to what effect? The politics and pleasures of 'following the story', the assumption that readers have indeed done so, and the ways that screen personae appear and re-appear in news stories, are aspects of news narrative shared with other cultural genres, including narrative fiction.

Sociological research on how audiences read texts has marked out the differences between professional critics' readings and those of other audiences, a separation the *Bad News* books elide. For instance, John Corner's work on documentary has tested the assumption that readers read in terms of naturalistic realism,[21] and Dorothy Hobson's empirical sociology of women's readings and uses of media, including news, suggests very marked gender differences: news is not the same thing, in

its patterns of use, for men and women.[22] Hobson offers a particularly useful challenge to the *Bad News* books, which, in spite of their extensive attention to bias, treat news as gender-neutral.

This question of the genders and gendering of readers has also been approached from a completely different position. Psychoanalytic criticism has been the principal territory on which theories of the subject have been contested in the 1970s and 1980s. But although psychoanalysis has become a central and accepted mode of criticism in, for example, film and writing studies, it is hardly evident at all in television news criticism. Across the *Bad News* books (and other studies of news) there are indications, usually marginal or curtailed, that something more is going on in television news than what we are being told about. Consider for instance what might be called the 'masculine language' of news, as a factual and rational language, premised on the position of truth outside all representation. The complex presentation of the screen personae of news has often been remarked, and the *Bad News* books have much to say about technical features and relative time allocations; but the nature of reader identifications, as influentially questioned in 1975 by Laura Mulvey's work on visual pleasures and the gendered viewing of film, has been largely absent from news studies.[23] And there are also affective responses to news. John Birt and Peter Jay are quoted in *More Bad News* as suggesting that longer, more current-affairs types of news would be an answer to bias, and that this might also overcome a feeling of 'unease' which they see as the result of present information- and explanation-starvation.[24] So, does news create anxieties, but then also use devices to resolve them? Is that one reason it climbs high in the ratings, and also persists in its present form?

It is particularly striking that at several points in their analysis, the Group speak of news as 'boring'. But why then should news in its present form continue to be produced at all, and why does it achieve such high viewing figures?[25] The persistance of a dominant form could be explained in terms of dominant institutional interests. But how and why is this power accepted? Posed as a problem of dis/pleasures, this offers a site of investigation which the *Bad News* books foreclose. It also opens the question of how and why audiences re-use news, outside the immediate moment of reception.[26]

VIII

A final question: how much will this imaginary future news be like 'news'? News, as a genre, is highly intertextual. There are strong

continuities with current affairs and documentary; but news also makes reference to more distant television genres, and draws on their textual devices and discourses: news and sport, news and education programmes, news and travel magazines, news and chat shows. News is also open to modes of reading normally associated with fictional genres, especially when it addresses disasters, war, human interest stories, the investigations of 'private' families and 'public' scandals, and so on. It does not seem good enough to repeat with the professionals that simple reference to the real is the unique source of value in news programmes.

News is not a soap opera. But on the other hand readers do not just receive the day's events. Readers are obliged to construct readings of news programmes, for which knowledge of other television genres, and also non-media discourses, is necessary. This suggests that news texts, and maybe news, should not be taken as a discrete object of study.[27] 'News' does not start with the title music and conclude with the pay-off, contained by the surface of the television screen.

IX

To summarise, then, the *Bad News* books offer a picture of news as inherently naturalistic, existing independently of readers and audiences, and distinct from other genres. Could such news continue within the new institutional conditions that the Group propose in their programme for reform? This programme is perhaps the most important and yet under-discussed part of the *Bad News* books. The Group call, principally, for changes in the powers and constitution of the controlling apparatuses of television news, including the appointment of sociologically-representative governors, later elected and accountable to a national conference. They also want changes in access to news production, through offering franchises to non-profit-making groups, giving access, training and a percentage of resources to non-professional groups and to minority groups especially in 'areas of conflict', giving rights of reply in response to cases of 'distortion', and operating positive discrimination within the news production structures (*RBN*, p. 153ff.).

These are institutional changes; what effect might they have on texts? What is at stake will be the definition of news. These changes would, first, produce a heterogeneous and shifting constituency of producers, with the result that a naming of authors, as social groups, would be a political necessity. Once anonymous authorship goes, so

does the position of authority: no longer 'Today in Parliament the Prime Minister said', but 'BBC news journalists (or whoever) report that today in Parliament . . .'. And that raises instantly the question of whose voice we are listening to, and how we locate ourselves in relation to that voice. This would be good news, but it is not news at present.

Three further issues would arise. The sense of what constitutes an 'event' would be under threat. Deeply-instated distinctions of, for example, public from private, or factual news from features, would have to be re-assessed, probably replaced. The generic identity of news would also be questioned. What, for instance, if a point-of-view on an event, for one group of people, required historical contextualisation? News would become historiography. Would that be within the rules, a legitimate view on an event for inclusion in a daily bulletin? And lastly, non-professional producers would be essential, but this raises the problems of taking any non-professional practice into an already-established professional sphere. Sometimes these encounters have been generative and important – some are familiar from the long histories of community arts in Britain, some from 'open door' television. But there is no reason to suppose that the resulting differentials in technical norms, values and conventions could allow the present kind of news text to continue. Though news at present is a montage of potentially-contradictory materials, these are contained by textual conventions which establish and seek to hold consistency across the surface of the text. The loss of that surface would be the loss of the myth of textual verisimilitude.

Here, the bias debate re-enters but by a different door. One effect of having a public discourse on bias, with recurring and often vitriolic debates, is to preserve the notion of a relative autonomy of broadcasting apparatuses from government – to remind us that ITN is not a government department. But a more important effect is to establish the identity of news, to police its nature as a site of guaranteed facticity. All bias debates are in this sense reassurances that news is there to continue as truth. This is a political issue in that news preserves in dominance both an ideal bourgeois subjectivity in the guise of 'rational man', the assumed present addressee of news, and also a bourgeois notion of truth: that notion in which a text can become the events of the day.

So perhaps the most interesting question generated by the *Bad News* books is this: whether or not news can and should continue as the factual presentation of daily events. If truths are manufactured where

there is the greatest power of persuasion, and if some of that power were to be redistributed through the Glasgow group's reforms, the resulting scenario is that news ceases to operate simply as truth. Instead it becomes provisional and relative, with its powers of persuasion fractured by difference within its texts. The politics of this is clearly much more difficult than suggested in the *Bad News* books; what is also clear is that this politics will require the redefinition of news.

NOTES

1 John Hartley, *Understanding News*, London: Methuen 1982, p. 190.
2 See for instance Peter Sissons and Paul McKee, 'Legal, Decent and Honest', *New Statesman*, 20 March 1981, and Martin Harrison, *TV News: Whose Bias?*, Hermitage Berkshire: Policy Journals 1985.
3 See for instance Louis Heren, 'Grey Areas', *The Times*, London, 15 May 1980; Digby Anderson and W. Sharrock, 'Biasing the News: Technical Issues in "Media Studies" ', *Sociology*, vol. 13 (1979); and for American television news of the period, C. Richard Hofstetter, *Bias in the News: Network Television Coverage of the 1972 Election Campaign*, Columbus: Ohio State University Press 1976.
4 Edward W. Said, *Covering Islam: How the Media and the Experts Determine how we see the Rest of the World*, London: Routledge 1981, p. 164.
5 Glasgow University Media Group, *Bad News*, London: Routledge 1976; *More Bad News*, London: Routledge 1980; *Really Bad News*, London: Writers and Readers Publishing Co-operative 1982.
6 This generic definition is often explicit; for instance: 'News seeks above all to answer the questions WHO, WHAT, WHERE, WHEN and HOW. It is primarily concerned with new facts and the factual background to them. Its interest in the question WHY is confined to the audience's urgent interest in understanding what has just happened within the bounds of immediately available information.' *The Task of Broadcasting News*, London: BBC publication, 1979, pp. 9–10, quoted in *More Bad News*, p. 474.
7 For instance the following comment on the BBC's coverage of the Falklands war in 1983: 'I believe our coverage was fair, balanced and a credit to all concerned. We succeeded because, although plainly not neutral between Britain and the aggressor, we upheld our overriding commitment to truth and to freedom of expression of all shades of opinion.' Lord Howard of Henderskelfe, Chairman of the BBC, Foreword to the *BBC Annual Report and Handbook*, 1984. For discussion of these terms, see: Gillian Skirrow, ' "More Bad News" – a Review of the Reviews', *Screen*, vol. 21, no. 2 (summer 1980); *Report of the Committee on the Future of Broadcasting*, chairman Lord Annan, Cmnd. 6753, London: HMSO 1977, pp. 267–87; and Peter Golding and Philip Elliott, *Making the News*, London: Longman 1979, chs. 4 and 8.
8 Quoted in T. F. Carney, *Content Analysis: a Technique for Systematic Inference from Communications*, London: Batsford 1972, p. 23. For an account of content analysis in the 1960s, see George Gerbner et al., *The Analysis of*

Communication Content: Developments in Scientific Theories and Computer Techniques, New York: George Wiley 1969.

9 This follows Klaus Krippendorf's 'communication model', in which content 'becomes manifest in processes of control within dynamic systems of interaction'; see Klaus Krippendorf, 'Models of Messages: Three Prototypes', in G. Gerbner et al., op. cit., pp. 69–106.

10 Michele Barrett, 'Althusser and the Concept of Ideology', in Lisa Appignanesi (ed.), *Ideas From France: the Legacy of French Theory*, London: Free Association Books 1989; also Louis Althusser, 'Ideology and Ideological State Apparatuses', in *Lenin and Philosophy and Other Essays*, London: New Left Books 1971. This is also the grounds of an earlier critique by Rosalind Coward; see Rosalind Coward, 'Class, "Culture" and the Social Formation', *Screen*, vol. 18, no. 1 (1977), and Iain Chambers, J. Clarke, I. Connell, L. Curtis, S. Hall and T. Jefferson, 'Marxism and Culture', *Screen*, vol. 18, no. 4 (1977–8).

11 The Group explicitly avoided totalising theories of media or society, and did not relate professional ideologies directly to a 'dominant ideology' or to social reproduction.

12 See G. Skirrow, op. cit.

13 This has also been remarked as a factor in audience perceptions of the relative partiality of different news media and channels; see Richard Collins, 'Seeing is Believing: the Ideology of Naturalism', in J. Corner (ed.), *Documentary and the Mass Media*, Stratford: Edward Arnold 1986.

14 In the *Report of the Committee on the Future of Broadcasting*, cited in *More Bad News*, p. 193.

15 For an introduction to these issues, see David Buckingham, 'Television Literacy: a Critique', *Radical Philosophy*, vol. 51 (spring 1989); also J. Hartley, op. cit.; for a more extended semiotic account, see Umberto Eco, *A Theory of Semiotics*, Bloomington, Ind.: Indiana University Press 1976, pp. 191ff.

16 A resumé is given in Robert Lapsley and Michael Westlake, *Film Theory: an Introduction*, Manchester: Manchester University Press 1988.

17 It is noticeable that one of the most evidently Saussurean treatments of news advocates neither institutional reforms nor a different practice of textualisation, only reformed 'critical' readings: see J. Hartley, op. cit., pp. 9–10.

18 John Corner (ed.), op. cit., p. xii.

19 A summary of some of these approaches is given in Ann Gray, 'Reading the Audience', *Screen*, vol. 28, no. 3 (summer 1987); see also Annette Kuhn, 'Women's Genres', *Screen*, vol. 25, no. 1 (Jan.–Feb. 1984), for an account of the methodological implications of distinguishing between 'spectators' and 'audiences'.

20 See for instance John Corner, 'Codes and Cultural Analysis', *Media, Culture, Society*, vol. 2, no. 1 (Jan. 1980); and Justin Wren-Lewis, 'The Encoding/decoding Model: Criticisms and Redevelopments for Research on Decoding', *Media, Culture, Society*, vol. 5 (1983), pp. 179–97; also Rosalind Coward and John Ellis, *Language and Materialism: Developments in Ideology and Theories of the Subject*, London: Routledge 1977.

21 John Corner and Kay Richardson, 'Documentary Meanings and the Discourse of Interpretation', in J. Corner (ed.), op. cit.
22 Dorothy Hobson, 'Housewives and the Mass Media', in Stuart Hall et al., *Culture, Media, Language*, London: Hutchinson 1980.
23 Laura Mulvey, 'Visual Pleasure and Narrative Cinema', *Screen*, vol. 16, no. 3 (1975).
24 'Our economic problems . . . manifest themselves in a wide variety of symptoms The news, devoting two minutes on successive nights to the latest unemployment figures or the state of the stock market, with no time to put the story in context, gives the viewer no sense of how any of the problems relate to each other. It is more likely to leave him confused and uneasy.' John Birt and Peter Jay, *The Times* London, 28 February 1975, quoted in *More Bad News*, p. 405.
25 For instance, BARB ratings for the week ending 27 January 1991 indicate, within the top 30 programmes for each channel, ten BBC1 news broadcasts, with a largest single audience of 10.53 million viewers; and two ITN broadcasts with a largest single audience of 9.65 million.
26 See for instance Susan J. Smith, 'News and the Dissemination of Fear', in Jacquelin Burgess and John Gold (eds), *Geography, the Media and Popular Culture*, Beckenham: Croom Helm 1985.
27 An outline of possibilities is given in Jacquelin Burgess, 'The Production and Consumption of Environmental Meanings in the Mass Media: a Research Agenda for the 1990s', *Transactions*, vol. 15, no. 2 (1990).

FURTHER READING

Cameron, Deborah, *Feminism and Linguistic Theory*, London: Macmillan 1985.
Flitterman-Lewis, Sandy, 'Psychoanalysis, Film and Television', in Robert C. Allen (ed.), *Channels of Discourse*, London: Methuen 1987, pp. 172–210.
Fowler, Roger, *Language in the News: Discourse and Ideology in the Press*, London: Routledge 1991.
Morley, David, *Family Television: Cultural Power and Domestic Leisure*, London: Comedia 1986.
Wren-Lewis, Justin, 'Decoding Television News', in P. Drummond and R. Patterson (eds), *Television in Transition*, London: BFI 1985.

Chapter 5

Stuart Hall, *Policing the Crisis*

Martin Barker

'we ignore these conjunctural aspects at our peril.'

(p. 304)

It is a little strange to consider a major book whose topic is ostensibly the cultural politics of 'race' in Britain, and to realise that most of its influence has been in other fields: of state theory, of theories of political ideology, and of left political strategies in response to 'Thatcherism'.

Policing the Crisis (henceforth *PTC*) was first published in 1978, and has gone through successive reprints since then. Written collectively by Stuart Hall (in his last years as Director of the Centre for Contemporary Cultural Studies, Birmingham), Chas Critcher, Tony Jefferson, John Clarke and Brian Roberts (all postgraduates at the Centre), it was never simply a theoretical/polemical book. At its heart was the determination of the Centre's founders and early members to connect with the struggles of exploited and oppressed groups – hence the statement (p. x) that the book is an 'intervention' and the acknowledgement to the 'Paul, Jimmy & Musty Support Committee'. For it was their case, their story, that provided one main motivation for the study.

POLICING THE CRISIS: STRUCTURE AND SUMMARY

PTC is about mugging, or more correctly about how 'mugging' came to be put in the 'eye of the storm' of British politics in the 1970s. Their argument begins with the story of Arthur Hills, a pensioner, who was attacked by three young black men on his way home from the theatre in Handsworth, Birmingham in August 1972. What Hall et al. then set out to show is the disjunction between this event and its subsequent vast mobilisation by newspapers and television, by politicians and police, by

judges and other moral and legal entrepreneurs as a major new social problem called 'mugging'. Hall et al. invite us to examine this disjunction through the idea of the 'moral panic'.

The idea of the 'moral panic' has its origins in the work of Stanley Cohen, one of the new deviancy theorists who emerged in the late 1950s. The keynote idea of deviancy theory was that crime cannot be understood separate from societal definitions of crime, methods of social control and reactions to those who are labelled 'deviant'. In his well-known study of the mods and rockers of the mid-1960s, Cohen showed how a 'spiral' of response led to the seaside skirmishes of the mods and rockers being regarded, briefly but effectively, as a threat to the whole of society.[1] The point was that what most needs our scrutiny is not the petty acts of violence and vandalism of the mods and rockers but the way in which official British society responded to them. For reasons other than their crimes, society was 'in a mood' to find them a threat.

One of the common criticisms of Cohen, and of transactional sociologists generally, has been that they do not explore the very institutions of power which do this labelling, and panicking: what power is it that they are deploying, whose interests are thus served, and what wider developments prompt the labelling and panicking? For example, Cohen himself had nothing to say about the political contexts in which his panics took place. A Labour government elected after thirteen years of pragmatic Toryism; the undermining of that government's minimal reformism by the currency crisis of 1964–5; the emergent signs of social and political discontent, which climaxed in the seamen's strike of 1966; and so on. This is the direction in which Hall et al. will go, to a systematic study of the conditions that made possible a 'panic' about street crime.

They begin by exploring the unreliability of crime statistics, showing (among many other things) the way in which the Metropolitan Police, having kept no statistics on 'muggings' before 1972, were none the less apparently able in that year to show a steep rise in their occurrence. They look at the way the term 'mugging' arrived in Britain already carrying a baggage of meanings from its American roots (among other things, the 'threat of Americanised crime'). This sets the scene for a chapter exploring how from the mid-1960s legal institutions and police spokespeople began to push back against 'permissiveness' generally, opposing soft sentencing and linking rises in criminal statistics to shifts towards tolerance in a series of cultural areas: censorship, sexual morality, drug-taking, for instance. What

emerges from this and the next chapter on the media is a picture of a circuit between police, judges and magistrates, newspapers and politicians, reinforcing each other in defining a problem and demanding action to solve it. Typically, the police might report their fears of losing control of some problem-group. A newspaper would editorialise on this, demanding tougher sentencing; a judge would dish out a severe sentence, noting (by reference to the press) that the public are evidently demanding tougher action; the police would then use the judge's address (as reported in the press) to demand of their political masters new powers or new legislation.

This circuit, argues *PTC*, surrounded and created the mugging panic. But making sense of one element provokes another. If this explains how the Handsworth mugging became an exemplary crime, it also brings to light a wider set of 'images, explanations, ideologies and . . . a sense of loss' (p. 119) – which requires them to cast the net wider to consider how the press claim to speak on behalf of ordinary people, 'orchestrating public opinion' through this means; and how doing this involves conflicting explanations of things like crime. Crime is caused by the breakdown of family life. Crime is caused by bad environments. Crime is caused by loss of discipline in society. But these are not obvious or natural explanations. They have to be *made* natural, they have to be made into 'common sense'. And here the second major concept (after 'moral panic') that is woven through *PTC* makes its entry: the idea of 'common sense' as the form and bearer of ideology.

This shows the general argumentative structure of the book. Each stage, on being explored, throws up gaps and puzzles which can only be grasped and surmounted by going wider. We begin with a sad but common crime, and find we have 'MUGGING!'; to understand that we have to look at the way 'primary definers' (press, magistrates, police and the like) were able to make the event into a symbolic one; we then realise that this was time-bound and coincided with a rise of concerns about a 'violent society' where law and authority was breaking down; so what forms did these fears take, and how were we persuaded to accept the state's solutions? This leads to 'new dimensions of explanation' (p. 184), or a third storey: for labelling some behaviours as 'crimes' is intimately bound up with how the state retains control of refractory populations, and how far it feels safe and legitimised. So, the eruption of fears about a 'violent society', the conflation of anxieties about strikers, student demonstrators, hippie drug-takers, pornography and a resistant black population all indicate that in this period the British state was undergoing a *crisis in hegemony*. That is, British

capitalism (like all advanced capitalist countries) had had to involve the state increasingly in planning, ordering and maintaining its activities. But then, when social and political tensions arise, they lead inevitably to a questioning of the right of the state to govern, and in whose interests it governs.

The book retraces the stages by which an 'exhaustion of consent' was matched by a rising tide of moral panics; first discrete, then falling over each other until they merged in the early 1970s into a general terror of the collapse of society, the 'barbarians at the gate'.[2] In the end the 'black mugger' became the condensed symbol of everything that was going wrong with Britain. 'In these conditions blacks became the "bearers" of those contradictory outcomes; and black crime becomes the *signifier* of the crisis in the urban colonies' (p. 339). The mugger was the 'enemy within', he signified the arrival of alien values, alien cultures, the disintegration of a mythical English past. Fears and anxieties about other processes were displaced on to black people, who increasingly became identical with the 'mugger'. And all blacks were potentially criminal. It is only within this larger framework, say Hall et al., that we are able to look at actual muggers, at the young blacks who do in indeterminate numbers commit street robberies of various kinds and with varying degrees of violence.

This argumentative strategy is one of the reasons why the book has a strongly claustrophobic feel. It can be rather like playing a role-playing computer game. As you solve each level, you are projected to the next; and the first thing you must do is to look around and get just enough information (theory) to explore the new terrain. But as in computer games, how much information/theory you get is entirely in the hands of the games-makers. So, when we had to explore newsmaking, we got the theory necessary to that (for example, theories of selection and representation, of media routines and of the accessing of primary definers of events); but no history of the media. History comes in at the second storey, so was 'not needed' before (although actually it might have queried their picture considerably if we had been able to review the particular character of the press in the late 1960s/early 1970s). When we come to ideologies of crime, we get just the theory we need to think about common-sense ideologies (although – as I shall try to show later – a closer scrutiny might have pointed up that it is used in several, inconsistent ways). And when we come to the question of the state, we are introduced to the Marxist debates about the state – but with an absence, never remedied in the book, of thinking about the meaning of 'class' and 'class conflict'

in Marxism. This absence in the end sets up a political trajectory out of *PTC*, towards the theory of 'authoritarian populism' and 'New Times'.

EVALUATING *POLICING THE CRISIS*

PTC is an overwritten book. It is as though every example, and every thought, had to be crammed in. It reads like a summary of all the work that had been done in Birmingham up to this point – and that is the reason for the ironic headnote to this essay. It is as if the results of all cultural studies' areas of work up to that point were funnelled through *PTC* to create a new synthesis and direction. First, and positively, it is a research direction. Here was a positive demonstration of the ways in which cultural forms and cultural contexts, embracing relations of power and exploitation, are manifestly interconnected; and it is impossible to study either one without the other. In this sense, *PTC* was a model work of cultural studies.

It was a model work, also, in tackling and resolving in unrhetorical fashion the issue of 'Marxist reductionism'. Often, post-Stalinist Marxist arguments have admitted that we mustn't 'reduce' any phenomenon to the structural/economic. Too often, that had been simply a gesture, without substance. What Hall et al. offered was a case study of relatedness without reduction. 'Race', they concluded (in a frequently-quoted phrase), 'is the modality in which class is lived.' This requires us to look at the class-position of black people in Britain, both how it is defined from above and how it is lived out; but at the same time insists that it has been defined as a separate arena with its own internal dynamics.

PTC was a bold work, above all else. It attempted to draw together so many previously-disconnected fields. Deviancy theory – but going beyond it to situate the social production of criminal labels within a historical framework. Ideas of media representation, but also their involvement in circuits of social and political power. State theory, in advance of most of the debates about the forms of the capitalist state. Theories of ideology – but now conceived as practical ways of 'living out' the conditions of one's society. The courage to go for the whole is no small matter.

But there are also risks in aiming for new syntheses. Although we must surely admire *Policing the Crisis*, it is important also to measure it. With a book so wide-ranging, it is impossible to review all possible avenues. I am going to focus on only four: the concept of a 'moral

panic'; their analysis of Powellism; the concept of 'common sense'; and their picture of the placing of black people in Britain.

PANICKING ABOUT MORALS

The concept of a 'moral panic' developed from Cohen creates, I want to suggest, a dual problem: of what it leaves out, and what it puts in instead.

What gets left out is any notion of *agency*. A 'moral panic' is pictured as being like the epicentre of an earthquake. Way under the surface of society, deep structural changes are going on which are *vented* as ideological crises of hegemony. Those deep-going processes are hardly visible, are very hard to grasp, and certainly are not caused in any meaningful sense by anyone's plans. They are structural shifts – but they are lived out 'on the surface' through the waves of moral panics which engulf us.

I am concerned at the apparent agentlessness of this, which turns out in practice to have a very distinct agent. Look, first, at how the authors depict the change from pre-crisis to crisis:

> We would argue that a crisis of hegemony or 'general crisis of the state', precisely as Gramsci described it, has indeed been developing in Britain since the spontaneous and successful 'hegemony' of the immediate post-war period: that, classically, it first assumed the form of a 'crisis of authority'; that, exactly as described, it first reverberated out from the parties of 'represented and representatives'. (pp. 216–17)

Now, to represent the 1950s as 'spontaneous hegemony' is itself dangerous. It implies, first, that no hard work had to be done (no agency) to ensure that hegemony. But think about the proliferation of government propaganda bodies after the Second World War (see William Crofts's excellent study of these).[3] Consider the Labour government's taking on and defeating important sections of the working class in the immediate post-war period.[4] And remember the large concessions granted (in the form of the creation of the whole social welfare programme) to fend off what was widely seen as the threat of wider, possibly revolutionary, demands after the Second World War.

But this is not the centre of my concerns, although it does connect inasmuch with the neglect of the *forms of organisation of the working class* overall. For when we leave the period of 'spontaneous hegemony', the picture subtly shifts. Consider first how *PTC* presents the role of the Labour government, from 1964 to 1970:

The emergence of an open class struggle, in a state temporarily under the command of social-democratic character, undermines and destroys such a government's *raison d'etre*. The only rationale for entrusting the management of the corporate capitalist state to social democracy is either (i) that in a tight squeeze it can better win the collaboration of working class organisations to the state, if necessary, at the expense of their own class; or (ii) that if there is going to be an economic crisis, it is better that such a crisis should be indelibly identified with yet another historic failure of Labourism. (p. 261)

Hang on, who is doing this entrusting? What unspoken agency is this? It seems that a hidden manipulative hand is manoeuvring behind the scenes. This is not an accidental 'slip', I feel. For otherwise, they would have to acknowledge that the Labour party had *changed in its relationship to the working class*. But that would have the effect of altering the whole terms of the debate. It would lift it out of discussions of ideology, hegemony and domination, into a debate about working-class organisation, confidence and autonomous action.

The same problem reappears when *PTC* discusses (briefly) the French general strike of May 1968. Although the French Communist Party is mentioned, its role in limiting and defusing the strike's potential is replaced by a less focused failure: 'The very hesitancy before the citadel of the state was to be its undoing' (p. 241). Whose hesitancy? The sad fact about France in 1968 was that it was the students and workers who were 'before the citadel of the state', but it was the French CP which did the hesitating – and because of the weakness of other organisations, they were indeed undone, and Gaullism was reinstated.[5]

This is a strong tendency throughout the book. But, because of the book's narrative organisation, the problem of agency constantly retreats from view. Chapter 1 hands on with a comment that 'the soil of judicial and social reaction was already well tilled' (p. 28) – so someone else did it then!; chapter 2 ends with the remark that 'though [the judiciary and the police] are crucial actors in the drama of the moral panic, they, too, are acting out a script which they did not write' (p. 52) – so who did?; chapter 3 closes by referring the problem even higher – 'the media – albeit unwittingly, and through their own "autonomous" routes – have become effectively an apparatus of the control process itself ' (p. 76); and so on.

This tendency to agentless acts was a component of other work

coming from Stuart Hall and others at the Centre in this period – for example, Hall's classic essay on encoding/decoding.[6] There, while making his important argument that we cannot study texts without being forced to study the systems of their production and reception, he frames the relationship between these in a very particular way: 'the moments of encoding and decoding are . . . determinate moments' (p. 2). The text and its codes have a kind of ontological priority. Producers produce them, of course – but *how* they produce them must not be understood as a process of creativity, or will, or consciousness. They are the results of other – professional – codes which *enable* them to produce. Codes are always pre-eminent over coders. So, when Hall concludes that texts have preferred meanings, that is because *built into the codes themselves* are mechanisms and devices for *preferring* one reading. Thus he talks of their being within the code of a programme: a code (and the transferral metaphor in this remains strong); decoding devices ('work to enforce plausibility'), disguising devices ('transparency' and the 'taken-for-granted'), and linking devices ('the communicative process consists of *performative rules* – rules of competence and use, or logics-in-use – which seek to *enforce* or *pre-fer* one semantic domain over another, and rule items in and out of their appropriate meaning-sets' (p. 14, emphases in the original)). All these features of the texts combine to create the preferred meaning.

The difficulties with the encoding/decoding model have been rehearsed, of course. Notably, David Morley's honest self-appraisal after the *Nationwide Audience* study (See Chapter 8) pointed out much of what was left out of it: awareness of pleasure in texts, its limited notion of genre, its conception of audience's complex locations, etc.[7] But I am particularly interested in an argument from Justin Wren-Lewis who points out how ahistorical the coding model makes audiences' reading skills.[8] Wren-Lewis argues that people's abilities to understand genres are subject to both personal and social development (thus making possible, for example, ironic revisitings of *Muffin the Mule* in *Def II*). I am curious, though, that both Wren-Lewis, and Thomas Streeter after him, only see this in terms of dehistoricising *reading*-skills, and not also production-skills. Yet I think the latter is equally true.[9] In Hall's account, both of television and of ideological forms more generally in *PTC*, only ideological forms have histories – people don't. It is instructive to counterpose to this the kind of detailed attention to production motives and regimes evidenced in Scannell and Cardiff's new history of the BBC.[10]

Police actions 'without scripts'. Labour governments 'allowed' into

power. Crises have become gigantic texts inscribing their audiences. And they are able to do this because panics are *moral* and thus bypass cognitive appraisal.

MORALISING ABOUT POWELLISM

Consider *PTC*'s discussion of Enoch Powell's 1968 intervention on 'race'. This in fact takes a surprisingly small space, given the topic of the book. After reminding us of his use of the story of the little old lady and the 'grinning piccaninnies', they comment:

> Such stories and phrases intersected directly with the anxieties among ordinary men and women which come flooding to the surface when life suddenly loses its bearings, and things go careering off the rails. An outcast group, a tendency to closure in the control culture, widespread public anxiety: Mr Powell himself provided the dramatic event. (p. 245)

After a reminder of the Rivers of Blood metaphor in Powell's April 1968 speech they continue:

> Discrimination, Mr Powell continued, was being experienced, not by blacks, but by whites – 'those among whom they have come'. This invocation – direct to the experience of unsettlement in a settled life, to *the fear of change* – is the great emergent theme of Mr Powell's speech. . . . Long-term, 'Powellism' was symptomatic of deeper shifts in the body politic. Mr Powell employed race – as subsequently he was to use Ireland, the Common Market, defence of the free market, and the House of Lords – as a *vehicle* through which to articulate a definition of 'Englishness', a recipe for holding England together. . . . The themes which are closest to his heart – a Burkean sense of tradition, the 'genius' of a people, constitutional fetishism, a romantic nationalism – do not obey the pragmatic imperatives of a Wilsonian or Heathian 'logic'. They are ordered by more subliminal nationalist sentiments and passions. It was one of Mr Powell's gifts to be able to find a populist rhetoric which, in the era of rampant pragmatism, bypassed the pragmatic motive, and spoke straight – in its own metaphorical way – to fears, anxieties, frustrations, to the national collective unconscious, to its hopes and fears. (p. 246; emphasis in original)

There are a number of striking features in this way of considering Powell. First, the emphasis on 'fears' and 'anxieties' – ironically, just

Powell and his supporters' own language of self-justification. They did not speak for themselves, they said, they spoke for others' fears and anxieties. We who had been settled and tolerant had had our tolerance too much tested by the influx of alien immigrants who threatened our culture and way of life. Of course, Hall et al. are not defending these responses. But still, these people with their fears are oddly without a history or location. There is no Imperial past; there is not even any sense of the kind of past working-class communalism that Hoggart tried to document.[11]

Why do Hall et al. focus so much on 'fears' and even a 'collective subconscious' – all these epithets for non-rational affects? I want to suggest it was because in their view Powell's *mode of effect* had to be non-rational. There is an unwillingness to consider the rationality of racism, the logic of its arguments. If anything, racism is dissolved away into a displacement effect at other changes. And talking of an indivisible 'English consciousness' sets aside the question how far Powell's challenge was directed to the *Conservative party itself*.[12] What Powell mainly offered was a position to reappraise the whole of Conservative party policy, from a new standard; as Angus Maude put it in the *Spectator* just months later, Powell had enabled a whole body of other issues to be aired.[13] I am pointing to the danger of dissolving the responses to Powell – some strategic, some racist, all of course involving feelings as well as forms of reasoning – into a puddle of emotions. In itself I think this is misleading. But in context of *PTC*, it becomes another component in the 'moralising' of ideologies.

THE THREE FACES OF 'COMMON SENSE'

The concept of 'common sense' not only plays a large part in *PTC* but has come to represent one of the primary ways in which cultural studies think about ideology. Where 'ideology' smacked of large systems of ideas, 'common sense' spoke of fragments; where 'ideology' spoke conscious acceptance and commitment, 'common sense' spoke of the 'taken-for-granted'. Coupling closely with Gramsci's concept of 'hegemony', 'common sense' became the residual commitment to notions of power in ideas at a time when a good deal of cultural studies was heading into the postmodern soup, in which all swim free, if stickily. And a good deal of the thinking about 'common sense' can be traced to *PTC*.

In fact the book evidences three, not very compatible, notions of 'common sense'. In the first, 'common sense' is a peculiarly English

tradition involving appeals to 'experience', supposedly grounded in the empiricist philosophies of John Locke and David Hume, and their popular counterparts. Without indicating its preference, *PTC* cites both Perry Anderson's explanation of the rise of empiricism and Marx's. According to Anderson, 'empiricism . . . faithfully transcribes the fragmented, incomplete character of the English bourgeoisie's historical experience' (cited, pp. 150–1). This is actually a very weak way to depict a theory that, while certainly focusing on experience and sensations, did so *in a grand theoretical manner*. From Hobbes to Bentham, empiricism displays considerable theoretical confidence, even bravura, a certainty about the possibility of a unified philosophy of experience. Marx on the other hand saw empiricism as essentially *practical*, though admittedly he focused more on the nineteenth-century utilitarians than on the seventeenth- and eighteenth-century philosophers of experience.

Giving interpretations of the ideological significance of 'empiricism' has become a kind of left game. What gets included under 'empiricism' fluctuates as wildly as any flag of convenience (a point particularly apposite to Althusser, as many have noted). But whatever the interpretation, two points need noting: (1) by any of its readings, empiricism is a *theorised* tradition, even if that theory offers a justification of fragmentary, individualised knowledge; (2) it is always seen in this guise as peculiarly English, rather than as a feature of hegemonised capitalism-in-general. *PTC* is none the less willing to account for modern common sense, with its references to the 'man-in-the-street' and to 'nature', as outcomes of this style of thinking. In granting that these are peculiarly English forms, Hall et al. are saying that there might be other forms which do not then refer to 'nature', 'experience' etc. What would mark them as 'common sense', then, I wonder?

The second version of 'common sense' points to the way subordinate classes live out their subordination. Not just a matter of ideas or attitudes, this also means the forms of subordinate culture; it includes the ways in which dominant structures and institutions are acknowledged day-to-day by subordinated groups. Why call this 'common sense'? Why not 'good sense', as in the practical understanding that if you aren't careful, for example, the police can come and get you? Hall et al.'s answer at first seems to be 'because such ideas are contradictory': for example, workers believing that wage rises cause inflation, yet demanding more for their own group. But that suggestion – which sounds like the application of a criterion of logic – is immediately qualified:

The important thing is not only that commonsense thought is contradictory, but that it is fragmentary and inconsistent precisely because what is 'common' about it is that it is not subject to tests of internal coherence and logical consistency. (p. 155)

Why not? The language inflecting Hall et al.'s answer is significant; they speak of the dominant understanding 'masking', 'concealing', 'harmonising', 'universalising', and 'naturalising' its own hegemony. *To the extent, then that subordinate groups accede the dominance of some set of ideas, they disable themselves; they make themselves incapable of rational, consistent judgements.* This is the concept of common sense that has grown like Topsy within cultural studies, and become the standard way in which 'ideology' is now thought through Gramsci. It is the form in which it was carried forward into the CCCS's next major incursion in race-theory, *The Empire Strikes Back*.[14]

But there is a third option, not so clearly laid out in *PTC* but lurking there and with its roots in quite another interpretation of Gramsci. This approach stresses the linkages of theory and practice. It notes that there are indeed different degrees of generalisation and scope of ideas to explain the world; and it wants to work on those through political organisation, to build common sense into an oppositional theory and practice. It differs from the other two interpretations on several counts: it sees nothing special in the English case. It needs to make no reference to empiricism, since 'experience' can be partly oppositional. But most importantly, the fragmentary nature of some common-sense thinking is not now an index of defeated rationality but a symptom of how far a group/class has fashioned for itself its own organisation and view of the world.[15] There is no assumption in this approach of some kind of epistemological failure in 'common-sense' thinking, or that it is somehow *induced* thinking.

However, the idea of common sense that predominates in *PTC* is the second, which combines the following elements: it sees common-sense thought as essentially non-rational, hence its proneness to moral panics; it sees it as a produced form of knowledge. It is needed to do a definite job of work within the book. It is not arrived at by empirical investigation but by projection from the needs of a general theory:

One of the effects of retaining the notion of 'moral panic' is the penetration it provides into an otherwise extremely obscure means by which the working classes are drawn in to processes which are occurring in large measure 'behind their backs', and led to experience and respond to contradictory developments in ways which

make the operation of state power legitimate, credible and con-sensual. To put it crudely, the 'moral panic' appears to us one of the principal forms of ideological consciousness by means of which a 'silent majority' is won over to the support of increasingly coercive measures on the part of the state, and lends its legitimacy to a 'more than usual' exercise of control. (p. 221)

At one fell swoop this enables Hall et al. to sidestep all the arguments of, for example, Abercrombie and Turner who have questioned just how far any dominant ideology is taken up and accepted by the working class.[16] It also takes for granted just what John Thompson, among others, has wanted to query about 'cohesion-producing' models of ideology.[17]

One outcome of seeing these distinctions is to deflect, or reshape, a popular argument against the work that most obviously followed *PTC*, Hall and Jacques's *The Politics of Thatcherism*. One of its critics' complaints has been that the book seems to be claiming that Thatcher-ism was successful because it had greater ideological coherence than its enemies – thus apparently making ideological form into a wholly independent variable. Hall himself disputed this interpretation of his work, and I tend to agree with him.[18] It would not be the *coherence* of Thatcherism that would mark it for success, but its *ability to make itself appear as common sense, agentless* – and that is, I am suggesting, a far more mysterious process according to its roots in *PTC*.

FROM CLASS-CULTURE TO CULTURE-CLASS

The last chapter of *PTC* reads quite differently from the rest. Here, the authors face up to the package of questions: well, what is mugging, how and why does it happen, and how can we understand it? Here they open a set of issues of great importance for thinking about the class and culture of black people. I tend to agree with Lee Bridges's review-comment that it is by far and away the best chapter of the book, and perhaps the most profitable still to read. But not unproblematic.

A key element is the authors' discussion of the meaning of a 'lumpenproletariat'. Given that a large number of black people seem now set into the pool of permanent unemployment, is it right, they ask, to think of them as constituting a new subclass in Marx's terms? There are fascinating discussions here both of Marx's comments on subclasses (which he largely saw as demoralised and mainly reactionary), of Fanon's challenge to this from his discussion of the 'wretched of the

earth', and of the American Black Panthers who drew their political strength from the traditions of sub-legal street hustling. The argument of this chapter is much more open and uncertain than preceding ones; but its tendency is best captured by this quotation:

> Now there are several ways of understanding the position of a whole class fraction which appears systematically vulnerable – as migrant workers are now everywhere, in the period of capitalist recession . . .; and one of them is in terms of the traditional *lumpenproletariat*. What makes this position tenable is the fact of its growing dependence on crime and the dangerous life of the street as its principal mode of survival. But it can clearly be shown that it is not, in any classical or useful sense, a *lumpenproletariat* at all. It does not have the position, the consciousness, nor the role in relation to capital of the *lumpen*. (p. 392)

This is an important issue, without question, and *PTC*'s raising of it is still valuable. I am less happy about the direction it opened up. For their suggestion is that the economic position of black people is qualified by the nature of their culture: a culture of resistance. The refusal of many young blacks to take 'shit-work', their hostility to white policing, and their development of cultural (especially musical) forms embodying their rejection of 'white norms' mark them out as an exceptional formation. These ideas are only partly present in *PTC*; they were taken much further in subsequent writings, especially by Paul Gilroy.[19]

This is not the place to offer a satisfactory analysis of this idea, and anyway I don't feel competent to do it satisfactorily. But one or two problems can at least be pointed up. A number of critics have suggested that Hall et al. overstate the degree to which young black people do reject 'official white society'. For example, Barry Troyna, and George Gaskell and Patten Smith have published evidence showing a sharp divide in young black attitudes towards work, white racism and the possibilities of acceptance into society.[20] There is evidence of quite another sort, which puts a different gloss on this, in Thomas Cottle's extraordinary *Black Testimony*.[21] One of Cottle's interviewees, a young black boy from London, strikingly reveals a split and self-conflictful attitude to a white teacher:

> You want to know how far it goes? I'm playing football couple of years ago in school. So they have this bloke teaching us how to be goalie. He's telling us, don't catch the ball 'cos it can pop out, hug it. Hold it all the way round, you know what I mean, so you'll be sure

to have it. So each kid gets to be goalie and we're practising to throw the ball at the goalie so he can hug it, and the man hugs the kid *and* the ball, from behind. We're all having a go, and he comes to Ben Stellen, this tiny little kid, but because he's black, the man says 'OK, let's see you do it', but he doesn't hug Ben. He stands back and watches. So Ben, he doesn't catch the ball right and it goes past him, everything bad happens. So the man says, real nice, mind you, real nice, 'That's OK, Ben. Next time just try a bit harder'. But he doesn't touch him or anything. Then the next kid comes up, white kid, right, and the man goes back to hugging him from behind like before. He didn't hug me neither when it was my go but I didn't care. Who wants to be hugged by that guy anyway? That's what I thought. But I still remember that day and I can tell you, man, if that bloke had hugged me from behind like he did all the others, I wouldn't have minded. (p. 53)

This suggests that the split evidenced by Troyna and others may not just be between individuals but within them. If this is right, it seriously qualifies the homogeneity which followers of the *PTC* approach tend to impute to black culture. It also challenges the very image of a 'culture' which they project, in which resistance somehow produces a complete and unified culture, and negates any internalised harm or damage from racism – as though the creation of cultural resources mounted a kind of psychic defence.[22]

Finally, this approach seems to impute an oddly timeless and essential quality to black resistance. 'Black culture' takes on a mask of romantic power, not unlike the way in which for Marcuse in the 1960s student revolt became a 'last hope of radicalism'.[23]

CONCLUSION

Policing the Crisis was important as much for the time it came out as for the particular arguments and point of view it offered. Its very wholeness offered an anchor for many on the left, a way of thinking about the defeats we were suffering, and by extrapolation a strategy. That strategy has been the subject of a vast debate, far beyond anything I have evidenced here. For all that I have always found myself very opposed to the politics of this book and its offspring, I cannot help but admire its aim and its bravado, every time I re-read it. It was, simply, an astonishing achievement, and without it, cultural studies would be much less rich.

NOTES

1 Stanley Cohen, *Folk Devils and Moral Panics: the Creation of the Mods and Rockers*, London: MacGibbon & Kee 1972.

2 See my *The New Racism: Conservatives and the Ideology of the Tribe*, London: Junction Books 1981, p. 45 for this quotation. This retracing has for me often an overwhelming quality. Nothing, it seems, is missing. Everything was part of it, and is judiciously summed up. People you had forgotten about are not only recalled but snapped into an exact focus:

> The adoption of guerilla tactics in or near the metropolitan centres and the use of terrorist attacks on its vulnerable cities hastened the process of 'bringing political violence back home'. Ulster and the Quebec Liberation Front were examples of the first; the kidnapping of businessmen and diplomats, and the hijackings and terrorist attacks by 'Black September' and the Palestine Liberation Front (PLO) were tangible examples of the second. Four PLO hijacks in succession in 1970, ending in the capture of one of their outstanding militants, Leila Khaled, were followed by the Dawson Field hijack, forcing her release. (pp. 290-1)

This kind of detail brooks no disagreement, since everything is already known and known to fit.

I confess, by the way, that writing this essay is partly a settling of accounts. Reviewing references to *PTC*, I have become aware how many people have linked my account of the 'new racism' with Hall et al.'s subsequent notion of Thatcherism as an ideological project. (See for example Charles Husbands's closing essay, 'British Racisms: the Construction or Racial Ideologies', to the second edition of his *'Race' in Britain: Continuity and Change*, London: Hutchinson 1987, pp. 319–31.) It is not difficult to understand why, since both seem to be concerned with the emergence of a new, structured, and hence more powerful ideology of conservatism. For all the apparent similarities, I hope to suggest a fundamental divergence.

3 William Crofts, *Coercion or Persuasion?: Propaganda in Britain after 1945*, London: Routledge 1989.

4 See, for example, David Coates, *The Labour Party and the Struggle for Socialism*, Cambridge: Cambridge University Press 1975, esp. chs. 3–4.

5 The same problem is evident in their discussion of the battle against the Industrial Relations Act, opposition to which is understood entirely in terms of the 'unmasking of the true relationship between law and capital'. Again, there is no discussion of the way, temporarily, the bureaucratic interests of trade union leaders in shielding their Unions from legal interference coincided with a rising politicisation of many of their members. See pp. 303–4. Once again, on its own, it might not matter much. But it is a persistent ideologising of everything, and loss of political/organisational issues.

6 Stuart Hall, 'Encoding and Decoding in the Television Discourse', *Occasional Paper, Centre for Contemporary Cultural Studies* no. 7, 1973; reprinted in CCCS, *Culture, Media, Language*, London: Hutchinson 1987.

7 David Morley, '*The Nationwide Audience*: a Critical Postscript', *Screen Education*, no. 39 (1981), pp. 3–14.

8 Justin Wren-Lewis, 'The Encoding/decoding Model: Criticisms and Redevelopments for Research on Decoding', *Media, Culture and Society*, vol. 5 (1983), pp. 179–97.

9 Thomas Streeter, 'An Alternative Approach to Television Research: Developments in British Cultural Studies at Birmingham', in W. Rowland and B. Watkin (eds), *Interpreting Television: Current Research Perspectives*, London: Sage 1984, pp. 74–97.

10 Paddy Scannell and David Cardiff, *A Social History of Broadcasting: Vol. 1*, Oxford: Basil Blackwell 1991. See for example their discussion of the meanings of 'public service' broadcasting, and of the ways broadcasters themselves argued over these.

11 Richard Hoggart, *The Uses of Literacy*, Harmondsworth: Penguin 1957.

12 See for example Colin Seymour-Ure's detailed account of Powell's use of the mass media, bypassing Conservative Central Office and thus embarrassing it, just days before the Second Reading Debate on the Race Relations Bill. C. Seymour-Ure, *The Political Effects of the Mass Media*, London: Sage 1974, see ch. 4.

13 See on this my *The New Racism*, p. 37.

14 See in particular Errol Lawrence, 'Just Plain Commonsense: the "Roots" of Racism', *The Empire Strikes Back*, London: Hutchinson 1982, pp. 47–94. There, Lawrence takes me to task for suggesting that Powellism might have a theory underlying it, counterposing Hall et al.'s view that 'common sense' must be seen as a sediment of fragments, without coherence; and that it is their very sedimentation that 'naturalises' them and fools people into accepting what goes against their interests.

I have to say that this stipulative definition, by fiat, must come up against tests of empirical evidence. The work of Abercrombie and Turner, among others, has thrown severe doubt on any notion that working-class people have *accepted* dominant ideas, even if they may (quite differently) have *accepted them as dominant*. Robert Miles and Annie Phizacklea directly tested some of these ideas in their essay, 'Working-class Racist Beliefs in the Inner City', in R. Miles and A. Phizacklea (eds), *Racism and Political Action* (London: Routledge 1979, pp. 93–123). They found working-class racism to be very complicated, and to be derived more from personal experience of housing and job competition than from any learnt (for example post-Imperialist) conceptions of races.

For an interesting critique of this concept of 'common-sense racism' from another angle altogether, see John Brewer, 'Competing Understandings of Commonsense Understanding: a Brief Comment on "Commonsense Racism" ', *British Journal of Sociology*, vol. 35, no. 1 (1984), pp. 66–74. Coming from an ethnomethodological background, Brewer highlights in particular the issue of the commonness of 'common sense'.

15 There are two key quotations in Gramsci which point us in this direction. In the first, Gramsci is arguing against the view that ideology is essentially a form of self-deception:

Self-deception can be an adequate explanation of a few individuals taken separately, or even for groups of a certain size, but is not adequate when the contrast occurs in the life of great masses. In these cases the contrast between thought and action cannot but be the expression of profounder contrasts of a social historical order. It signifies that the social group in

question may indeed have its own conception of the world, even if only embryonic and in flashes – when, that is, the group is acting as an organic totality. But this same group has, for reasons of submission and intellectual subordination, adopted a conception of the world which is not its own but is borrowed from another group; and it affirms this conception verbally and believes itself to be following it, because this is the conception which in it follows 'in normal times'. (Antonio Gramsci, *The Prison Notebooks*, London: Lawrence & Wishart 1971, p. 327)

The key question in this is evidently how far a group has become its own agent, has shaped itself in and through an appropriate self-conception. That this is seen symptomatically can be seen from the also-frequently-quoted Notes which precede it:

Note 1: In acquiring one's conception of the world, one always belongs to a particular grouping which is that of all the social elements which share the same mode of thinking and acting When one's conception of the world is not critical and coherent but disjointed and episodic, one belongs simultaneously to a multiplicity of mass human groups. The Personality is strangely disjointed; it contains Stone Age elements and principles of a more advanced science, prejudices from all past phases of history at the local level and intuitions of a future philosophy *Note 3*: If it is true that every language contains the elements of a conception of the world and of a culture, it would also be true that from anyone's language one can assess the greater or lesser complexity of his conception of the world. (ibid. pp. 324–5)

Essentially, Gramsci is offering common sense as an area for empirical investigation, not offering a finished theory of its nature. Hall et al.'s use of Gramsci is, as David Forgacs has noted, one conditioned by the political approaches emergent in Britain at the time (David Forgacs, 'Gramsci and Marxism in Britain', *New Left Review*, no. 176 (1989), pp. 70–90).

16 See among others Nicholas Abercrombie et al., *The Dominant Ideology Thesis*, London: Allen & Unwin 1980.

17 See John B. Thompson, *Ideology and Modern Culture*, Cambridge: Cambridge University Press 1990, esp. ch. 2.

18 The main debates are listed in the Further Reading. Hall's own key reply was 'Authoritarian Populism: a Reply', *New Left Review*, no. 151 (1985), pp. 115–24. There is also a very useful discussion of this issue in Ruth Levitas's introduction to her (edited) *The Ideology of the New Right*, Cambridge: Polity 1986.

19 See especially his *There Ain't No Black in the Union Jack*, London: Hutchinson 1987.

20 Barry Troyna, 'Differential Commitment to Ethnic Identity by Black Youths in Britain', *New Community*, vol. 7, no. 3 (1980), pp. 406–14; and George Gaskell and Patten Smith, 'Are Young Blacks Really Alienated?', *New Society*, 14 May 1981, pp. 260–1.

A student of mine, Jane Tyrer, also pointed out to me the worrying implication in Gilroy's work that black people moving out of the St Pauls area in Bristol must thereby have become culturally 'homeless' – because they became disconnected from the 'culture of resistance' there. Appar-

ently no other kinds of cultural belonging can be 'valued' the same as an ethnically-based one.

21 Thomas Cottle, *Black Testimony*, London: Wildwood House 1978, p. 53.

22 There is an echo here of the argument over a 'slave mentality', begun by Stanley Elkins's rather speculative *Slavery* (Chicago: University of Chicago Press 1959). challenged in detail by Eugene Genovese, *Roll, Jordan, Roll: the World the Slaves Made* (London: André Deutsch 1975), but met with a touch of venom by CCCS and *Race and Class* reviewers, notably when some of its theses were carried into Kenneth Pryce's *Endless Pressure* (Bristol: Bristol Classical Press 1986).

23 This I take to be part also of the meaning of John Solomos's complaint, that the Centre's work on race is surprisingly short on engagement with the political economy of black people in Britain. See John Solomos, 'Varieties of Marxist Conceptions of "Race", Class and the State: a Critical Analysis', in John Rex and David Mason (eds), *Theories of Race and Ethnic Relations*, Cambridge: Cambridge University Press 1986, pp. 84–109.

FURTHER READING

The obvious direct developments, or applications of the theses, of *Policing the Crisis* are:

In the field of 'race':

CCCS, *The Empire Strikes Back*, London: Hutchinson 1982.

Gilroy, Paul, 'You Can't Fool the Youths', *Race & Class*, vol. 28, nos. 2/3 (1981/2); and *There Ain't No Black in the Union Jack*, London: Hutchinson 1987.

In the field of 'ideology'-theory and -politics:

Hall, Stuart and Martin Jacques (eds), *The Politics of Thatcherism*, London: Lawrence & Wishart 1983.

Hall, Stuart and Martin Jacques (eds), *New Times: the Changing Face of Politics in the 1990s*, London: Lawrence & Wishart 1989.

This is not intended to suggest that any of the above would see their work as straightforwardly extending *PTC*, nor that they would be wholly uncritical of it – only that in important ways they have followed its trajectory.

For the dispute about 'authoritarian populism', see in particular:

Jessop, B. et al., 'Authoritarian Populism, Two Nations and Thatcherism', *New Left Review*, no. 147 (1984), pp. 32–60.

Hall, Stuart, 'Authoritarian Populism: a Reply', *New Left Review*, no. 151 (1985), pp. 115–24.

Jessop, B. et al., 'Thatcherism and the Politics of Hegemony: a Reply to Stuart Hall', *New Left Review*, no. 153 (1985), pp. 87–101.

For a very useful history of British adoptions of Gramsci (although disappointingly it does not look at the understandings of 'common sense'):

Forgacs, David, 'Gramsci and the British Left', *New Left Review*, no. 176 (1989), pp. 70–90.

For a thoughtful discussion of recent Marxist thinking about 'race', which covers the CCCS approach:

John Solomos, 'Varieties of Marxist Conceptions of "Race", Class and the State: a Critical Analysis', in John Rex and David Mason (eds), *Theories of Race and Ethnic Relations*, Cambridge: Cambridge University Press 1986, pp. 84–109.

Chapter 6

Dick Hebdige, *Subculture: The Meaning of Style*

Anne Beezer

In October 1988, David Holbrook wrote in the *Guardian* about his reactions to seeing a postcard depicting two punks 'leering at me . . . making an obscene gesture'. Holbrook was in no doubt the image represented 'a powerful tide of moral inversion . . . expressing a playful contempt for established values and meanings (which were) beginning to threaten society'.[1] More than a decade after the original appearance of punks on to the streets of Britain, the iconography of punk style can elicit a shock/horror response, as if style itself could signal the breakdown of western civilisation.[2]

It is this subversive power of punk style which fascinates Dick Hebdige, and which he sets out to interpret in *Subculture: The Meaning of Style*.[3] First published in 1979, the book has been reissued annually since then, a fact which testifies to its theoretical and political significance within studies of youth subcultures. In fact, *Subculture* can be seen as a signpost to some of the central approaches that have been used in cultural studies to come to political terms with the emergence of post-war 'spectacular' youth subcultures. Like its street counterpart, Dick Hebdige's book points in two directions: 'backwards' towards a theorisation of youth subcultures developed at the Centre for Contemporary Cultural Studies during the 1970s, which stressed the continued significance of social class as the basic structural framework shaping the political importance of subcultural groups; and 'forwards' to theories of discourse, increasingly influential in literary and cultural studies during the 1980s, which sought to understand cultural meanings as forms of language which possessed their own internal logic.[4]

The first sustained research into post-war youth subcultures from a cultural studies perspective was undertaken by the staff and postgraduate students of the CCCS, based at Birmingham University. This research was published as a series of Working Papers collected

together and given thematic unity by the title *Resistance Through Rituals*.[5] This body of work challenged the view that post-war 'affluence' had given rise to classless 'teenagers', a new social grouping defined by age and leisure pursuits. While acknowledging that important changes had occurred in post-war Britain, and that living standards of working-class people had improved, the authors of *Resistance Through Rituals* insist that during this period 'what comes through most strongly is that stubborn refusal of class – that tired, "worn-out" category – to disappear as a major dimension and dynamic of the social structure'.[6]

Drawing on the theories of Antonio Gramsci, the book located youth subcultures within the crosscutting parameters of class and generation, suggesting that youth subcultures constituted a response by working-class youth, expressed predominantly through ritual and style, both to the 'hegemonic culture' and to the working-class parent culture. The styles of working-class youth cultures – their forms of dress, group identities and territorial loyalties – represent ways of 'winning cultural space' from the hegemonic institutions that impact on working-class life. In doing this, youth draw on but adapt the traditions of resistance developed in the working-class parent culture. Where once that culture had negotiated the communal space of the neighbourhood as a means of asserting informal control in the face of agencies of public control, now working-class subcultures represent a reassertion of community in the face of its actual destruction brought about by economic change and housing 'development' schemes.[7] However, the authors of *Resistance* add that this reassertion of community is symbolic, only a 'ritual' resistance to the values of the dominant culture rather than an explicit form of political opposition. The addition of this caveat gives their use of the term 'hegemony' an Althusserian inflection, since the spaces 'won' or 'negotiated' are at the level of ideology, represent-ing an 'imaginary' relation between working-class youth and their conditions of existence.

'Structure' becomes a key term linking *Resistance Through Rituals* and Hebdige's book. Working-class youth live within an ideological structure which works behind their backs, and which they challenge only symbolically. Ideas of agency and intention are marginalised as explanations are sought to account for the pre-given dominance of hegemonic forces within society. It is through expressive styles that subcultures express their resistance, although Tony Jefferson acknowledged that since 'there is, as yet, no "grammar" for decoding cultural symbols like dress', the meaning of the stylistic innovations of

subcultures such as the Teds could not be interpreted with any degree of certitude.[8]

It is this aspect of youth subcultures which Hebdige addresses in *Subculture*. His theoretical project is to begin the work of building a 'grammar' which can decode 'the hidden messages inscribed on the glossy surfaces of style' (p. 18). The conceptual framework Hebdige draws on in order to accomplish this is semiology, the science of signs first postulated by Ferdinand de Saussure, and subsequently developed by Roland Barthes. Like Barthes's *Mythologies*, *Subculture* is a dazzling book. Semiology and post-structuralist theories of signification are woven together with quotations from Jean Genet's writing and excerpts from art historical discourse in a complex and often elliptical account of subcultural style. To extend semiological methods to an analysis of post-war youth subcultures is an act of breathtaking imagination, and the brilliance of the results can be blinding. To unpick this closely textured analysis is an altogether more pedestrian, albeit necessary, act of criticism. It must also be done in stages.

THE SEMIOLOGICAL FRAMEWORK

The main components of Saussure's structural linguistics have been described in innumerable texts, and need not be rehearsed here.[9] More relevant are the problems it poses both as a theorisation of linguistic activity, and as the basis for an account of non-linguistic forms of signification. As an approach to understanding language, Saussure's distinction between *langue* and *parole* renders the activity of speech entirely subservient to, and determined by, the structure of language. According to Saussure's foremost critic, Valentin Vološinov, it is a conception of language which construes it as an inert and alien thing rather than one of the most important means by which human beings engage in social relations. By contrast, Vološinov offers an understanding of language as dialogic, as socially purposive verbal interaction.[10] The Saussurian legacy inherited by semiology has involved a theoretical (and, ultimately, political) turning away from any dialogic and processual conception of language towards a view of language as a system which has its own rules and obeys its own immanent logic.

The other significant element of Saussure's linguistic theory that has influenced subsequent semiologies is the insistence that language is an arbitrary system of differences. As Jonathan Culler points out, this is the core of Saussure's structural linguistics.[11] Both signifier and signified are arbitrary divisions of, respectively, a continuum of sound

and a conceptual field. Concepts are thus purely relational, defined only by their difference from other concepts within a system which can only be conceived in abstract and formal terms. The effect of conflating the unproblematic arbitrariness of the relation between signifier and signified with the much more contentious claim that conceptual distinctions are also arbitrary is to view language as a classificatory system which is disconnected from the social and political uses of language. Meanings are system products, unresponsive to human intervention and social contestation. Again, this conception of meaning can be contrasted with that offered by Vološinov, who insists that speech rather than language is the basis of language, and that the linguistic sign is a two-sided act in which both speaker and recipient engage. It is the siting of speech within social relations which enables Vološinov to make the further argument that language is characterised by a struggle over the sign, since the outcome of this social relationship conducted through language is not determined but a matter of social contestation. For Saussure, language gained its coherence and unity at the level of form rather than substance, and it was this reduction of language to a formal signifying system that provided the theoretical basis for him to postulate a more general science of signs which would be able to illuminate other forms of signification.

As Hebdige notes, Barthes's application of structural linguistics to other cultural forms, such as food, fashion and advertising images, 'opened up completely new possibilities for contemporary cultural studies' (p. 10). Barthes's semiology welded together Saussurean linguistics and a Marxist conception of ideology as a means of decoding the 'anonymous ideology' which suffused bourgeois democracies. In Barthesian semiology, Saussure's language system has become an 'anonymous ideology' or 'structure of myths' which effaces its own activity of constructing meanings, passing off these meanings as 'natural', and thus converting 'culture' into 'nature'.

This 'anonymous ideology' is the system whose codes and conventions the semiotician seeks to uncover. Hebdige links Barthes's conception of ideology as 'anonymous' to the more systematic theorisation of ideology developed by Louis Althusser. The point of connection is that both conceive ideology as a 'structure', an organised and interrelated system which operates 'behind people's backs', defining their place within the system, and giving that system the appearance of naturalness or common sense. To a significant extent, the concept of ideology that Althusser and Barthes share is one which suggests that people do not so much 'have' ideologies as 'live' them. And one of the most important

ways in which they do this is through their participation in the world of cultural signs.

There are a number of problems posed by semiology as a method of analysing the political and social significance of cultural signs. The conception on which it is based, of ideology as all-encompassing and anonymous, makes it difficult to account for opposition and change. A further difficulty is the identification of the system and the elements or signs which it comprises. Whereas Saussure had treated the system of language as coextensive with natural languages, there are no such obvious limits to other forms of cultural meaning. If we turn to the example of dress or fashion, there is no obvious equivalent of a 'natural language' given the limitless variety of styles that have existed historically and continue to be created. Furthermore, how do we distinguish one cultural sign from another, and how do we determine the significance of any such differences we may find? Hebdige confronts all of these difficulties in his reading of subcultural style, and in doing so reveals the interpretative strengths of semiology as well as its limits.

Hebdige sees the various post-war youth subcultures as 'natural' or practical semiologists. In contrast to a theoretical semiology, which seeks to discover the codes and conventions governing the construction of cultural meanings through intellectual means, Hebdige argues that subcultural groups enact a disruption of dominant codes of meaning through their adoption of distinctive styles. It is the punks more than any of the other post-war spectacular subcultures that exemplify this practical semiological activity. Hebdige returns to examine their stylistic subversions throughout *Subculture*, and they represent a limit case or means of testing the adequacy of both the approach to subcultures adopted by the authors of *Resistance* and by semiology. It is a reading of the 'excesses' and 'contradictions' characterising punk style which leads Hebdige to read subcultural youth groups 'against the grain' for the less obvious but no less significant connections that exist between white subcultures and black youth. This previously hidden history of white subcultural groups was brought to the surface with the punks, enabling Hebdige to read back from the surface signs of that subculture the 'deep structural' links that connect white and black youth subcultures.

RACE AND SUBCULTURE: A 'PHANTOM HISTORY'

In order to uncover this hidden history of the relations between black and white youth, Hebdige does not turn to sociologies of race relations, to a history of state policies on immigration or to social-psychological accounts of racial attitudes and prejudice. Consistent with the theoretical premises of semiology, Hebdige infers a system of black/white relations from a reading of the surface signs of subcultural style and activity. This system, whether consciously perceived by the subcultures themselves or operating as a structure of relations beneath consciousness, shapes the meanings circulating around white subcultural groups. In fact Hebdige emphasises the latter by referring to this structure as a 'phantom history' in which a process of 'musical miscegenation' between black and white musical forms occurs. Hebdige provides an account of the contradictory and subterranean conversation, conducted through music and style, which brought black and white subcultures into 'symbolic dialogue'. Hebdige cites the Teddy Boys as one subcultural group whose musical preference for rock music, a music ultimately derived from black musical traditions, placed them in symbolic dialogue with the black presence in Britain, even where their overt political commitments led them to oppose black youth and black immigration to Britain. Where there was a conscious turning towards black music such as ska, blues or reggae by first the mods and later the skinheads, it is not at this conscious level that Hebdige interprets the relations between white and black youths. Rather, he argues that the relationship is a formal one operating at the level of the 'dialectical interplay of black and white "languages" ' (p. 57).

In the case of the punks, however, the dialogue between black and white youth took an explicit form, as evidenced by the support that many punks gave to the Rock against Racism campaign. Punks danced to reggae music, emulated the styles of black youth, and saw themselves, like black youth, as outcasts from dominant British culture. Hebdige suggests that 'the punk aesthetic can be read in part as a white "translation" of black "ethnicity" ' (p. 64). While some punk bands, such as The Clash, fused elements of punk and reggae to create the musical hybrid of punk dub, punk and reggae forms generally remained separate, even 'audibly opposed'. Hebdige sees this as a wilful segregation that concealed a more profound identity. Drawing on a concept derived from structuralist readings of literary texts, Hebdige argues that 'punk includes reggae as a "present absence" – a black hole around which punk composes itself ' (p. 68). Punk music's rhythms did

not merely differ from those of reggae; they embodied a kind of 'immanent' recognition of their relation of difference to reggae. Hebdige sees the relationship of punk and black youth culture as symptomatic of all white, post-war subcultures. Black immigrant culture and black musical forms constitute the 'hidden history' of white youth subcultures, infusing them with a vigour and rebelliousness that have been appropriated as style, even where, as with the Teds and later the skinheads, overt political identification has been refused or rejected.

In recomposing white youth subcultures within a history of black/white relations, *Subculture* partially corrected the over-emphasis of previous subcultural studies on white, male working-class youth. It also drew attention to what was then a neglected area of study, namely the ways in which subcultural identities are formed in relation to sites of pleasure, such as music, as well as being mediated responses to social class. However and paradoxically, the structural history of post-war subcultures that Hebdige constructs is 'synchronic'. Black culture and black music constitute a sign within a system of subcultural relations whose limits are read from a decoding of surface forms. But this reading did not reveal gender as a sign within the structure of subcultural relations. In her thoughtful assessment of subcultural theory, Angela McRobbie points to the absence of any sustained attention to the role that girls have in subcultures, or to ways in which girls are marginalised from many subcultural interests and pursuits.[12] It is difficult to see how a reading of surface forms could distinguish between girls as a 'significant' or 'present absence' from the system of subcultural relations, and girls as merely an irrelevance, a group which is simply beyond the boundaries of the system.

Two comments are relevant here. The more visible presence of girls in the punk culture suggests that the history of subcultural formation is more usefully conceived as an emergent one in which new elements appear. The condition for the emergence of these elements may or may not be reflected in the surface forms of subcultural style, and cannot therefore be deduced from them. McRobbie makes a valuable point when she argues 'that rock does not signify alone, as pure sound. The music has to be placed within the discourses through which it is mediated to its audience and within which its meanings are articulated'.[13] In arguing thus, McRobbie reintroduces questions of both production and consumption into the subcultural analysis. We need to know who is speaking to whom, and therefore to use an

approach which considers subcultures as ways of speaking, but does not know in advance the limits of what they can say.

If a structural history of subcultural formation does not provide a theoretical framework within which we can gain an adequate under- standing of the significance of emergent groups, such as girls, in subcultural activity, it also slides over the question of the political impact of those groups (elements within the system) which it has identified. This, then, is the second difficulty which arises from reading black/white youth relations as a 'dialectical interplay of languages'. Simon Jones articulates this difficulty with admirable clarity. He maintains that 'the history of white youth's engagement with black culture cannot be reduced to a succession of stylistic responses. These relations have a substantive and not just a "phantom" history'.[14] Jones's approach is to study actual encounters between black and white youth, framing this in an historical account of the variable impact black culture has had on the structures and institutions of British society. His account of the nature of punk involvement with race issues details some of the contradictions embodied in such encounters.

> Punk's attempt to express an affinity with Rasta and reggae culture by subverting the symbols of nationalism (for example in the Sex Pistols' iconoclastic use of the Union Jack and the Queen's figure- head) and by drawing parallels between the experience of racism and the dispossessed whites in song like 'White Riot', all contained ambiguities which were susceptible to fascist manipulation. Such contradictions were unsurprising given that punk was born out of the same social and economic crisis that had produced the rise in nationalist right-wing activity. For the same powerlessness, desire to shock and sense of anger at official smugness expressed by punk's more working-class constituency, were precisely the same motives and feelings which steered jobless and powerless young whites towards organised racism.[15]

Here, punk is placed not in structures of language but in a history of the contradictory social relations that have given rise to 'race' as a political category capable of mobilising ideas of black identity and white reaction to this. As Jones's ethnographically-based study of Birm- ingham youth suggests, within this broader political and social context, the extent to which white youth associate themselves with and appropriate black cultural forms will depend on 'contingent' factors such as geographical location and the nature of local cultural provision in the form of clubs and discos. 'Style' may be an outward expression of

these complex determinants, but it cannot of itself reveal them; nor is it a reliable indicator of their effects.

SUBCULTURAL FORM AND FORMATION

In his account of the punks, Hebdige questions those arguments which see subcultural activity as an expression of the alienation experienced by working-class youth. The view that subcultures arise as ways of dealing with generation-specific class experience does not take into account the fact that experience is not a 'raw' category but is always mediated through systems of representation such as the mass media. Media representations provide the ideological framework within which subcultures can represent themselves, shaping as well as limiting what they can say. The interrelation between the 'language' of the dominant society and the 'speech' of subcultures is particularly evident in the case of the punks. Hebdige claims that the punks did not so much express the alienation they felt from mainstream society as dramatise contemporary media and political discourse about 'Britain's decline'. The punks appropriated a rhetoric of crisis by enacting that crisis in symbolic form.

The stylistic 'excesses' of the punks amounted, according to Hebdige, to a form of 'semantic disorder' which subverted momentarily the codes and conventions which govern established orders of meaning. Since our sense of social order is so closely bound up with conformity to the rules of language, and to the symbolic order generally, challenges to the latter are perceived to be subversions of the former. Thus the 'semantic disorder' represented in punk transgressions of taken-for-granted codes of dress, behaviour, musical and dance forms initiated a 'moral panic', orchestrated by the mass media, which condemned the 'unnatural' and 'animal' behaviour of the punks. This kind of media response reveals the politically subversive potential of subcultural style, for in challenging the established orders of meaning, the punks were inevitably perceived to constitute a threat to the social order itself.

However, Hebdige maintains that the punks and other subcultural groups represent only momentary subversions of social order, since stylistic innovation is inevitably incorporated back within established orders of meaning: the 'semantic disorder' of subcultural style becomes part of a new symbolic order as it is returned to 'semantic sense'. The history of subcultures is, then, a cyclical history in which subversion is followed by incorporation. This process of incorporation takes two

main forms, the ideological and the commodity form, and Hebdige uses the punk movement to illustrate both of these processes. Scanning press reaction to the punks, he points to the way the initial press reactions of shock and horror were soon followed by articles which focused on the 'ordinary family life' of punks. Punks were discovered to be like the rest of society, mothers, sisters, sons who just happened to be punks. Concurrently, the subversive style of the punks became a new fashion as record and fashion industries 'commodified' punk music and punk style. Hebdige concludes from this that 'youth subcultural styles may begin by issuing symbolic challenges, but they must inevitably end by establishing new sets of conventions; by creating new commodities, new industries and rejuvenating old ones' (p. 96).

In Hebdige's account of the history of subcultures, a series of key conceptual oppositions emerges: the 'semantic disorder' of subcultural style is defined against the symbolic order issuing from the 'anonymous ideology' pervading mainstream society; the moment of subcultural innovation is contrasted with its later ideological incorporation; and subcultural subversion is seen as a momentary break in a social and symbolic order characterised by consensus and conformity. In sum, street-originating subcultural styles end up in the high street as marketable and mainstream fashions. The punk bin liner and safety pins, once icons of rebellion, are reduced to decorative innovations which rejuvenate the flagging fashion industry.

Simon Frith's account of the relations between youth and rock suggests that Hebdige's version of subcultural history is, paradoxically, too romanticised and overly pessimistic.[16] Frith focuses not on the form of subcultures but on their formation, and on the relations between formation and form. For example, he argues that there are important distinctions to be made within subcultures, between those who are committed to subcultural identity and those who have only a temporary and transient association with it. The leaders of subcultural stylistic innovation set themselves apart from followers and have a strong sense of their exclusive identity. They use subcultural style in significantly different ways from those who have a transient relationship to it. This differential commitment to subcultural style can in turn be mapped on to social differences. An instance of this is the mod cult which 'began in the early 1960s with the "modernists", a few petit-bourgeois kids, clothes-conscious children of Jewish rag-trade families, who met up with a few street-culture drop-outs – semi-beatniks – in the coffee-houses of London's Soho'.[17] Contemporary observers also noted the way these early mods were among the first to adopt the style and attitudes

later described as 'hippie'. Frith argues that commitment to subcultural identity is more usually a suburban rather than an urban phenomenon, the route that bohemian drop-outs from the middle-class success ethic and the working-class work ethic take in rejecting the way of life their class backgrounds presuppose. If this is the case, it becomes difficult to read 'mod' and 'hippie' as formally opposed terms (or signs) within an overall system of cultural meaning. The use of subcultural style and commitment to subcultural identity are more socially significant than the 'meanings' of style, which appear to be fluid and interchangeable.

In *Art into Pop*, Frith traces the links between art school education and involvement in pop and rock music.[18] The origins of punk, he argues, lies in this art school/rock music nexus, since 'punk rock was the ultimate art school music movement'.[19] It was this art school background which encouraged students to bring avant-garde ideas absorbed from art historical discourse to bear on fashion and music styles.[20] With punk, commercialism and subversion became not opposed terms but the (politically unstable) site where these inherited oppositions were interrogated. Self-conscious users of imagery and style, such as Malcolm Mclaren and Vivienne Westwood, played with ideas of commercial consumption through gestures which were intended to draw attention to style as production. As Frith notes, for these stylistic leaders 'punk was no longer a problem (to be explained by sociologists and leader writers) but a solution, a solution to the continuing Romantic dilemma – how to be subversive in a culture of commodities'.[21] Placed within the wider context of record and art industries, however, these gestures, Frith claims, are not so much co-opted but incoherent since 'this argument was indistinguishable from that of advertising – the joy of consumption defined in terms of the "value" of the commodity (and vice versa)'.[22]

If, for the leaders of the punk movement, 'creative consumption' was an inherently unstable ideology since ironic attitudes to the market are in the end difficult to distinguish from any other kind of attitude, the use of music by fans is equally unstable. As Frith notes, music, so often the focus of subcultural identity, isn't simply a commodity: it is a leisure commodity. As such, it is how music is used, and why it is used, that become important. The industrialisation of music, and the movement of music from a folk to a mass context, has undoubtedly changed the relationship between performers and fans, as well as multiplying the uses music can have. It can be used to dance to; it can be a background to other activities; and it can be the focus around which cultural and subcultural identities are formed. But in all these contexts

of use, which cannot be easily mapped on to some scale of com-modification, music signals an alternative set of values to those associated with the world of work. Although the culture industries may seek to define and contain the uses made of music, these can never be completely controlled, and the meanings attributed to music never fully determined. A view of subcultures as a movement from subver-sion to incorporation is a romantic story with a tragic ending. When the use of music, particularly its subcultural use, is considered, any narrative of its history must inevitably be more inconclusive and open-ended. As Frith suggests, it is an account of a struggle, 'the struggle for fun'.[23]

READING STYLE

In the final chapters of *Subculture*, Hebdige addresses the central question posed by a semiotic approach to subcultural style: what meanings are communicated through style both to members of a subculture and to the rest of society? To account for the generally subversive nature of subcultural style, Hebdige mobilises the structur-alist distinction between 'open' and 'closed' texts, arguing that subcultural style is a 'loaded choice' which displays the codes that organise its meanings, in contrast to the 'closed texts' of mainstream styles where such codes are effaced and naturalised. The stark division posited by 'classic structuralisms' between the 'closed' texts of main-stream culture and the 'open' texts of radical avant-garde culture has now been subject to criticism from a range of perspectives, including those which remain within a broadly structuralist problematic as well as those which challenge it.[24] Both readers and texts remain, within this structuralist perspective, unlocated socially and historically; and it has now been recognised that readers of all kinds of texts bring to them a range of cultural competences, such that even the most seemingly 'closed' text offers 'negotiated' rather than 'fixed' meanings.[25]

The difficulties posed by Hebdige's reading of subcultural style connect with these debates, but also go beyond them. For all that the reading of literary or film texts raises theoretical problems of defini-tion and interpretation – what are the boundaries of texts given their placing in a system of intertextual relations? how do the meanings they construct relate to their various audiences? – they remain forms of produced culture. Subcultural style by contrast is in a constant state of production, and is thus a cultural process rather than a text. The significance of this is that the primary identification of subcultures by a

reading of the surface forms of their style may be misleading. Hebdige argues that 'the communication of significant *difference* [his emphasis], then . . . is the "point" behind the style of all spectacular subcultures. It is this superordinate term under which all other significations are marshalled, the message through which all other messages speak' (p. 102). Without this surface difference, subcultures slip from view, to the point where their existence can be thrown into question.[26] Furthermore, where one subcultural style transmutes into another form, as in Frith's example of the early modernists who later became hippies, surface differences of style may lead to an over-reading of subcultural differences. In this case, stylistic difference effaced continuities and similarities in what was basically a bohemian subculture adapting to new concerns and circumstances.

The theoretical problems of a semiotic reading of subcultural style are posed most graphically by punk style. The punks pushed to extremes the stylistic practices of other subcultural groups, and their anarchic reordering of dress, music and dance forms 'signified chaos at every level' (p. 113). In John Clarke's reading of skinhead style, he had drawn on Lévi-Strauss's concept of 'homology' to show how the skinheads' boots, braces and cropped hair expressed at a formal level the 'hardness, masculinity and working-classness' which characterised the subculture's situation and experience.[27] Hebdige also detects homologies between the punks' styles of spiky hair, pogo dancing and frantic, unmelodic music, and their concern to challenge and defy the symbolic order of mainstream society. But the further step of reading 'punk music as the "sound of the Westway", or the pogo as the "high-rise leap" ' is more problematic (p. 115). The semantic units of punk style, such as the bin liner and safety pin, defy the kind of homological reading that Clarke provides for the skinheads. Although punk style signifies, the elements or signs comprising its system of meaning cannot be decoded at an individual level. What, for example, were the punks signifying when they wore swastikas emblazoned on their clothes and bodies?

The signs of punk style resist the act of semiotic translation, presenting only a blankness and absence of meaning to the theorist. It is for this reason that Hebdige turns to post-structuralist theories of disourse, and in particular to Julia Kristeva's concept of 'signifying practice'. The importance of Julia Kristeva's work for a reading of punk style lies in her interpretation of the 'semiotic' as a pre-Oedipal force or 'pulsion' which breaks through the rigid classifications and orderings of organised language, thereby revealing as well as undermi-

ning its structure. Some writing, such as that of the French symbolist poets, exhibits this disruptive activity of the 'semiotic' more than others, according to Kristeva. In doing so, such writing draws attention to its own 'signifying practice', a process which, as Eagleton notes, questions and transgresses the limits of conventional systems of signs.[28] Herein lies its radicalism and, at least for Hebdige, its relevance for a reading of punk style, for the radicalism of punk derives not from its construction of an alternative system of meanings but from its questioning of the meaning process itself. Punk style amounted to a refusal of meaning, a blankness which resists any complete and final decoding.

Subculture, as Angela McRobbie has remarked, ends on a note of political pessimism.[29] The radicalism of the punks is a momentary gestural politics which is quickly absorbed back into the 'anonymous ideology' which manages these contradictions and subversions; and the semiotician is condemned to only a 'theoretical sociality' with the subcultural stylists that are studied. Hebdige reaffirms the insuperable fact of distance that divides the 'texts' of the subcultures themselves and the reading of them that he provides. This distance is, in part, premised on the original Saussurean distinction between *langue* and *parole*, which subsequent structuralisms have modified rather than eliminated. For example, a reading of punks in Kristevan terms as a 'semiotic' disordering of the meaning process tells us little about the material and social conditions which gave rise to punk; and it does not provide a theoretical framework which we can use to understand the social relations the punks hoped to create (even if they failed) through their stylistic innovations. In sum, it retains the formalist emphasis of 'high structuralism' which excludes an approach to cultural signs which sees them not as bits of language which carve out meanings but, as Vološinov proposed, as forms of dialogue which embody orientations to other social groups within society.

Recent historical research into subcultural styles, particularly black styles such as the 'zoot suit', reveals that the adoption of spectacular forms of dress, as a way of proclaiming cultural identity, is far from being a post-war phenomenon.[30] What this research also reveals is that the adoption of subcultural identity, whether through the visible signs of dress and use of patois or by the less visible commitments to specialist activities and interests, is a way of asserting cultural identity and a sense of exclusive community in the face of a society fragmented by divisions of class, race and gender.[31] It is often in the interstices of these social divisions that subcultures take their most visible form and exert their most exacting loyalties. The petit-bourgeois Jewish kids

who proclaimed their modernism, the bohemian drop-outs from the middle-class success ethic, the art school romantics seeking ways of articulating ideas of creativity within a world dominated by commodities, and the hip, zoot-suited young black laying claim to the streets are all examples of this impulse.

Subcultures, it would seem, are not just ways of saying something; they are also the means by which oppressed or alienated groups do something. They take hold of the material conditions that they inherit, and out of them fashion cultural identities which, however temporary and fragile, confirm belonging in a world which is perceived to deny this. But the existence of subcultures, and the styles they adopt, cannot of themselves tell us anything about political identity. The skinhead asserting British identity in the face of the immigrant 'threat' is just as much an example of subcultural belonging as the punk who is involved in organised anti-racism. What a swastika means will depend on what it is used for, for its meanings derive from these contexts of use, which in turn arise out of the changing material conditions of existence which impinge on subcultural groups. It is these we must examine, as well as the dialogues initiated by subcultural groups, if we are to understand what is said and done through subcultural style.

Subculture: the Meaning of Style pushed to the limits and beyond a structuralist approach to subcultural analysis. Criticisms of its approach are only possible because Dick Hebdige revealed its interpretative strengths and honestly confronted its weaknesses. Despite Hebdige's own gloomy prognostication about the inevitable gulf that separates the intellectual from the practical semiotician, *Subculture* was reviewed in publications outside of the academic circuit, and has become part of the 'currency' which circulates in and among those proclaiming some form of subcultural identity.[32] The significance of its theoretical intervention into the study of subcultures is attested by the fact that it has not yet been superseded by any work of similar scope which challenges its structuralist perspective.

NOTES

1 *Guardian*, 1 October 1988.
2 Holbrook's tirade against these 'menacing greeting cards' is just a recent instance of his long-standing opposition to popular cultural forms, which are thrown into the problematic heap he describes as 'mass culture'. The Leavisite position this represents is given classical exposition in Denys Thompson (ed.), *Discrimination and Popular Culture*, Harmondsworth: Penguin 1973.

3 Dick Hebdige, *Subculture: The Meaning of Style*, Methuen New Accents Series, London: Routledge 1979.

4 The terms 'backwards' and 'forwards' are not intended to signal any sense of theoretical progression; they merely refer to the historical siting of these differing approaches to subcultural analysis.

5 Stuart Hall and Tony Jefferson (eds), *Resistance Through Rituals*, London: Hutchinson 1976.

6 John Clarke, Stuart Hall, Tony Jefferson and Brian Roberts, 'Subcultures, Cultures and Class', ibid., p. 25.

7 The authors of *Resistance Through Rituals* and Hebdige acknowledge their debts to Phil Cohen's classic study of the response made by youth to the material and social changes affecting Bethnal Green in East London. See Phil Cohen, 'Subcultural Conflict and Working Class Community', *Working Papers in Cultural Studies*, no. 2, CCCS, University of Birmingham 1972.

8 Tony Jefferson, 'Cultural Responses of the Teds', in *Resistance Through Rituals*, p. 86.

9 Jonathan Culler's exposition of Saussure's linguistics is still one of the clearest and most thorough available. See Jonathan Culler, *Saussure*, London: Fontana 1976.

10 Valentin Vološinov, *Marxism and the Philosophy of Language*, trans. Ladislav Matejka and I. R. Titunik, New York: Seminar Press 1973. For a lucid exposition and detailed assessment of Volosinov's approach to language, see Martin Barker, *Comics, Ideology, Power and the Critics*, Manchester: Manchester University Press 1989.

11 Jonathan Culler, op. cit., pp. 19–25.

12 Angela McRobbie, 'Settling Accounts with Subcultures: a Feminist Critique'. This article was originally published in *Screen Education*, no. 39 (spring 1980), but has been republished in Angela McRobbie, *Feminism and Youth Culture: From Jackie to Just Seventeen*, London: Macmillan 1990.

13 *Feminism and Youth Culture*, p. 28.

14 Simon Jones, *Black Culture, White Youth: the Reggae Tradition from JA to UK*, London: Macmillan 1988.

15 Ibid., p. 100.

16 Simon Frith, *Sound Effects: Youth, Leisure and the Politics of Rock 'n' Roll*, London: Constable 1983.

17 Ibid., p. 220.

18 Simon Frith and Howard Horne, *Art into Pop*, London: Methuen 1987.

19 Ibid., p. 124.

20 Frith and Horne argue that Malcolm McLaren and Jamie Reid (art students turned pop managers) saw the Sex Pistols as a work of art, and that the main theoretical influences these punk artists drew on were Andy Warhol and American Pop Art, and situationism as mediated by the French student movement of 1968.

21 *Art into Pop*, p. 133.

22 Ibid., p. 144.

23 *Sound Effects*, p. 272.

24 See T. Bennett and J. Woollacott, *Bond and Beyond: the Political Career of a Popular Hero*, London: Macmillan 1987 (reviewed in Chapter 3) for a critique of this division from a position broadly critical of structuralism, and J.

Henriques, W. Holloway, C. Venn and V. Walkerdine, *Changing The Subject: Psychology, Regulation and Subjectivity*, London: Methuen 1984 for a reformulation of text/reader relations from a post-structuralist perspective.

25 See Janice Radway, *Reading the Romance: Women, Patriarchy and Popular Literature*, London: Verso 1987 (reviewed in Chapter 9) and Helen Taylor, *Scarlett's Women: Gone with the Wind and its Female Fans*, London: Virago 1990. Feminists have been concerned to 'rescue' romance from its place in the 'mass culture' scrap-heap, and show it to be the contradictory site where women readers negotiate the pleasures they gain from reading romantic fiction.

26 This was the position taken by *Marxism Today* in their 'New Times' edition, where it was suggested that the Thatcherite 1980s had witnessed the transmutation of subcultural style into a more generalised 'style culture', a 'youth into yuppies' scenario which saw Thatcher's popular capitalism as converting everyone into affluent 'thirtysomethings'. *Marxism Today*, October 1988.

27 John Clarke, 'Style' in *Resistance Through Rituals*.

28 Terry Eagleton, *Literary Theory: an Introduction*, Oxford: Basil Blackwell 1983, particularly chs 4 and 5. For a discussion of Kristeva's work, see Toril Moi, *Sexual/Textual Politics: Feminist Literary Theory*, London: Methuen 1985.

29 Angela McRobbie, *Feminism and Youth Culture*, p. 30.

30 See Stuart Cosgrove, 'The Zoot-Suit and Style Warfare' in *History Workshop*, no. 18 (autumn 1984) and Steve Chibnall, 'Whistle and Zoot: the Changing Meaning of a Suit of Clothes', *History Workshop*, no. 20 (autumn 1985).

31 For an excellent account of the way the adoption of stylistic dress and mannerisms can proclaim identity and dignity in the face of social and political marginalisation, see Jerry White's discussion of lumpenproletariat youth living in Islington between the wars. Jerry White, *The Worst Street in North London, Cambell Bunk, Islington, Between the Wars*, London: Routledge (History Workshop Series) 1986.

32 The publisher's blurb on the back cover of the 1988 edition of *Subculture* quotes from (undated) reviews in the *Rolling Stone*, *Time Out* and *The New York Times*, and Angela McRobbie refers to a (undated) review appearing in the *New Musical Express*. Steve Redhead also points out that the magazine *Underground* 'had a keen sense of inherited youth discourses, playing on Dick Hebdige's work on subculture and style with a column entitled "Subculture: the style of meaning" '. See Steve Redhead, *The End-of-the-century Party: Youth and Pop towards 2000*, Manchester: Manchester University Press 1990. Hebdige has ironically acknowledged this postmodernist slippage of categories as his own work moves across these cultural divisions he had once thought unbridgeable. See Dick Hebdige, 'Making do with the "Nonetheless": In the Whacky World of Biff ', in *Hiding In The Light: On Images and Things*, London: Routledge (Comedia) 1988.

FURTHER READING

Chambers, Iain, *Urban Rhythms, Popular Music and Popular Culture*, London: Macmillan 1985.

Clarke, J., C. Critcher and R. Johnson (eds), *Working Class Culture: Studies in History and Theory*, London: Hutchinson 1979.

Frith, Simon, *Sound Effects: Youth, Leisure and the Politics of Rock*, London: Constable 1985.

Frith, Simon, *Music For Pleasure: Essays on the Sociology of Pop*, Cambridge: Polity 1988.

Frith, Simon, *World Music, Politics and Social Change*, Manchester: Manchester University Press 1989.

Frith, Simon and A. Goodwin, *On Record: Rock, Pop and the Written Word*, London: Routledge 1990.

Hall, S. and T. Jefferson (eds), *Resistance Through Rituals*, London: Hutchinson 1976.

Hebdige, D., *Hiding in the Light: On Images and Things*, London: Routledge (Comedia) 1988.

Jones, Simon, *Black Culture, White Youth: the Reggae Tradition from JA to UK*, London: Macmillan 1988.

McRobbie, Angela, *Feminism and Youth Culture: From Jackie to Just Seventeen*, London: Macmillan 1990.

Mungham, G. and G. Pearson (eds), *Working Class Youth Culture*, London: Routledge 1976.

Redhead, Steve, *The End-of-the-century Party: Youth and Pop towards 2000*, Manchester: Manchester University Press 1990.

Shepherd, John, *Music as Social Text*, Cambridge: Polity 1991.

Wilson, Elizabeth, *Adorned in Dreams*, London: Virago 1987.

Chapter 7

Tania Modleski, *Loving with a Vengeance: Mass-produced Fantasies for Women*

Kim Clancy

I

Loving with a Vengeance was published in Britain in 1984. A pioneering study, it brought together analyses of popular romantic fiction and soap opera in order 'to begin a feminist reading of women's reading'.[1] The text was first published in North America in 1982, and two of its chapters had previously appeared in US academic journals in 1980/1.[2] Modleski's work was thus ongoing and shared much in common with studies in Britain, theorising the relationship between popular texts and their readership.

I was not introduced to Modleski's study via an academic reading list or involvement in an educational course but through the enthusiasm of a friend who had come across a copy of the book in her local public library. She wrote me a long letter, full of quotations, urging me to go out and find a copy of the book for myself.

The memory of this introduction remains with me. It is a major strength of this study, and of Modleski's later work, that she avoids tendentious linguistic posturing, an unfortunate attribute associated with many academic studies of the 'popular'. She writes in a style which is relatively accessible to a 'lay' reader, while remaining theoretically rigorous, illuminating. The study obviously seeks to address an audience beyond that confined within the narrow boundaries of the academy, although it probably fails to reach most readers of romantic fiction themselves.

Am I a reader of popular romantic fiction? No. Nothing to do with a university education rooting out my working-class background and persuading me to 'better' myself, of course. Pleasurable memories of reading historical romances as a teenager (from which I learnt much more about 'history' than I ever did at school) remain with me. But it is

difficult to make the transition from a working-class culture to middle-class academia without shedding a few skins along the way.

My position is this. All women, whether readers of popular romances or not, are implicated in, positioned by, the derision which is poured upon these texts and their audiences. It is a 'feminine' pursuit. Until the late 1970s there seemed to be only two options available to women: either associate oneself with an objectionable practice, or denounce it, from whatever political position one chose to occupy. Modleski's study, and others that followed, enabled me to negotiate a third option, one which did not necessitate the naming of women who engage in such pleasures as fools, dupes.

II

Modleski's concern is to explore the narratives of romantic fiction and soap opera in an attempt to understand their immense popularity for some women, a popularity which 'suggests that they speak to very real problems and tensions in women's lives' (p. 14). She intends to show that such narratives 'contain elements of protest and resistance underneath highly "orthodox" plots' (p. 25), and that although 'the popular-culture heroine and the feminist choose utterly different ways of overcoming their dissatisfaction, they at least have in common the dissatisfaction' (p. 26).

It is necessary to situate Modleski's study historically in order to assess its significance for a British audience. There are three major concerns which informed its reception: the relative 'absence' of women and women's culture from earlier work in cultural studies; the shifts in the feminist 'images of women' debates; and the theoretical concerns preoccupying British cultural critics around the period of publication.

On the first question, Modleski's position is clear: popular cultural forms enjoyed by women have been inadequately theorised by cultural critics; for example, 'one cannot find any writings on popular feminine narratives to match the aggrandized titles of certain classic studies of popular male genres' such as the gangster movie or the detective novel (p. 11). She charges critics with exhibiting a 'pervasive scorn for all things feminine' (p. 13). It is this perception of a readership which is female and, by definition, 'uneducated', that places romantic fiction at or near the bottom of the hierarchy of 'tastes' which characterises contemporary culture.[3]

As Modleski suggests, it is certainly possible to trace a lack of address to and interest in women's culture within a British cultural studies

'tradition'. Neither woman as reader/spectator nor women's cultural production is adequately explored. Such an absence can be traced from the dominance of a 'male tradition' in the work of Raymond Williams and Richard Hoggart through to the interest in subcultures characterising much of the work published in the late 1970s and early 1980s. The object of attention tends to be male culture; the absence or marginalisation of women's culture is overlooked as the 'male' experience is globalised into the experience of all. There are several feminist critiques of this tendency.

For example, Jane Miller in a recent collection of essays revisits the work of Raymond Williams.[4] Acknowledging that his influential studies of working-class culture have been of great importance to the work of many feminists, Miller problematises Williams's tendency to marginalise women, to suppress their role as active makers and readers of culture. Women tend to be relegated to the family, and the family to the margins of his political analysis: 'In the end we are left with the sense of women skulking, hovering, on the edge of, slightly behind or somehow contingent to, the argument and the theory.'[5]

III

A challenge to more recent work on subcultures has been made by, amongst others, Angela McRobbie. She argues that the absence or marginalisation of young women in early, influential accounts of subculture fails to problematise the constructions of masculinity with which the male subjects of the studies resisted their oppression. In particular she notes the absence of an interest in the domestic arena, in the family ('Few writers seemed interested in what happened when a Mod went home after a weekend on speed. Only what happened on the streets mattered') and the failure of male writers to confront the sexism of the language used by boys to assert their masculinity.[6]

There is a second trajectory within which one can situate Modleski's study, what might be called the 'images of women' debate. For example, in the early 1970s many feminists were concerned that women were reduced to a handful of stereotypes by the media, represented as the sex symbol, the good girl or the femme fatale. It was argued that such representations were false, untruthful, that the media failed to depict women as they really were. By the late 1970s this rather simplistic 'window on the world' approach had been replaced by a more complex analysis which recognised that there was no absolute

'reality' shared by all women; that women themselves were culturally diverse, divided by class, race, age, sexuality. The media, it was then argued, offered certain definitions of women, usually constructed by men, and failed to provide others. Rather than merely dismissing such representations as 'negative', feminist critics began to consider the function they might serve culturally. Whose voice was speaking? Whose perspective was privileged? Who was marginalised, rendered invisible? In addition, they considered the possibility that women might 'read against the grain', seek out the 'blind spots' of this privileged discourse, 'refuse' the dominant meanings in circulation and attempt to construct their own.[7] In this context, Modleski explores the subject positions that romantic fiction and soaps may construct for women and the extent to which readers/spectators negotiate these postions.

The emphasis has continued to shift from the text to the spectator/reader in much feminist theory and to an extent that I find problematic. Questions around the possibility of a 'female gaze' now occupy many film critics. In the realm of literary/cultural production feminist writers and photographers argue for the right to produce work which others claim to be offensive, or pornographic. The space to object to certain images is shrinking, to be replaced by an argument which, at its crudest, can be used to justify the production and circulation of any text on the grounds that it is the responsibility of the spectator to produce her own meanings. In popular culture this debate plays itself out through competing analyses of films such as *The Accused* or *Silence of the Lambs*. The riddle has become: when is a 'negative' image not a negative image? And the answer is difficult to find.

A third point to consider when situating Modleski's study is her position as a North American academic. Despite the differing intellectual traditions informing work taking place in Britain and the USA, she is a prominent presence in British cultural studies. This can be explained by the fact that her work draws upon the same post-structuralist theories which have informed recent British work, and that she applies these theories to questions which also preoccupy British critics – the production of textual meaning, the relationship between the text and the reader. It is these theories which inform Modleski's critique of the Frankfurt School, whose position, she argues, 'makes contempt for mass art a politically progressive attitude' by equating popular culture with the contruction of 'false consciousness' and high art, alone, with the potential to deconstruct the ideological (p. 26).[8]

Her study, then, is closely related to work beginning to emerge in Britain during this period – for example, the work of Dorothy Hobson

and Charlotte Brunsdon on the television soap *Crossroads* and the work
of David Morley on the regional news programme *Nationwide*, all of
which sought to explore the relationship between audiences and
popular texts.[9]

IV

Modleski's study considers three areas: the Harlequin romance, the
Gothic novel and the daytime US soap opera. In what she refers to as
'an admittedly overschematized lineage' Modleski traces the Harlequin
to the novels of Samuel Richardson through the writing of Charlotte
Brontë and Jane Austen and the Gothic to the eighteenth-century work
of Ann Radcliffe again through Charlotte Brontë, and soaps as the
'descendants of the domestic novels and the sensation novels of the
nineteenth century' (p. 15). This approach, while representing too
sweeping a generalisation for many critics, does allow her to challenge
the 'high/low' cultural dichotomy within which romantic fiction is
caught. She problematises the subordinate status of contemporary
romantic fiction by mapping out links between its thematic concerns
and narrative structures and those of earlier eighteenth- and
nineteenth-century feminine narratives which have gained critical
approval and been allowed entry to the 'canon'.

The American publishing imprint Harlequin, like the British
publishing house Mills and Boon, has become synonymous with low
status, worthlessness, a lack of artistic merit. How far is this an
expression of contempt aimed at the implied readership – women – as
opposed to anything intrinsic to the texts themselves? Feminist critics
have tended to theorise romantic fiction either as evidence of women's
inherent masochism or as undiluted patriarchal ideology foisted upon
the female reader. Modleski disputes the oversimplification of these
positions: 'In exploring romantic fantasies, I want to look at the varied
and complex strategies women use to adapt to circumscribed lives and
to convince themselves that limitations are really opportunities' (p. 38).

She argues that the reader's identification with the protagonist is
more complicated than has previously been acknowledged. The reader
knows the formula, is aware at the point of selecting and opening the
text of the likely narrative closure: 'she is superior in wisdom to the
heroine' thus 'she is intellectually distanced from her' and does not have
to share her confusion. Therefore 'since readers are prepared to
understand the hero's behaviour in terms of the novel's ending, some of
the serious doubts women have about men can be confronted and

dispelled' – safely. This 'mystery of masculine motives' is seen as a central element in most popular romance, particularly Gothics. Titles such as *Enemy Lover*, *Beloved Tyrant* and *Fond Deceiver* suggest for Modleski that 'male brutality' must come to be understood 'as a manifestation not of contempt, but of love' (pp. 39–41).

Modleski suggests that the novels provide an outlet for female anger at the male hostility encountered in actual experience that cannot be so simply resolved. 'The few analyses written about romances almost always mention the childish qualities of the heroine, but no one has noted the large amount of anger expressed by the child/woman.' Nevertheless, such expressions of anger are frequently depicted as petulant, ineffectual and a source of amusement to the hero, providing a 'constant reminder of the impossibility of winning' (pp. 44–7).

In conclusion Modleski suggests that Harlequins, 'in presenting a heroine who has escaped psychic conflicts, inevitably increase the reader's own psychic conflicts, thus creating an even greater dependency on the literature' (p. 57). She argues, however, that it is the material conditions of women's lives making such novels necessary as opposed to the novels themselves that one should 'condemn'. The role which such novels play in constructing these material circumstances remains unclear.

Modleski identifies strong similarities between the Harlequin novel and the Gothic romance: 'Both deal with women's fear of and confusion about masculine behaviour in a world in which men learn to devalue women' (p. 60); for example, pure Gothics almost always have 'a handsome, magnetic suitor or husband who may or may not be a lunatic and/or murderer' (p. 39).[10] However, given that Gothics are frequently written in the first person Modleski argues that the reader has a closer identification with the character, sharing more of her uncertainty than in the Harlequins.

V

Her discussion of the Gothic relies more heavily on psychoanalytic insights than her consideration of the Harlequin. She provides an account of the Gothic, structured around the dissolution of a 'boundary confusion' between mother and daughter. She invokes psychoanalytic arguments which suggest that the female child experiences greater difficulty than the male in separating from the mother, quoting Nancy Chodorow: that the woman may 'have difficulty recognising herself as a separate person. She experiences herself, rather, as a continuation or extension of . . . her mother'. As Modleski points out, in the typical

Gothic narrative, for example, the (orphaned) heroine almost invariably finds herself linked or obsessed with another woman from the past, one who had been, perhaps, mutilated or murdered. Uncanny coincidences occur, the heroine may discover that she resembles this mysterious woman, was perhaps related to her, there is a sense of being possessed, that the past is repeating itself through the heroine. Modleski argues that the narrative provides the means through which this terrifying and inexplicable link is either rationally explained away or broken: 'Gothics, then, serve in part to convince women that they are not their mothers' (pp. 70–1).[11]

In ceasing to identify with the mother, the heroine must then learn to identify with the father. For Modleski, this accounts for the obsessive need for the heroine to discover the 'enemy' within the text, and that this must not be the father i.e. the lover, the husband, the hero. The heroine secures the 'proof' she seeks, the hero is exonerated; the crimes of which he was suspected are explained away as 'mistakes' or fall to the lot of a shadowy, 'weak' male who had perhaps originally been presented as the heroine's ally.

Modleski argues that this anlaysis helps to explain why Gothics have proved so popular with female writers and readers; they 'probe the deepest layers of the feminine unconscious, providing a way for women to work through profound psychic conflicts, especially ambivalence towards the significant people in their lives – mothers, fathers, lovers' (p. 83). However she is concerned to point out that 'Although I have been analysing Gothics in the light of what is usually seen to be a psychic illness – paranoia – I have not done so in order to show up Gothic readers as neurotic and unstable' for 'the structure of the western family, with its unequal distribution of power, almost inevitably generates the kinds of feminine conflicts and anxieties we have been discussing' (p. 81).

Modleski concludes that the resolutions of romantic fiction are precarious, unsatisfactory. In both Gothics and Harlequins 'the transformation of brutal (or indeed murderous) men into tender lovers, the insistent denial of the reality of male hostility towards women, point to ideological conflicts so profound that readers must constantly return to the same text (to texts which are virtually the same) in order to be reconvinced' (p. 111).

VI

When Modleski considers American daytime soaps, her definition of

soap opera excludes American soap-serials, such as *Dallas* or *Dynasty*. Rather she refers to what a British audience may best perceive as the American kin of British soaps such as *Coronation Street* or *EastEnders*, that is, soaps set in a small town/neighbourhood and structured around the activities of a handful of closely connected families.

She proposes to focus on the 'feminine' in soap operas, that is to show how for women 'they provide a unique narrative pleasure', one which 'provides an alternative to the dominant "pleasures of the text" analysed by Roland Barthes and others' (p. 87). This concern to identify a soap aesthetic which can be opposed to the classic (male) film narrative is of immense interest. For in beginning to theorise such an opposition, Modleski is both problematising women's pleasures in popular culture and also overtly challenging the givens of established film theory of the late 1970s. The derided pleasures of the soap opera and the women who watch it are transformed into a kind of guerrilla warfare in which soaps possess the potential 'force of a negation, a negation of the typical (and masculine) modes of pleasure in our society' (p. 105).

Modleski provides three examples of this oppositional 'female' aesthetic. First, the soap invites indentification with a number of different characters, rather than identification with a key controlling central character, which, argued 1970s film theory, was the means by which the (male) spectator gained pleasure from the text. This process is thus overturned in soaps: 'the multiple identification which occurs in soap opera results in the spectator's being divested of power'. If multiple egos are each in fruitless conflict with others then the spectator is 'frustrated by the sense of powerlessness'. Indeed, Modleski suggests that such a process of multiple identification constitutes the spectator 'as a sort of ideal mother . . . whose sympathy is large enough to encompass the conflicting claims of her family (she identifies with them all)' (pp. 91–2).

Second, and once again referring explicitly to the work of Nancy Chodorow, Modleski argues that women are socially constructed to seek 'connectedness', 'fusion', a 'blurring of boundaries' and that the 'constant, claustrophobic use of close-up shots' both stimulates and satisfies this desire. She contrasts soap opera's excessive use of the close-up with the conventions of other cultural forms which are 'aimed at masculine visual pleasure . . . often centred on the fragmentation and fetishization of the female body' (p. 99).

Third, she argues that soaps, in their formal properties, foreground distraction, interruption, repetition. The constant narrative complica-

tions, obstructions, multiplication of enigmas forever defer a soap's resolution, making 'anticipation of an end an end in itself. Soap operas invest exquisite pleasure in the central condition of a woman's life – waiting' (p. 88). Soaps illustrate for the female spectator 'the enormous difficulty of getting from desire to fulfilment' and can thus be opposed aesthetically to 'the classic (male) film narrative, which, with maximum action and minimum, always pertinent dialogue, speeds its way to the restoration of order' (p. 106). The climax or mini-climax of soaps, rather than delivering a resolution of difficulties, a desired order, serves to complicate by introducing further difficulties.

Modleski concludes her chapter on soap operas by suggesting that the soap speaks to women of utopian possibilities, offering a collective fantasy of community, 'a kind of extended family, the direct opposite of her own isolated nuclear family' (p. 108). It is from this starting point that feminist academics and artists should begin, seeking out 'clues to women's pleasure which are already present in existing forms, even if this pleasure is currently placed at the service of patriarchy' (p. 104).

VII

Modleski's study was – and is – an extremely influential piece of research. Her arguments have been of immense value in informing and encouraging subsequent theoretical work on popular romantic fiction and soaps. Nevertheless, there are problems with her approach. Although she is theorising a process of reading, she uses no ethnographic evidence. She talks neither to women who read the novels nor to fans of soaps, and implicit in her address to the reader is that she is not such a woman. Her interest is, rather, that of a feminist academic. She speaks of 'we', 'our', 'as readers'; however this 'we' is not defined. The personal histories which women bring to such texts in terms of class, age, race, ethnicity or sexuality are not addressed; rather, Modleski globalises the readings of a white feminist intellectual into the readings of all women.

How adequate is her methodology for the project she sets herself if the wider context within which women read and make sense of romance and soaps is absent from her study? Without ethnographic work, can Modleski claim to have produced 'an early contribution to a psychology of the interaction between feminine readers and texts' (p. 31)?

It is interesting to consider Modleski's own position in relation to

ethnographic work. In her introduction to a 1986 collection of essays on mass culture she acknowledges that ethnographic research 'has produced some brilliant and edifying studies', with particular reference to the work of the Birmingham Centre for Contemporary Cultural Studies; however, she warns also of the 'problems and dangers' implicit in such an approach:

> If the problem with some of the work of the Frankfurt School was that its members were too far outside the culture they examined, ciritics today seem to have the opposite problem: immersed in their culture, half in love with their subject, they sometimes seem unable to achieve the proper critical distance from it. As a result, they may unwittingly wind up writing apologias for mass culture and embracing its ideology.[12]

What exactly is 'the proper critical distance'? I have used the study with students from working-class backgrounds who argue that Modleski is so 'distanced' from the actual readers/audiences of the texts she analyses – i.e. they do not appear in her study at all – that critically she has little to offer. They argue that she fails to take sufficient account of the material conditions within which working-class heterosexual women read such fiction (although this is not to suggest that romantic fiction has no other audience) thereby failing to acknowledge the overwhelmingly oppressive nature of the encounter.

Whilst acknowledging the above points I am less inclined to be critical of Modleski's methodology. Ethnographic research in itself does not produce conclusions which differ to a great extent from those provided by her work (see below). Furthermore both ethnographic research and textual analysis provide similar opportunities for a selective rendering of 'evidence'. Such interpretation is surely inevitable. Some contextualisation of the publishing industry and of the process of reading, particularly in relation to questions of class, race and ethnicity, would have been useful. It is not available in this study and the reader must simply seek it elsewhere.

VIII

For the reasons stated above it is useful in any work on romantic fiction to use Modleski's study in conjunction with a piece of ethnographic research. The obvious choice is *Reading the Romance* by Janice Radway (see Chapter 9).[13]

The two books were published in close proximity, and Radway cites

Modleski several times with reference to a 1980 article which became, in slightly altered form, chapter 2 of *Loving with a Vengeance*.[14] Her references are critical and tend somewhat to misrepresent Modleski's position. However, as Radway admits in her introduction to the later British edition, she had tended to 'misread earlier feminist work on the romance resulting in a blindness to the continuity between my own arguments and those of scholars such as Tania Modleski' (p. 6).

Despite the differing methodologies that Modleski and Radway employ, they reach remarkably similar conclusions. For example, Radway argues that during the course of the romantic narrative the hero is transformed 'from the heroine's distant, insensitive and cold superior into her tender, expressive intimate' (p. 216), a process which enables feminine, nurturing values to gain primacy over the masculine 'world of money and status' (p. 214). She asserts that the reader actively reads ahead of the narrative, assembling the plot and gaining a certain critical distance from the heroine; that the act of reading allows women 'to focus on themselves' (p. 211), to carve out their own space free of domestic and familial responsibilities or, in Modleski's words, 'to disappear' (p. 58).

Like Modleski, she concludes that the reading of the romance provides a point of expression for 'repressed emotions deriving from dissatisfaction with the status quo and a utopian longing for a better life' but that, for feminists, it is crucial to consider how it may be possible to enable this 'valid, if limited, protest . . . to be delivered in the arena of actual social relations rather than acted out in the imagination'.[15]

A further criticism can be made of Modleski's analysis: her failure to consider the possibility that implicit in the pleasures available to women reading romantic fiction is the opportunity to identify with the hero, with the seducer, as opposed to the heroine, thereby refusing the 'masochistic' pleasures implicit in the latter position. For this reason Cora Kaplan in a recent essay has argued that Modleski's analysis is 'quite gender bound . . . crossing the boundaries of gender as part of the acts of reading and fantasizing plays no significant part in her analyses', whereas Kaplan attempts such an analysis in her discussion of the blockbuster novel *The Thornbirds*.[16] This failure to pursue such possibilities is disappointing, particularly given the concerns of Modleski's next study, which considers the relation between the female spectator and the films of Alfred Hitchcock. There she explores possibilities 'to destabilize the gender identity of protagonists and viewers alike'.[17]

IX

A further academic study which I have found useful to consider in relation to work on romantic fiction is the 1986 publication *The Progress of Romance*, edited by Jean Radford. This collection of essays provides a historical perspective on the various forms that popular romance writing has taken. In doing so it challenges the tendency of critics to pose the literary and the popular as oppositional categories, and of male critics in particular to mistake 'the thing on the page for the experience itself' with regard to romantic fiction.[18] Of particular interest is the chapter 'Mills and Boon meets feminism' which seeks to provide a 'sequel' to recent feminist work on romantic fiction. Here Ann Rosalind Jones engages in textual analysis of seventeen Mills and Boon romances published in winter 1983/Spring 1984 to consider to what extent the genre has negotiated a shifting social context by incorporating elements of a feminist discourse into its narratives. She finds evidence to suggest that writers/editors 'are now willing to experiment in liberal-feminist directions' by, for example, depicting heroines who are strongly committed to their work/careers. However, she concludes, such experimentation can also take the form of mockery and, at times, a 'sinister appropriation of feminist politics'.[19]

Turning specifically to studies of soap opera, there are three particularly useful texts to consider: Ien Ang's *Watching Dallas* (see Chapter 1), David Morley's *Family Television* (see Chapter 8) and Christine Geraghty's *Women and Soap Opera*.[20] The first is based on an analysis of letters discussing *Dallas* sent to the author by Dutch viewers and provides a useful point of reference in conjunction with Modleski's textual analyis. Morley's study seeks to provide an analysis of the domestic viewing situation and provides some interesting comments on the continued derogation of the romantic/fictional terrain. Finally, Geraghty's study provides a very useful overview on work on women and soaps to date and, building on these insights, enables the author to explore further the relationship between the female spectator and popular feminine texts.

Could it be argued that, during the 1980s, soaps have gained increased status, particularly in the popular discourses of the media? For example, Barry Norman, long-standing film critic of *Film '91*, has deemed it appropriate to apply his critical intelligence to the popular Australian soap *Neighbours*. The chat show host Terry Wogan regularly features interviews with cast members of various television soaps. While Wogan's interest, like that of the tabloids, can be accounted for

in terms of the general chat/personality format of his shows, Norman has always sought to project an intellectualised 'film buff' persona. In this context it is useful to consider the thirtieth anniversary celebrations which took place for the soap *Coronation Street* in 1990. Alongside the glitzy ITV 'birthday party' hosted by television 'personality' Cilla Black, audiences encountered a serious Channel 4 lecture given by Labour politician Roy Hattersley, which praised the soaps' 'realism' (*sic*) and disputed its low cultural status. Consider also the 'cult' status of director David Lynch's much hyped appropriation of the soap format, *Twin Peaks*, broadcast by the BBC in 1990/1.

In contrast, romantic fiction has not enjoyed a similar increase in status. Gateshead may offer an annual Romantic Fiction Festival, Barbara Cartland may appear on numerous chat shows, but Mills and Boon culture remains the object of popular contempt. Why should soaps, as opposed to romantic fiction, be granted increased space and status within both an academic and a popular discourse? How far has the traditional gender composition of soap audiences - previously so strongly female identified - shifted? Is a 'masculisation' of soaps currently taking place in which rationalisations for viewing must be sought?

There is no doubt that since the late 1970s an academic space - albeit marginal - has opened up for work on women's popular texts. Modleski's study has enjoyed immense influence in this arena. Nevertheless, the status which such work carries, outside the specific discourses within which it operates, remains questionable. It may be permissible to be caught on a train reading *Loving with a Vengeance* - but what about a copy of a Mills and Boon?

NOTES

1 Tania Modleski, *Loving with a Vengeance: Mass-produced Fantasies for Women*, Hamden, Conn.: Archon; London: Methuen 1984, p. 34.
2 Chapter 2 appeared in slightly altered form as 'The Disappearing Act: a Study of Harlequin Romances', *Signs: Journal of Women in Culture and Society*, vol. 5, no. 3 (spring 1980), pp. 435–48. Elements of chapter 4 appeared as 'The Rhythms of Reception: Daytime Television and Women's Work', *Tabloid: a Review of Mass Culture and Everyday Life*, no. 4, (summer 1981) and subsequently in E. Ann Kaplan (ed.), *Regarding Television. Critical Approaches: An Anthology*, New York: American Film Institute, 1983.
3 For further discussion of the stratification of taste and its relation to social structure and cultural reproduction see Pierre Bourdieu, *Distinction*, London: Routledge 1984, pp. 11–57.
4 Jane Miller, *Seductions: Studies in Reading and Culture*, London: Virago 1990.

5 Ibid., p. 51.

6 Angela McRobbie, 'Settling Accounts With Subcultures: a Feminist Critique', in T. Bennett, T. Martin, C. Mercer and J. Woollacott (eds), *Culture, Ideology and Social Process: a Reader*, Milton Keynes: Open University Press 1989, p. 113.

7 See, for example, E. Ann Kaplan (ed.), *Women in Film Noir*, London: BFI 1980, and, more recently, E. Deidre Pribram (ed.), *Female Spectators: Looking at Film and Television*, London: Verso 1988.

8 Modleski's second full-length study: *The Women Who Knew Too Much: Hitchcock and Feminist Theory*, London: Methuen 1988. In addition see her essays 'Femininity as Masquerade: a Feminist Approach to Mass Culture', in Colin MacCabe (ed.), *High Theory/Low Culture: Analysing Popular Television and Film*, Manchester: Manchester University Press 1986; and 'Time and Desire in the Woman's Film', in Christine Gledhill (ed.), *Home Is Where the Heart Is: Studies in Melodrama and the Woman's Film*, London: BFI 1987. The anthology, Tania Modleski (ed.), *Studies in Entertainment: Critical Approaches to Mass Culture*, Bloomington, Ind.: Indiana University Press 1986, includes essays by several British critics.

9 Dorothy Hobson, *Crossroads: the Drama of a Soap Opera*, London: Methuen 1982; Charlotte Brunsdon, 'Crossroads: Notes on Soap Opera', *Screen*, vol. 22, no. 4 (spring 1982) and subsequently in E. Ann Kaplan (ed.), *Regarding Television*; David Morley, *The Nationwide Audience: Structure and Decoding*, London: BFI 1980. Also useful in this context is Judith Williamson, 'How Does Girl Number Twenty Understand Ideology?', *Screen Education*, no. 40 (1981/2).

10 A quote from the former editor of Ace Books taken from Joanna Russ, 'Somebody Is Trying to Kill Me and I Think It's My Husband: The Modern Gothic', *Journal of Popular Culture*, vol. 6 (1973), pp. 666–91.

11 Nancy Chodorow, quoted form *The Reproduction of Mothering: Psychoanalysis and the Sociology of Gender*, Berkeley, Cal.: University of California Press 1978. Chodorow's insights have influenced the work of numerous American feminists. Alongside Modleski, Janice Radway cites her as a crucial source, as do film theorists such as E. Ann Kaplan and Mary Ann Doane. However, there are criticisms of her work. See, for example, Jacqueline Rose's introduction to J. Mitchell and J. Rose (eds), *Feminine Sexuality*, London: Macmillan 1987 and Maria Ramas's essay 'Freud's Dora, Dora's Hysteria', in C. Bernheimer and C. Kahane (eds), *In Dora's Case*, London: Virago 1985.

12 Modleski, *Studies in Entertainment*, p. xi.

13 Janice Radway, *Reading the Romance: Women, Patriarchy and Popular Literature*, London: Verso 1987.

14 Ibid., pp. 6, 242, 251, 254.

15 Ibid., pp. 220–1.

16 Cora Kaplan, 'The Thorn Birds: Fiction, Fantasy, Femininity', in *Sea Changes: Culture and Feminism*, London: Verso 1986, p. 129.

17 Modleski, *The Women Who Knew Too Much*, p. 5.

18 Jean Radford (ed.), *The Progress of Romance: the Politics of Popular Fiction*, London: Routledge 1986.

19 Ibid. See in particular, Ann Rosalind Jones, 'Mills & Boon Meets Feminism', pp. 195–218. Two further relevant essays in this context would

be Alison Light, 'Returning to Manderley: Romance Fiction, Female Sexuality and Class', *Feminist Review*, no. 16 (April 1984) and Valerie Walkerdine, 'Some Day My Prince Will Come' which can be found in her collected essays, *Schoolgirl Fictions*, London: Verso 1990. See also J. Batsleer, T. Davies, R. O'Rourke, C. Weedon, *Rewriting English: Cultural Politics of Gender and Class*, London: Methuen 1985, pp. 86–105 and 140–54.

20 Ien Ang, *Watching Dallas: Soap Opera and the Melodramatic Imagination*, London: Methuen 1985. David Morley, *Family Television: Cultural Power and Domestic Leisure*, London: Comedia 1986. Christine Geraghty, *Women and Soap Opera*, London: Polity 1990. Two further British texts on soap opera which may be useful are: *Teaching Coronation Street*, an education pack complete with slides, compiled by the British Film Institute, 1983 and David Buckingham, *Public Secrets: EastEnders and Its Audience*, London: BFI 1987.

Chapter 8

David Morley, The *Nationwide* Studies

Mark Jancovich

INTRODUCTION

Despite apparent differences in focus and approach, there has been a strong line of continuity within David Morley's research and writing over the years. In his three major publications, *Everyday Television: Nationwide* (with Charlotte Brunsdon), *The Nationwide Audience* and *Family Television*,[1] he has worked through different aspects of the 'encoding/decoding' model of communications developed at the Centre for Contemporary Cultural Studies in the 1970s. These texts also attempt to integrate semiotic and ethnographic approaches to the study of culture, a project which was also a feature of the Centre during the same period. Whatever the problems with the various stages of this work, the line of development from *Everyday Television* to *Family Television* can be described as a movement of focus from the text to the context.

FROM TEXT TO CONTEXT

In *Everyday Television*, the authors presented a largely semiotic analysis of *Nationwide* in which they concentrated upon a number of different features of the text: they discussed the construction of the text; the manner in which topics were articulated; the use of background detail and explanatory frameworks in the presentation of these topics; the use of expert commentary; and the handling of interview material. However, even at this stage, the semiotic analysis was only seen as part of a larger project. They maintained that the analysis of the text was merely 'a base line against which differential readings might be posed, and our readings of the programme will be open to modification in the light of audience work'.[2] *Everyday Television* already signalled the need

for a book such as *The Nationwide Audience* which would study the processes by which specific audiences decoded the text.

In *The Nationwide Audience*, then, Morley moved on from a focus upon the semiotic construction of the text to a study of the text's 'conditions of consumption'. He moved to a study of the ways in which various audiences decoded an edition of *Nationwide*. The purpose of this study was not simply to correct the original analysis but to examine the ways in which different readings might be related to the varying socio-economic positions of the audience. From this study, Morley aimed to produce 'a typology of the range of decodings made';[3] an account of the reasons for the differences; a demonstration of the means by which different interpretations were produced; and an account of the relation between these different interpretations and cultural factors such as class, sex, race and age.

Despite this last aim, Morley did 'not assume a direct and exclusive correspondence [between interpretations and cultural factors] so that one group would inhabit only code.' He acknowledged that 'the interpretation of the different groups might overlap with one another',[4] and for this reason, he sought to identify the extent to which decodings may vary according to other factors. He examined, for example, the impact of 'cultural frameworks and identifications' from formal institutional structures (such as trade unions and political parties) through to more informal cultural factors (such as subcultures whether these be 'youth or student cultures or those based on racial or cultural minorities').[5]

He also studied whether interpretations were affected by the extent to which 'the topics treated are distant or abstract to particular groups'.[6] This involves two factors which, at the time of *The Nationwide Audience*, are not sufficiently distinguished. One is the extent to which the presence or absence of alternative information provided by a group's experience might make it more or less likely to accept or reject the presentation of a particular topic. In other words: would a group, for example, be more likely to accept an interpretation of a topic about which it had little real experience, or more likely to reject an interpretation of a topic about which it had considerable experience? The second factor, which Morley was to clarify in *Family Television*, is the way in which judgements concerning the relevance and irrelevance of a specific topic are shaped by cultural factors and may affect a group's decoding.

Morley was therefore concerned to study the manner in which different group contexts might give rise to different decodings; and at

this stage, he regretted that he was unable to compare the decodings made by the same person within the different contexts of the workplace and the home. He considered still more serious his inability to study 'the differential decodings, within the family context, between men and women'.[7] Just as *Everyday Television* signalled the need for a study such as *The Nationwide Audience*, *The Nationwide Audience* signalled the need for a study such as *Family Television*, a study which would examine the manner in which the gendered roles within the domestic sphere might give rise to different processes of decoding.

In *Family Television*, then, Morley moved to a concentration upon 'how people watched television within the more "natural" setting, at home with their families'.[8] However, in so doing, he goes beyond the concerns of *The Nationwide Audience* to consider not simply the production of different decodings but also the more general role of the television within domestic relations. As Morley put it, his 'focus of interest [had] shifted from the analysis of the pattern of differential audience "readings" of particular programme materials, to the analysis of the domestic viewing context itself – as the framework within which "readings" of programmes are (ordinarily) made'.[9] This approach has both its strengths and its weaknesses. It does illustrate that the meaning of television viewing cannot simply be reduced to the 'decodings' produced, but there is a tendency for Morley to loose sight of the relationship between the various activities and relations within which television viewing is situated on the one hand, and the process of textual decoding on the other. Morley tends to loose sight of the textual processes through which television establishes social, cultural and political agendas.

None the less, he is right to emphasise that the decoding of television programmes is not the only activity which takes place in relation to the television; and he argues that it is necessary that an analytical distinction is made between the activity of interpretation and the various activities within which the television is involved within the home. For example, he refers to the case of one male who, when he is angry after work, comes home and immediately sits down to watch television. According to Morley, the meaning of this particular viewing activity is not limited to his interpretation of the text. In fact, by watching television, the man is displaying his desire to 'see and hear nothing'. This activity of viewing involves a complex set of relationships to his work and home life. Morley also refers to Janice Radway's study of women's reading of romance novels (see Chapter 9). For Radway, whether the romance is ideologically conservative or not, the

act of reading is, for many women, a reaction against demands made upon them within a patriarchal society. The women whom she studied constructed the act of romance reading as a 'declaration of independence' from the demands of husbands and children within the home. As she puts it, 'the significance of the act of reading itself might, under some conditions, contradict, undercut, or qualify the significance of producing a particular kind of story'.[10]

For this reason, Morley discusses the way in which television is used within the home in a number of different ways: as an organiser of time; a way of generating collective activities and discussions, or suppressing conflicts; a way of defining a time for physical intimacy; and as a way of bartering between family members. A parent, for example, may offer to let a child watch a certain programme in exchange for a certain favour, or else refuse to let a child watch a certain programme as a punishment. In this way, the activity of television viewing, regardless of the ideological meanings of the television texts, operates within domestic power relations in a number of different ways.

Moreover, these relations mean that television viewing is not strictly tied to the ideological predispositions of the audience. The choice and selection of television programmes is rarely based upon individual choice, but on a variety of different factors and relations within the domestic sphere. As a result, television viewing does not directly relate to either an acceptance of the ideological positions of the programme watched or even a liking for specific programmes. The textual features may be the least important feature of the activity of viewing in certain cases.

It is Morley's discussion of the way in which the domestic sphere gives rise to different styles of television viewing which establishes the closest links with his previous studies, though. It is also the area in which he comes closest to an examination of the relationship between the power relations of the domestic sphere and the processes of decoding. In seeking to challenge the notion that the television affects all family members in the same way, Morley argues that different family roles give rise to different styles of viewing and different types of attentiveness in relation to different forms of programmes. For example, he mentions research that suggests that mothers and fathers will assume different relationships to other members of the family while they watch television. Mothers tend to adopt 'a "managerial" or "overseer" role, while fathers will assume a "playmate" role in relation to their children – that is, fathers will tend to join their children in activities while mothers sit and monitor the situation'.[11]

More significantly perhaps, the different ways in which males and females tend to define the domestic sphere is also seen as accounting for different styles of viewing. In seeking to explain the common complaint from men that women tend to lack concentration while watching programmes, and the common complaint from women that men keep telling them to 'shut up' and concentrate, Morley argues that these different gendered styles of viewing are not based on 'essential', biological, or even psychoanalytic characteristics which distinguish men and women. Instead he argues that while the home is defined for men as a sphere of leisure in opposition to the industrial sphere of work, for women (even if they work outside the home) the domestic sphere is defined as a sphere of work. As a result, television viewing tends to be an activity which women tend 'to do distractedly and guiltily, because of their continuing sense of domestic responsibility'.[12] What is more, Morley seems to suggest that women appear to have little trouble concentrating when freed from domestic responsibilities.

Even on these issues, Morley's interviews are too general to examine how this might inform the 'encoding/decoding model'. Morley may argue that it is necessary to distinguish analytically between the interpretation of a text on the one hand and the various activities with which the television is associated within the domestic context on the other, but the implication is that they are none the less related. The context and meaning of viewing may change the process of interpretation and vice versa. For Morley, the limitation of *The Nationwide Audience* was that he could not conduct interviews within the home to study the ways in which the domestic context might affect the process of decoding. The limitation of *Family Television* is that it lacks the concentrated analysis of audiences' decodings of specific texts, or types of texts, necessary to explore the ways in which these roles give rise to different ideological positions with regard to media texts.

In *The Nationwide Audience*, Morley himself had suggested the kind of study which might be called for at the point at which he discusses the need for a study such as *Family Television*. He mentions the ways in which an investigation of decodings of media presentations of the Saltley pickets of 1972 'showed a vast discrepancy between the accounts of the situation developed by miners who were at the Saltley Picket and those of their wives who viewed the events at home on TV'.[13] Despite the somewhat patronising tone which can be detected in these early comments, more concentration on the different decodings of specific media texts would have developed not only the 'encoding/decoding model' but also research into the ways in which the media are

involved in the domestic sphere as an active force. *Family Television* tends to ignore the impact of media structures and texts upon the family. As such, the study tends to contradict Morley's own theoretical and political project by concentrating too much on the activities of the audience and the process of consumption, rather than studying these activities and processes as part of the larger processes of communication which involves both production and consumption. To appreciate these problems, it is necessary to clarify the way in which Morley's theoretical and political position and project is defined in reaction to other traditions within media and cultural studies.

THEORISING THE AUDIENCE

Morley's work is a response to two different traditions within the analysis of mass communications. These traditions might be referred to as the 'effects' tradition and the 'uses and gratifications' tradition. The 'effects' tradition includes a variety of different, and often opposed, approaches from mass culture theory to contemporary psychoanalysis. The common feature of these approaches is their concern with what mass communications do to their audiences. As Morley puts it, this tradition mobilises 'a hypodermic model of media influence, in which the media are seen as having the power to "inject" their audiences with particular messages which will cause them to behave in a particular way'.[14] Even within many approaches which are not concerned with the 'messages' of mass communication, there are claims that the media either turn their audiences into passive, acquiescent 'zombies' or stimulate violent, anti-social behaviour. The right have accused the media of destroying 'traditional values' while the left have claimed that they foster an unquestioning acceptance of authority.

Examples of the 'uses and gratifications' tradition, on the other hand, share a concern with what audiences do with mass communications. Often conceived of as a challenge to the 'effects' tradition, it does not regard the audience as a passive mass which is simply acted on from without, but it examines various audiences' active engagement with mass communications. In so doing, it has challenged the notion of a homogeneous audience whose members all respond in the same way to any specific 'message' or 'stimulus'.

For Morley, there are problems with both these traditions. The 'effects' tradition, for example, is not simply concerned with what the media do to people – it is usually preoccupied with what the media do to other people. Few people would claim that they themselves were

affected by the media in the ways claimed by this tradition. Media effects always happen to other people who are less intelligent, less enlightened, less critical, or whatever. As his references to the 'hypodermic model' suggests, Morley also regards the 'effects' tradition as both mechanistic and deterministic. It is not that he denies that a relationship exists between the media and its audience, but rather that he claims that there is little actual analysis of the workings of this relationship. The audience is conceived of as an inert mass who are largely acted on by the media. Effective or ineffective communication is seen as a result of the media themselves, and there is little consideration of the conditions which might make an audience receptive or unreceptive to a particular message or stimulus. One of the problems with most examples of the 'effects' tradition is that they rely on conceptions of 'The Audience' rather than socially specific audiences and viewers.

This problem can be seen in relation to contemporary semiotic and psychoanalytic approaches. Psychoanalysis in particular has attempted to provide an analysis of the relationship between the text and the process of reading. For example, it has been concerned with the ideological organisation of spectatorship within the process of viewing visual texts, such as films and television programmes. However, rather than studying the process of viewing of specific audiences, psycho-analysis has tended to 'deduce' the responses of 'The Audience' from an analysis of the structures of the visual texts. It has been concerned with the manner in which the position of the spectator, or the audience, is organised by the forms of the text. As a result, there has been little concern with the relationship, or even the gap, between actual audiences and viewers, and the position of the audiences as inscribed by the text. Actual audiences may be invited or even encouraged to take up the position inscribed by the text, but these actual audiences are never simply the subjects of a single text. They are also subjects of other social and historical processes which will affect their relationship to these textual positions. In fact, for Morley, this issue is related to a more substantial problem within psychoanalysis. Much of psycho-analysis is concerned with the criticism of 'the subject' itself, not specific forms of subjectivity. As Stuart Hall puts it, within the psychoanalytic critique of the subject 'the manner in which this "subject" of culture is conceptualized is of a trans-historical and "universal" character: it addresses the subject-in-general, not historically-determinant social subjects, or socially determinant particular languages'.[15]

This problem leads Morley to make two related criticisms of

psychoanalytic criticism. First, he draws upon a reading of Vološinov and others to argue that the subject is never simply the 'effect' of a linguistic or symbolic order.[16] Instead he argues that any specific subject is always situated within a culture which is made up of conflicting and contradictory discourses because of the 'multiaccentuality of the sign'. As a result, Morley seeks to 'emphasize the unstable, provisional, and dynamic properties of subject positions'.[17] The subject is always situated within these processes and conflicts, and is necessarily involved within them.

Second, Morley challenges the tendency within psychoanalytic criticism, and particularly 'the *Screen* problematic', to concentrate purely on 'the process of signification as the production of the subject'. For Morley, it is not the production or positioning of the subject itself which secures the reproduction of dominant positions. Domination is not only produced through 'the successful positioning of the subject in the signifying process (the same signification or position is compatible with different ideological problematics; successful positioning in the chain of signification is no guarantee of dominant decodings); but also because of the acceptance of what is said'.[18]

For this reason, while Morley emphasises the 'unstable, provisional' features of subject positions, he is careful to avoid the claim that specific subjects lack any sense of coherence. He accepts the arguments of writers such as Laclau and Mouffe who claim that all subjects are positioned in relation to different and even contradictory discourses. He also accepts that none of these relations, discourses or subject positions can be defined as the 'essence' which explains all the others. However, Morley does not accept that these subject positions are all equally powerful, or that they are unrelated to one another in any way. In fact, it is central to his argument that subject positions are related, or as he puts it: 'that subjects have histories and that past interpellations affect present ones'.[19] It is because of these relations between subject positions that specific audiences and viewers do not necessarily accept the positions inscribed by a specific text or discourse, but may resist, at the very least, aspects of specific texts and discourses.

If Morley criticises the 'effects' tradition for concentrating on the media themselves and for ignoring the activities of the actual audiences and viewers, he is critical of the 'uses and gratifications' tradition for being too individualistic in its concentration. It tends to emphasise differences of interpretation and response, and attributes these differences to the personal and psychological features of specific individuals and groups. Examples of the 'uses and gratifications' tradition often

developed as challenges to the mass culture thesis. This thesis claims that contemporary communications involve forms of domination and control which result in the erasure of the individual features of the population and convert them into a standardised mass. In response the 'uses and gratifications' research attempted to emphasise the plurality of contemporary cultural life, but in doing so, it often tended to ignore, or even deny, issues of dominance and control.

For this reason, Ien Ang has attempted to distinguish Morley's work (and cultural studies itself) from this tradition. She argues that it is not differences as such which should be the main concentration of audience research. Instead she claims that it should be 'the meaning of differences that matter – something that can only be grasped, interpretatively, by looking at their contexts, social and cultural bases, and impacts'.[20] For Morley, the identification of cultural differences is not, in itself, the aim of his research. Instead his work is an attempt to examine the process of cultural differentiation – the process by which cultural differences are produced – and the forms of domination and control which are involved within it.

Morley's work is not simply concerned to identify differences but also relationships, continuities and regularities. He also rejects the conception of the text as completely 'open' to the responses of the audience, and seeks to emphasise 'the role of the media in setting agendas and providing cultural frameworks within which members of a culture will tend to operate'.[21] A variety of approaches (from examples of the 'uses and gratifications' tradition through to forms of criticism influenced by postmodernism and certain theories of Roland Barthes) have tended to deny that the text has any meaning which might be involved in structuring the responses of the audience. It is argued that texts are infinitely open to their readers; that they impose no formal constraints upon the activity of reading and can be interpreted in any way. The reader 'writes' the text and all interpretations are equally valid.

In response Morley proposes 'the preferred reading model'. This model accepts that readers engage in productive activity in their interpretation of texts, but it emphasises that they do so within conditions which provide limitations and pressures on that interpretation. The 'preferred reading model' proposes that all texts seek to elicit specific readings from their readers, but that actual readers' interpretations are not based on a simple acceptance or rejection of this preferred reading. Actual readers develop a position in relation to this preferred reading, which may range between acceptance or rejection,

on the basis of specific cultural competences and dispositions. As a result, Morley insists that any reading is produced within a set of determinant conditions which are 'supplied by the text, the producing institution and by the social history of the audience'.[22]

CRITICISMS AND CONCLUSIONS

The problems with *Family Television* are therefore very similar to those which Morley himself criticises in the 'uses and gratifications' tradition – it tends to ignore the forms of dominance and control exercised by the media and gives too great an importance to the activities of the audience. He is right to argue against those who tend 'to prioritise the study of production to the exclusion of the study of all other levels of the social formation'; and to argue that 'production is only brought to fruition in the spheres of circulation and exchange – to that extent, the study of consumption is . . . essential to the full understanding of production'.[23] An intelligent reading of Marx would certainly support Morley on this point, but in *Family Television* the analysis of the relationship between these different levels – which was so central to Morley's contribution to media and cultural studies – is at best vague, and in need of further elaboration. There is no necessary contradiction between the analysis of the political economy of culture and audience research. In fact any adequate analysis of the political economy of culture must take account of the ways in which the market is structured and segmented, and different cultural goods are produced for different audiences.[24]

Despite these problems with *Family Television*, it is depressing that the influence of Morley and other studies of audiences have had little impact outside television studies. Most film and literary analysis, for example, maintains an abstract conception of 'The Audience' or 'The Reader', even in most cases of 'reader-response criticism'. Figures such as Janice Radway,[25] Helen Taylor[26] and Valerie Walkerdine[27] are rare exceptions. There are, of course, reasons for this situation, many of them institutional. But these institutional reasons are also related to the culture of intellectual activity. Most obvious is the lack of available funding for such studies. Morley's studies themselves have frequently been limited by a lack of proper funding. This situation is made still worse by the institutional distinction between the humanities and the social sciences. Historically, film and literary studies have been identified with the humanities while television studies have had a strong foundation in the social sciences.

Another problem is the distinction of analytical skills between the humanities and the social sciences. Humanities students, particularly in film and literary studies, have rarely been required to acquire the research skills necessary for audience studies. In fact, the humanities have tended to oppose their own analytical approaches to the 'empiricism' of the social sciences. Literary studies (upon which film studies was heavily modelled) emerged as a profession specifically by defining its object of study as the linguistic processes of the text, rather than the social, political and economic conditions within which texts were produced and consumed. Nor has this focus on the linguistic processes of the text been dramatically altered by many of the theoretical innovations of the last couple of decades, such as the various forms of post-structuralist criticism.

The humanities' opposition to the social sciences can be seen in arguments such as those of Jane Feuer. For Feuer, audience research cannot get away from the problem of interpretation. Rather than reading the media text, the audience researcher simply 'reads another text, that is to say, the text of the audience discourse'.[28] Feuer is questioning the value of 'empirical' audience research in relation to an analysis of the media texts themselves. As Feuer rightly points out, both the media texts and audience members' accounts of their own responses are texts which have to be interpreted by the analyst. She therefore questions whether one form of text can be privileged over the other. Certainly audience research must involve a mode of interpretation, but I must agree with Morley that

> the interview (not to mention other techniques such as participant observation) remains a fundamentally more appropriate way to attempt to understand what audiences do when they watch television than for the analyst to simply stay home and imagine the possible implications of how other people might watch television, in the manner which Feuer suggests.[29]

These interviews are useful not only because, as Morley points out, they can give the analyst access to the textual 'terms and categories through which respondents construct their world and their own understanding of their activities',[30] but also because, as Morley has amply shown, cultural competences and dispositions are differentially distributed.

Speculative analysts may well not share, or even have access to, the same competences and disposition as an audience. As a result, they may interpret the text in a very different way to that audience. In this

connection Morley comments upon the criticism of Modleski's work by Seiter et al.

> Seiter et al. argue that Modleski's analysis of how women soap opera viewers are positioned by the text – in the manner of the 'ideal mother' who understands all the various motives and desires in a soap opera – is in fact premised on an unexamined assumption of a particular white, middle-class social position. Thus, the subject positioning which Modleski 'imagines' that all women will occupy in relation to soap opera texts turns out, empirically, to be refused by many of the working-class women interviewed by Seiter et al.[31]

In my own area of research – the horror genre – it is common for academic analysts who have little interest in, or knowledge of, the genre to dismiss as standard that which is innovative, and to praise as innovative that which is standard. Not only this, but their ideological analysis frequently contradicts that of audiences familiar with the codes of the genre.

An anecdote: a colleague working on colonialism and narrative with whom I watched James Cameron/Gale Anne Hurd's *Aliens* interpreted the character of Burke as the hero. For this particular viewer, Burke, the representative of the colonialist corporation, had to be the hero because this viewer already 'knew' that all American mass cultural texts were supportive of American corporatism and colonial expansion. By contrast a cinema audience in the West End of London shortly after the release of the film almost immediately identified Burke as an unsympathetic character. The preferred decoding clearly identifies Burke as at least as negative as the aliens unleashed by his attempts to promote himself through the company hierarchy. The audience booed and jeered at Burke's actions throughout the film until his final come-uppance which was greeted with a mixture of approval and belated sympathy.

The importance of Morley's work is therefore that he has demonstrated that the effects of cultural texts are always related to the conditions of their consumption; and that cultural analysts cannot simply deduce these texts' meanings for, and effects upon, the audience from an analysis of their textual structures. An acknowledgement of this situation does not invalidate the interpretation of specific cultural texts by the analysis – this was the project of *Everyday Television* – but that must be seen as only one aspect of cultural analysis. Cultural analysts must be willing to modify their interpretation in the light of further evidence supplied by the study of audiences. Analysts must also

be aware that the differential distribution of competences and disposi-
tions may mean that they do not have the cultural resources to interpret
certain types of text adequately.

The activities and responses of the audience are always produced
within the context of specific forms of domination though. As Henry
Jenkins III puts it: 'political intervention on the level of reception may
be no substitute for a politics that is also concerned with conditions of
production'.[32] Morley may be right to argue against the tendency to
privilege production over consumption, but in works such as *Family
Television*, his work runs the risk of privileging consumption over
production. His work on the consumption of the media is an important
contribution to cultural studies only so long as it regards consumption
in relation to the conditions of production, but it is this very relation
which has tended to be ignored or obscured recently, both within his
own work and in others' use of it.

NOTES

1 David Morley and Charlotte Brunsdon, *Everyday Television: Nationwide*,
London: BFI 1978, David Morley, *The Nationwide Audience: Structure and
Decoding* London: BFI 1980, and David Morley, *Family Television: Cultural
Power and Domestic Leisure* London: Comedia 1986.
2 Morley, *Everyday Television: Nationwide*, p. v.
3 Morley, *The Nationwide Audience*, p. 23.
4 Ibid., p. 26.
5 Ibid., p. 26.
6 Ibid., p. 26.
7 Morley, *Everyday Television*, p. 28.
8 Morley, *Family Television*, p. 14.
9 Ibid., p. 14.
10 Janice Radway, *Reading the Romance: Women, Patriarchy and Popular Literature*,
London: Verso 1987, p. 210.
11 Morley, *Family Television*, p. 29.
12 Ibid., p. 147.
13 Morley, *The Nationwide Audience*, p. 28.
14 David Morley, 'Changing Paradigms in Audience Studies', in Ellen Seiter,
Hans Borchers, Gabriele Kreutzner and Eva-Maria Warth (eds), *Remote
Control: Television, Audiences and Cultural Power*, London: Routledge 1990, p.
16.
15 Stuart Hall, 'Cultural Studies: Two Paradigms', in Richard Collins, James
Curran, Nicholas Garnham, Paddy Scannell, Phillip Schlesinger and Colin
Sparks (eds), *Media, Culture and Society: a Critical Reader*, London: Sage 1986, p.
46.
16 V. N. Vološinov, *Marxism and the Philosophy of Language*, New York: Seminar
Press 1973.

17 Morley, *Family Television*, p. 20.
18 Morley, *The Nationwide Audience*, p. 153.
19 David Morley, 'Changing Paradigms in Audience Studies', p. 20.
20 Ien Ang, 'Wanted: Audiences. On the Politics of Empirical Audience Studies', in Ellen Seiter, Hans Borchers, Gabriele Kreutzner and Eva-Maria Warth (eds), *Remote Control: Television, Audiences and Cultural Power*, London: Routledge 1990, p. 107.
21 David Morley, 'Changing Paradigms in Audience Studies', p. 17.
22 Ibid., p. 19.
23 Ibid., p. 29.
24 See for example, Nicholas Garnham, 'Contribution to a Political Economy of Mass-Communications', in Richard Collins et al. (eds), *Media, Culture and Society: a Critical Reader*.
25 Janice Radway, *Reading the Romance*.
26 Helen Taylor, *Scarlett's Women: Gone with the Wind and its Female Fans*, London: Virago 1989.
27 Valerie Walkerdine, 'Projecting Fantasies: Families Watching Films', unpublished paper, University of London, 1986.
28 Jane Feuer, 'Dynasty' (paper presented at ITSC, London, 1986) quoted in David Morley, 'Changing Paradigms in Audience Studies', p. 24.
29 David Morley, 'Changing Paradigms in Audience Studies', p. 24.
30 Ibid., p. 25.
31 Ibid., p. 25.
32 Henry Jenkins III, ' "It's not a Fairy Tale Anymore": Genre, Gender, Beauty and the Beast', *Journal of Film and Video*, vol. 43, nos 1–2 (spring–summer 1991), p. 91. Also to be published in Henry Jenkins III, *Textual Poachers: Television Fans and Participatory Culture*, London: Routledge 1992. Jenkins uses the work of Michel De Certeau in an examination of the historical relationship between fan cultures and the conditions of cultural production. See Michel De Certeau, *The Practice of Everyday Life*, Berkeley, Cal.: University of California Press 1984.

Chapter 9

Janice Radway, *Reading the Romance*

Susan Purdie

Radway's book, published in 1984, investigates the appeal of mass-marketed romantic fiction. She concludes that it offers its female readers real pleasures but at the same time perpetuates a restricting valuation of women's lives – for while such reading

> may enable women to resist their social role and to supplement its meagre benefits, romances may still function as active agents in the maintenance of the ideological status quo by virtue of their hybrid status as realistic novels and mythic ritual.[1]

To understand the 'ritual' which romances repeatedly perform, Radway mobilises Nancy Chodorow's analysis of feminine individuation, which argues that women form identities dependent on tender relationship, modelled on the infant's relation to the mother; but that males, to establish their distinct gender, reject such dependence. This produces an essential mis-match between the qualities women need in intimate relationships and the qualities men can supply: a lack which Radway, using a Proppian analysis, finds 'mythically' supplied in the basic story of fulfilling heterosexual love which romances continually repeat. Radway also identifies patriarchy's insistence that women can only find fulfilment in monogamous relations with men, and sees romances, in their aspect as 'realistic novels', reinforcing that message.

Radway locates popular romances' compulsive attraction in this paradoxical temporary comfort, needed and supplied in the situation that they also construct as desirable and necessary: a persuasive analysis very similar to Tania Modleski's in *Loving with a Vengeance* (see Chapter 7). Radway is unique, though, in her specific reliance upon Chodorow's theorisation, which raises problems in its suggestion of an essentialised, pre-social feminine psychology. *Reading the Romance* is also distinctive in its 'ethnographic' study of a group of romance enthusiasts in a small

mid-western town she calls 'Smithton'. Radway demonstrates these women's careful selectivity amongst the mass of publishers' offerings as well as their defiant, sometimes guilty, use of romance reading to claim personal time which escapes their families' constant demands. On this basis, despite the ideological manipulation which, as I shall argue, is implicit in her conclusion, Radway claims to respect readers' positive use of popular literature as, she insists, other studies of popular romance do not.[2] The book is often cited to support this important contention, in relation to romance readers and, more generally, all popular culture audiences.

Reading the Romance is a book that demonstrates characteristic assumptions which, taken together, considerably identify the discipline of cultural studies. I want to examine the book first of all in relation to these characteristic assumptions and the contradictions that emerge in their academic combination. In a more detailed examination I shall then suggest that, finally failing to resolve them, it stands as an exhibition, rather than the total solution, of problems which must continue to engage us.

CULTURAL STUDIES AND THE POPULAR AUDIENCE

The three terms of Radway's subtitle – 'women, patriarchy and popular literature' – together exemplify cultural studies' typical attention to mass-produced culture, plus the positions from which this is characteristically approached.

Attention to the specificity of 'women' as writers and as readers is one facet of the assumption generally informing cultural studies, that 'personal' attributes significantly affect individuals' reception of and agency within their culture. If the roots of such awareness lie in work founded on an explicit commitment to socialism (Richard Hoggart, Raymond Williams), the present wave of feminism[3] is connected with women's realisation that their oppression has been separate from, whilst often additional to, class oppression; and this understanding of the significance of gender has encouraged articulations of homosexuality and, rather slowly, of heterosexual masculinity, within the recognition that no identity can be formed without a gender and a sexuality and that these positions crucially delimit all our operations as subjects.[4] The issues of racial identity have also, in the last few years, become more prominent.[5]

Any use of the subtitle's second term, 'patriarchy', usually implies a further assumption which is again characteristic of cultural studies: that

these particular identities are disadvantaged within a system which accords inter-dependent socioeconomic and ideological privilege to males and by extension to white, middle-class heterosexuals. That recognition almost inevitably entails opposition to this state of affairs.[6]

Reading the Romance offers a usefully clear and persuasive introduction to all these assumptions and the way they inform each other, by exploring a site on which textual genre, individual values and beliefs and material power relations are very evidently interactive. It also energetically opposes critics who treat romance readers as passively manipulated receivers of the texts. This is a potentially contradictory position in explicitly anti-patriarchal critical work; but it remains prevalent, even though cultural studies has not only taken popular culture as a major academic topic but has consciously opposed traditional criticism's value judgements in which the 'proper' object of academic study is 'high' art (in all media) definitionally distinct from and superior to whatever is 'popular'.[7]

Anti-patriarchal criticism has evolved more sophisticated analyses of textual process than Hoggart's, laying emphasis instead on readers' active construction of textual meaning and increasingly invoking psychoanalytic theory to describe this process;[8] yet the final, pejorative evaluation of popular texts and of their audiences remains much the same as Hoggart's.

As Jean Radford argues, the high/low evaluative distinction remains, for 'literature is seen as operating transformatively on ideology, whereas popular fiction merely transmits this ideology'.[9] As she also demonstrates,

> this is particularly the case with discussions of women's popular writing; there is a slide into Left moralism about the 'self-indulgence' of 'habitual reading for entertainment'. (p. 7, citing Margolies)[10]

Radway challenges 'the commonplace view that mass cultural forms like the romance perform their social functions by imposing alien ideologies upon unsuspecting if not somnolent readers' (p. 8). To do this, she asserts,

> the analytic focus must shift from the text itself, taken in isolation, to the complex social event of reading where a woman actively attributes sense to lexical signs in a silent process carried on in the context of her ordinary life. (p. 8)

Radway's book is frequently cited, has indeed become the classic

reference, to insist upon the active and even oppositional *use* of popular texts by their audiences, and especially female audiences. For example, Anne Rosalind Jones declares 'Janice Radway has discovered that romance audiences read actively' as a refutation of 'David Margolies's dismissal of romance readers' tendency to "sink into feeling" ';[11] while, in an article reviewing research into popular television's audiences, Ann Gray declares Radway's 'methodological intervention is of tremendous importance to studies of the consumption of popular culture in general'.[12]

Radway's introduction locates the error that generates disparaging constructions of popular audiences in academics' projecting their *own* readings of the relevant texts on to their usual audiences; and her ethnographic intervention seeks to forestall this by collecting 'real' readers' views. However, her final account of romance reading and its motivations remains diametrically different from theirs and, crucially, it involves concepts (such as the unconscious) to which they have never been introduced. This last point suggests a more fundamental basis of the difficulty. Any criticism must assume itself to reveal something generally unrecognised about its object; and when its object is produced for a mass audience, the critical discovery is likely to involve concepts and information which are unavailable to the majority of its usual readers. In particular, criticism utilising psychoanalytic approaches to identify texts' unconscious effects obviously discusses effects of which audiences are immediately unaware – and non-clinical expositions of psychoanalytic theory barely exist, in the Anglophone world, outside higher education. In other words, academics' textual interpretations are different from most popular readers', because they are more educated.

This self-evident fact is rarely stated because, I think, the Anglophone world connects education with a set of attributes, including class, in turn treated as absolute values. It is ungracious to admit to extensive education in most circles because it implies a claim to personal superiority. Yet if it is unarticulated, this 'difference' cannot be interrogated; it remains assumed, without its implications of differentiated cultural power (which are relevant to any anti-patriarchal project) being elucidated. Also, if it is not examined, the difference between academic and mass readers may be misleadingly accepted as unlimited.

It seems important that critics of mass culture remain aware of their own particularities as well as those of popular audiences, so that the nature and extent of the differences between them can be examined.

Radway's introduction apparently tackles this problematic directly in relation to her first methodology:

> The ethnographic account is never a perfectly transparent, objective duplication of one individual's culture for another. Consequently, the content of that account depends equally upon the culture being described and upon the individual who, in describing, also translates and interprets. (p. 9)

Ethnography evolved in a recognition that geographically remote and technologically distinct peoples may understand the world quite differently; it is therefore initially surprising that a woman should apply its methods to other women living in the same country and socioeconomic system. However, as I have outlined, identifying people occupying different positions within that system as members of significantly different 'cultures' could lead to valuable insights about their respective cultural responses. My criticism centres on Radway's failure fully to investigate this perception.

What is clear from the beginning, implicit in the very choice of an 'ethnographic' method, is that Radway constructs herself – and, apparently, any 'critic' – as deeply separate from the women whose reading formed the site of her empirical investigation.

> [T]he methodological addition [sic] of investigating the ways real readers read cannot do away with the need for a critic's interpretation . . . because the analyst is inevitably trying to render the complex significance of events and behaviours as they are experienced by members of a culture *for others not in or of that culture*. (p. 9, emphasis in original)

Whilst as I have suggested, this separation is in many ways inevitable, there must also be some *similarities* between all ethnographers and their subjects, which it is equally important to explicate rather than assume; and there must also be distinctions arising from the academic's particular personality, which need to be identified as such if this ethnographic methodology operates validly. Radway does not disguise, for example, the fact that her own relationship with popular romance is purely scientific:

> Upon returning from my visit to Smithton, I read as many of the specific titles mentioned during the discussions and interviews that I could aquire, transcribed the tapes, and expanded a field-work journal I had kept while away. (p. 48)

Her book's readers are manifestly assumed to belong to her own culture and *therefore*, also, to be wholly unimplicated in popular romance reading.

However, the absoluteness of this division is problematic, even on the very specific site of popular romances: I know academic writers who dip into them in doctors' waiting rooms, who enjoyed in their youth novels at least similar to mass marketed romances, and many who greatly value works such as Jane Austen's which (as I discuss below) have clear affinities with popular romance that are ignored by Radway. If it can be argued that the Smithton women's chosen books, and their way of reading them, remain significantly distinctive, the total space between these two 'cultures' has nevertheless, surely, some bridges which it is important to locate – perhaps by asking what kind of books Radway herself reads 'purely for pleasure'.

Even if Radway and her own readers are assumed to be wholly free from popular romance's 'nets of fascination' (to use Rosalind Coward's telling phrase), parallels suggest themselves between romances and other 'popular' texts, and it seems unlikely that she herself and her audience have no engaged response with any connected elements in films, television or advertising. Much as we might like it to, academic education does not free us totally from desire and its commercial exploitation. In *Female Desire* Coward writes from the assumption that she and her readers form *part* of the audience whose incitement and manipulation by popular culture she nevertheless analyses, as a contribution to its resistance.[13] Judith Williamson's writing similarly analyses 'our' relationships to, for example, advertising (see Chapter 10).[14]

More is involved here than the *lèse majesté* of an academic 'admitting' to venial habits. Radway's use of psychoanalysis to account for romance reading involves the crucial insight that popular culture extends its harmful effects upon the back of deep psychological satisfactions. Yet identifying these structures as inherent in individuation is meaningless, unless they are assumed to be universal and therefore fundamentally operative upon 'academics' and 'populace' alike.

Here, then, a general question emerges: is cultural studies not a more intellectually coherent and politically effective discipline when its analyses are directed at objects whose harms and fascinations engage their analysts – so that differences of empowerment can be frankly explored because similarities of need and pleasure are acknowledged?

It might be argued that the popularity of woman's romance, the

critical attention given to that and the disparaging constructions of female readers which have resulted, justify Radway's intervention in a field from which she excludes herself. Such a focus on difference rather than similarity might still be fruitful if its nature were examined, so that whatever leads the Smithton women to enjoy pleasures Radway rejects might become apparent. The later chapters' use of Chodorow (see below) makes that question intrinsically insistent in *Reading the Romance*.

The division is 'symptomatically' (in Macherey's sense) evident throughout the book – for example, in Radway's description of first seeing her informant, Dot Evans 'in a lavender pants suit' or in Evans's recorded encouragement to her friends that 'Jan is just people!' (p. 47). At the same time Radway works hard to efface the distinction between herself and the Smithton women, often emphasising how freely they communicated ('after an initial period of mutually felt awkwardness, we conversed frankly and with enthusiasm' (p. 47)). One gathers in fact a sense of *social* embarrassment and perhaps it is an understandable desire to avoid apparent discourtesy to people who were clearly very hospitable that prevents Radway from elaborating on the implications of such contextual, 'ethnographic' information about the Smithton women. Acknowledgement of such evident distinctions of education and (therefore?) of class might imply Radway's claiming 'superiority'. As it is, neither the distinguishing characteristics of her studied group nor of 'the individual who . . . translates and interprets' are examined, despite Radway's introductory statements. (It is so tempting to ask 'what was *she* wearing?')

POPULAR LITERATURE AND MASS MARKETING

Radway begins her book with a detailed description of the process in which popular literature is produced and marketed. She traces the history, at least in the United States, of publishing as a commodity industry, relating the technology of mass-produced, cheap, paperback books to their mass-marketing; she notes for example that by working within 'lines' (e.g. Harlequins, the US equivalent of Mills and Boon, and others quickly produced to emulate Harlequins' success) publishers not only identified specific markets but created a repetitive 'replace-ment' purchasing habit which, unlike single titles, could be promoted within predictably successful advertising campaigns because the potential buyers were clearly identified. This in turn relates to the editorial production of texts within closely defined formulae, and to

systems of market research designed to establish which contents and presentations are most likely to succeed with those buyers.

This is a useful and unusual investigation. While the assumption I have pointed to as generally informing cultural studies – that material conditions and ideology are essentially interactive – implies a need to study the influence of the first upon the second as well as the reverse flow, the actual conditions of book production have received less attention than that of television and film texts (compare e.g. Steve Neale's *Cinema and Technology*).[15] It is however somewhat weakened by a failure to relate mass-marketed romance to other, significantly similar, textual categories. In this lack of comparative definition, again, the particularity of Radway's object of study is obscured.

In showing how popular publishers developed 'feminine romance' to produce a new market when thrillers lost their mass appeal, Radway gives the impression that this genre was invented *ex nihilo*. Much later (p. 197) she refers briefly to a discussion in which she established that few of the Smithton women read Jane Austen. Apart from this, she gives no indication that books generally included in traditional literature's 'canon' (of which Austen and the Brontës are the most obvious examples) share many of the characteristics she identifies in 'popular' romance; or that such reading, specifically associated with a female audience and 'mass' distributed (albeit on a smaller scale) through lending libraries, has a history stretching back to the early nineteenth century and arguably – as Jean Radford's book investigates – well back from there. Neither does Radway mention the non-gender-specific mass publication of popular literature represented by nineteenth-century periodical serialisation. Again, what are now firmly canonic authors – outstandingly Dickens, but also Gaskell, Wilkie Collins and others – originally published in this form.

As a result, neither the continuities nor the differences between what the Smithton women read and what, presumably, Radway and her implied audience regard as interesting books can be investigated; nor are comparisons between 'romance' and other currently mass-marketed genres considered at any point in the book. We learn that the Smithton women read prodigious amounts of romantic fiction, and the conscious and unaware pleasures they derive from that are explored, as is their preference for literary over television and filmic romantic fictions; but how this relates to other people's uses of other kinds of literary fiction, or any other type of reading material is not considered. Nor, though '62 percent of Dot's customers claimed to read somewhere between one and four books *other* than romances every week' (p. 60,

emphasis in original), is the nature of this 'other reading', as different content or as a different behaviour, investigated. Consequently the almost compulsive behaviour which she investigates cannot be considered as a distinctive use of the general activity which is *reading*.[16] In short, the possibly 'compulsive' nature of reading fictional texts *as an activity per se* is not considered by Radway, so that claims about the sociological or psychological significance of romance reading in the lives of Smithton women are made on the basis of a set of unexamined assumptions.

THE ETHNOGRAPHIC STUDY

It was through her research with publishers and editors that Radway came into contact with the woman she calls 'Dorothy Evans', who became central to her research project as an informant and arranger of Radway's contact with other romance readers in a small mid-western town that Radway calls 'Smithton'. Evans's own 'story' epitomises the needs, satisfactions and personal empowerment which Radway identifies in romance readers. She had begun reading when her doctor insisted that she should 'find an enjoyable leisure activity to which she could devote at least an hour a day' when her ceaseless family care was making her ill. Radway tantalisingly tells us that 'Dot read many kinds of books at first, but she soon began to concentrate on romances for reasons she cannot now explain'. Evans's daughter Kit 'encouraged her to look for a job in a book-store to make use of her growing expertise', and there she began to be regularly consulted by other women seeking out romances with the particular characteristics that satisfied them – to such an extent that eventually, with further encouragement and help from Kit, Evans started a newsletter reviewing new publications: 'Dorothy's Diary of Romance Reading' (pp. 51–2). It was through contact with the 'Diary' that a New York editor was able to put Radway in touch with Evans.

Radway's painstakingly noted field research included long discussions with Evans, plus two four-hour sessions with sixteen women, individual interviews with the five 'most articulate and enthusiastic readers' amongst them, and a questionnaire that these and another twenty-five women completed. After reflecting on all this, Radway redesigned her questionnaire, which was then completed by forty-two women, and she then returned to Smithton for a week, again staying and talking with Evans, re-interviewing the five enthusiasts plus 'Maureen, one of Dot's most forthright readers who had recently

begun writing her own romances' (p. 48). Both versions of the questionnaire and her 'Oral Interview Response Record' are included as appendices in the book. Radway reports the women's reading habits and preferences in terms of numerical samples and several 'tables' of particular responses are supplied. This elaborately scientific discourse raises problems. In what begins to appear as a recurrent pattern, Radway carefully states part of the difficulty but does not subsequently pursue its implications:

> It is clear that the Smithton group cannot be thought of as a scientifically designed random sample. The conclusions drawn from the study, therefore, should be extrapolated only with great caution to apply to other romance readers. (p. 48)

But the whole basis of the book is such an extrapolation. Her statistical presentation invests Radway's conclusions with an aura of objective truth that may not be valid. For example her summary of readers' familial situations – 'it appears that within the Smithton group romance reading correlates with motherhood and the care of children *other* than infants' – is actually at odds with the same page's report that 'five (12 percent) reported children under age five' while 'five (12 percent) reported having no children at all' and 'eleven (27 percent) . . . reported that all their children were over age eighteen' (p. 57). In other words, Radway's summary of her sample (whatever its general validity) does not apply to twenty-one (50 percent) of them; while it does, implicitly, support her later use of Chodorow.

For this reader at least, Radway's most convincing conclusions are those in which I can recognise some parallel with my own recreational reading. They are typically those established through emphatic repetition in conversation rather than responses to her multiple choice questionnaires. The crucially vaunted discovery that the women 'use' romances – in the sense that they discriminate minutely amongst publishers' offerings and, further, then view their reading as 'my time' taken consciously and even in direct opposition to their families' demands – specifically emerges from remarks that are volunteered (see discussion of terms like 'escape' as produced in the different conditions; p. 61, p. 88).

This is Radway's summary of these two points.

> Romance reading, it would seem, at least for Dot and many of her customers, is a strategy with a double purpose. As an activity, it so engages their attention that it enables them to deny their physical

presence in an environment associated with responsibilities that are acutely felt and occasionally experienced as too onerous to bear. Reading, in this sense, connotes a free space where they feel liberated from the need to perform duties that they otherwise willingly accept as their own. At the same time, by carefully choosing stories that make them feel particularly happy, they escape figuratively into a fairy tale where a heroine's similar needs are adequately met. As a result they vicariously attend to their own requirements as independent individuals who require emotional sustenance and solicitude. (p. 93)

This account, which is fully supported by quoted discussions, is at once plausible and interesting to me, because it 'rings bells': I too select predictably pleasurable books to read, at times when I want relief from external demands. There are manifest differences in my pattern of recreational reading and in the situations whose pressures I seek to evade; and I perceive differences in the books I select (for the record: typically, Dickens, Forster and (!) Austen) and the pleasures they yield. But the interesting question which could be pursued from Radway's conclusions is how far elements of 'escapism' are inherent in all (fictional?) textuality.

Barthes, in particular, and before him Bertolt Brecht, introduced the notion of 'pleasure' into textual studies:[17] pleasures of stimulation, incitements to break semantic or social rules, remain those that are valued. When Brecht denounced 'narcotic' theatre he was identifying precisely that smuggled inducement of ideological conformity which cultural studies typically opposes; and as can be argued in the particular case of the Smithton romance readers, it surely should be opposed because it promotes the audience's exploitation. If, though, pleasures of 'losing yourself' in texts represent a satisfaction of universal psychic needs, we ought perhaps to value them in themselves, separately identifying their harmful manipulations.

THE PSYCHOANALYTIC ACCOUNT

For those who know it, Marx's observation of religion as 'the opium of the people . . . the cry of the oppressed heart' may be evoked by my last paragraph. Drug-taking and religious observance may be viewed as related human strategies, other than reading, for escaping excessive demands and assuaging unmet needs. The compulsion of the Smithton women's reading, in its frequency and their intensely felt need to finish

a book once started, suggests connections with such behaviours. Radway reports 'relatively high' attendance at religious services (p. 58) and the parallel between religion and romance reading is implicit in her phrasing when reporting that 'thirty seven (88 percent) of Dot's readers indicated that they read religiously every day'. A relationship of substitution between 'pills or drinks' and romance reading is volunteered by Dot herself and other women; though they also reject this when advanced by outsiders (p. 87, p. 115). These connections, suggested but never explicitly investigated, are again implicitly used to support the pattern of explanation Radway takes from Chodorow's theorisation.

This follows from an analysis of the women's favourite twenty volumes (modelled on Propp's investigation of *The Morphology of the Folk-tale*). Radway's convincing analysis is in stark, and perhaps inevitable, opposition to the Smithton women's own perception that 'they are [all] totally and completely different books' (p. 53). I would, as I have suggested, be interested in a comparative Proppian analysis of these and some other literary categories: for example, with what is categorised as 'upmarket' women's reading and as male-targeted popular literature, or with the Booker Prize shortlists. I would also be interested in the Smithton women's response to Radway's own analysis of their selection, and her interpretation of that (though I am not suggesting that their potential rejection would negate either).

Finally, as I have indicated, Radway turns to Nancy Chodorow's theory of female identity formation, to offer an understanding of the behaviour she has notated. To summarise even more brutally than Radway's three-page account, Chodorow – using object-relations psychoanalysis (i.e. based upon Melanie Klein's development of Sigmund Freud) – assumes first that the infant's relationship with its nurturing parent supplies at a very early stage its essential model of a 'self-in-relationship'; second, that as a result females develop a sense of selfhood, which reproduces the female parent's perceived own identity, dependent upon tender relationships with others; while males, in order to distinguish their gender identity from that of their mothers, form self-models which reject dependency on tender relationships. When patriarchy, then, enforces upon women a primary relationship with and an economic dependency upon men, it produces a situation where women's essential psychic needs will never be met. Chodorow further assumes that in nurturing both their children and their spouses, women assuage this lack by projecting and supplying their own needs in those that they care for.[18]

Radway's extrapolation of this pattern into romance reading is

carried out in detail and with some care: she identifies, for example, a recurrent opening in which the heroine's 'social identity' is lost while the closure supplies this through the finally established relationship with a man who loves her in a 'nurturing' manner; she points to romances' consequent double effect, of reassuring women that the kind of relationship they need *is* achievable, whilst actually underscoring patriarchy's insistence that it is *only* through a relationship with one male that female needs can be supplied. She also insists that readers' desire to share vicariously in heroines' traumas, especially the experience of male violence, is better understood as a strategy for dealing with a real part of everyday life (because in romances all is always, finally, well), than as desire for an unexperienced fantasy. Given the dangerously recurrent tendency to attribute to women a masochistic desire for male violence this is perhaps the book's most important point.

Radway's introduction of Chodorow to support these conclusions, though, produces more problems than it solves. No room is allowed for Radway to interrogate, or even to explicate, assumptions in Chodorow which are at least questionable. At their heart lies the problematic *separation* of psychic and social positions (even though they are allowed to interact): a knowledge of gender difference, and a particular, differentiating, psychic patterning is taken to precede and explain social conditions. (The counter argument is not, as Chodorow asserts, that the social precedes the psychic but that the two are inseparably productive of each other, in the history of humankind and of the individual.) More simply, one has to be very careful about declaring any pattern as specific as this to be 'more or less universal'. Here then is the particular petard with which Radway hoists herself in marrying 'ethnographic' and 'psychoanalytic' approaches. If reading romances works for the Smithton women to kill the pain of a *universal* female deprivation, what is it about them that leads to this particular choice of analgesic? And what do other women, including academics, 'take'? If the pattern is not universal, what factors modify its appearance?

I have already suggested that factors of education and what is densely interrelated to that – class – are involved in this problem.[19] Further, while this book particularly produces a need to examine these factors within academic studies of popular culture, Radway is not alone in evading them. She is also far from unusual in citing her own domestic relationship as her most deserved 'Acknowledgement'. But the particular phrasing here, in the context of the ensuing content, acutely foregrounds the problem I have identified.

The last paragraph of Radway's Acknowledgements reads as follows:

> My final debt is perhaps the most difficult one to acknowledge because of its very intangibility. My husband, Scott, has helped in so many ways, at once practical and emotional, that it would be foolish to try and [*sic*] list them all here. I hope it is enough to say that I could not have finished this had it not been for his understanding, encouragement, and, above all else, his interest. This book is dedicated to him with love.

There could hardly be a more eloquent declaration that that ideal, tender, supportive attention which Smithton women can only fantasise via compulsive romance reading, is for Janice Radway a reality: given the book she has written, we are entitled to ask how that comes to be the case.

This may appear to be a tangential and even impertinently personal question; but I think it has implications whose rigorous pursuit is entailed in any valid study of popular culture. Cultural studies' characteristic assumptions, as I listed them at the beginning of this essay, are crudely summarised in the phrase 'the personal is political'. Alluding to other people's personal lives while excluding our own is intellectually as well as ethically dubious in that context. If the critic admits no implication in her subject, her project – no matter how radically intentioned – can only re-inscribe her own privilege.

NOTES

1 Janice Radway, *Reading the Romance: Women, Patriarchy and Popular Literature*, Chapel Hill and London: University of North Carolina Press and Verso 1984 (this reference p. 17). British publication: London: Verso 1987.
2 The works cited are: Anne Douglas 'Soft-Porn Culture', *New Republic*, 30 August 1980, pp. 26–30; and Tania Modleski 'The Disappearing Act: a Study of Harlequin Romances', *Signs*, vol. 5 (spring 1980), pp. 435–48; for Modleski's later book see below.
3 For the truth still needs to be constantly repeated that there has *always* been a 'woman's movement'.
4 E.g. work by Sinfield and Easthope respectively.
5 E.g. work by Said and Spivak.
6 There remains a vehement debate about how far it is useful to identify 'femininity' (and other categorisations) as culturally constructed and how far insisting upon this colludes with the dominant group's effacement of subordinated people's lived experience.
7 Q. D. Leavis's 1932 diatribe *Fiction and the Reading Public* offers the classic

example of traditional, 'humanist' criticism attending to popular art only in order to warn of the terrible threat it poses to elite culture. By contrast, the approach pioneered in Richard Hoggart's 1957 *The Uses of Literacy* views popular culture as a threat to the populace. Richard Hoggart, *The Uses of Literacy*, Harmondsworth: Penguin 1957. For an account of the two Leavis's part in traditional literary criticism see Francis Mulhern, *The Moment of 'Scrutiny'*, London: New Left Books 1979.

8 The major site on which these approaches were introduced to British audiences in the 1970s was the BFI journal *Screen*.

9 Jean Radford (ed.), *The Progress of Romance*, London: Routledge 1986, p. 6.

10 David Margolies, 'Mills and Boon, Guilt without Sex', *Red Letters*, no. 14 (1982).

11 Anne Rosalind Jones, 'Mills and Boon Meets Feminism', in Jean Radford (ed.), *The Progress of Romance*, pp. 104–19 (p. 119).

12 Ann Gray, 'Reading the Audience', *Screen*, vol. 28, no. 3 (summer 1987), pp. 24–35 (this quote p. 34).

13 Rosalind Coward, *Female Desire: Women's Sexuality Today*, London: Paladin 1984.

14 Judith Williamson, *Decoding Advertisements: Ideology and Meaning in Advertising*, London: Marion Boyars 1978.

15 Steve Neale, *Cinema and Technology: Image, Sound, Colour*, London: BFI/Macmillan 1985.

16 The Smithton women generally prefer their romance reading to watching television because they view the latter as an activity shared with, and controlled by, their husbands. In *Cultural Studies*, vol. 1, no. 4 (1987), Minu Lee and Chong Heup Cho discuss Korean women who are devotees of imported Korean soap opera videos. The women watch these in groups when their husbands are at work, and their accounts of their viewing as a 'self-indulgence' which represents a minor but explicit defiance of their husbands' demands and taste, is very similar to the Smithton women's reported construction of their romance reading. However, the Korean women's viewing is a female social activity, while the Smithton readers had no contact with each other outside Radway's discussions.

17 Roland Barthes, *The Pleasures of the Text*, trans. R. Miller, London: Jonathan Cape 1976; Bertolt Brecht, 'The Short Organum', in *Brecht on Theatre*, trans. J. Willet, London: Methuen 1979.

18 Radway's account of Chodorow is taken from Nancy Chodorow, *The Reproduction of Mothering: Psychoanalysis and the Sociology of Gender*, Berkeley, Cal.: University of California Press 1978. Chodorow has recently re-stated her position in *Feminism and Psychoanalytic Theory*, Cambridge: Polity Press 1989. In the introduction to this book she describes how 'as I reflected during the late 1960s upon the historical and cross-cultural record, it seemed clear that women's oppression well preceded class society and that its dynamics did not inhere exclusively or dominantly in material relations of work. I turned to psychological anthropology for an alternative to the Marxist account of women's oppression that would still privilege actual social relations as an explanatory underpinning. I concluded . . . that women's mothering generated, more or less universally, a defensive masculine identity in men and a compensatory psychology and ideology of

masculine superiority. This psychology and ideology sustained male dominance'; this illustrates some of the areas where her work is vulnerable to considered political and psychoanalytic interrogation.

Ironically, amongst Radway's many useful footnotes, which often constitute handy 'mini-bibliographies', one deals with the economic exploitation of women within the 'normal' family structure (chapter four, note 14). From this understanding a recognition of the interdependence of psychological and economic relationships, which I would offer as an argument against Chodorow's position, could start.

19 Radway notes, again without further comment, the generally pre-degree educational level of the romance readers and she does not investigate potential relationships between their different educational attainments and different responses to romances. She also remarks the Smithton women's consistent defence of their reading as 'educational' (e.g. pp. 106–12) whilst treating this as a rationalising justification of the 'self-indulgence' they themselves attribute to it. But she does not articulate how this conclusion (validly) follows from her superior knowledge that romances are not really a very good way of learning about history. When Radway finds it 'hard to say why intelligence was ranked so high [as a quality of the ideal hero] by the Smithton women' (p. 82) it is clear that she not only confounds 'intelligence' with 'intellectualism' but assumes her ethnographic objects to lack both.

FURTHER READING

On the 'popular' audience:
Gray, Ann, 'Reading the Audience', *Screen*, vol. 28, no: 3 (1987), pp. 24–35. (This is a thoughtful, if less polemical, approach to the problems I have outlined, with a more appreciative account of Radway's work (34) and a number of useful references.)
Ang, Ien, *Watching Dallas: Soap Opera and the Melodramatic Imagination*, London: Methuen 1985.

On romance reading:
Modleski, Tania, *Loving With a Vengeance: Mass-produced Fantasies for Women*, London: Methuen 1984.
Radford, Jean (ed.), *The Progress of the Romance: the Politics of Popular Fiction*, London: Routledge 1986.

On women and popular culture:
Coward, Rosalind, *Female Desire: Women's Sexuality Today*, London: Paladin 1984.
Williamson, Judith, *Decoding Advertisements: Ideology and Meaning in Advertising*, London: Marion Boyars 1978.

On textuality and feminism:
Moi, Toril, *Sexual/Textual Politics: Feminist Literary Theory*, London: Methuen 1985. (However, Moi's brief account of Lacan in this context is inaccurate; for this see the following.)

Grosz, Elizabeth, *Jacques Lacan: a Feminist Introduction*, London: Routledge 1990.

On textuality, class, gender and sexuality:
Dollimore, Jonathan, *Sexual Dissidence: Augustine to Wilde, Freud to Foucault*, Oxford: Clarendon Press 1991.
Easthope, Antony, *What A Man's Gotta Do: the Masculine Myth in Popular Culture*, London: Harper Collins 1990.
Sinfield, Alan, *Literature, Politics and Culture in Postwar Britain*, Oxford: Basil Blackwell 1989.

On textuality and race:
Said, Edward, *Orientalism*, Harmondsworth: Penguin 1985.
Spivak, Gayatri Chakravorty, *The Post-Colonial Critic: Interviews, Strategies, Dialogues* (ed. Sarah Harasym), London: Routledge 1990.

Susan Purdie happily acknowledges the understanding, encouragement and interest of Jeff Collins as aiding this essay.

Chapter 10

Judith Williamson, *Decoding Advertisements*

Liz Wells

First published in 1978, *Decoding Advertisements*, subtitled 'Ideology and Meaning in Advertising', explores the appeal of advertising and analyses ways in which advertisements assume meaning. Drawing upon the work of Saussure and Barthes, Judith Williamson's interest was not in what advertisements mean, but in how they mean. She was concerned to forge analytical links between Marxism and a critique of capitalism, on the one hand, and systematic structuralist methods of analysis, on the other. The book was located within the *Ideas in Progress* series published by Marion Boyars. It became prominent very quickly and, by 1982, was in its fourth impression. In her preface to the original edition of the book she uses the metaphor of a motor maintenance handbook, suggesting that what she has to offer are the tools for dismantling advertising imagery. The purpose of such deconstruction is, of course, to understand better the ideological processes whereby advertising not only functions economically to sell products but also reinforces the social, political and economic discourses of capitalism.

In 1992, sixteen years after writing and fourteen years after original publication, the book remains useful in that it offers a model of textual analysis. However, it seems dated in a number of ways, in particular in its relative disregard of the political and social contexts within which advertising operates. Williamson did note that she could not undertake a full sociological investigation. Given critiques of the limits of structuralist methodologies, this increasingly seems a major limitation. I shall return to this. Furthermore, the nature of capitalist markets within which advertising operates has obviously moved on from the 1970s. Europeanisation, global marketing strategies, economic recession of the late 1980s, 'green' consciousness, and a political agenda scarred by twelve years of Thatcherism, all contribute to making the content, if not the fundamental political argument, seem dated. On a

more positive note, the study incidentally offers a useful visual summary of advertising images and styles of the mid-1970s. Given the rate of stylistic change and technical developments in image-production methods, the examples to some extent stand as historical curiosities.

Judith Williamson is, of course, alive and well and writing regularly. *Decoding Advertisements* is a part of her history as, indeed, it is a significant part of the history both of those who make advertisements and of those of us who analyse them. Rumour has it that, along with publications such as Vance Packard's book *The Hidden Persuaders*, *Decoding Advertisements* speedily joined the classic texts on the shelves of the major design agencies. Understanding how advertisements work is as useful to the advertiser as it is to the semiologist, although their underlying objectives differ rather radically! While I have a number of critical points to make about the book, because academic histories and debates move on they are largely made with hindsight. I should therefore like to start by acknowledging the significance of Judith Williamson's contribution. My first edition copy of *Decoding Advertisements* is well-thumbed and annotated; I return to it often. As a Polytechnic lecturer working in the field of art, media and design I still recommend it to students as a useful text. Williamson offers a detailed study which provided one starting point for many of us involved in analysing ideological processes in relation to the role of advertising.

This essay is centrally concerned with discussing the strengths and limitations of the study, and to comment on its reception on publication, and the degree to which it has enduring value. First, however, it is worth considering the context of its production.

1976 AND ALL THAT

In her preface to the fourth impression Williamson notes that the book was written in 1976. It was first published in 1978. In her original preface she locates its source in a popular culture course which she offered at the University of California, Berkeley, but using many British examples. The course consisted of the formal analysis of a number of advertisements as texts. Her theoretical approach, offered as a fundamental starting position in the book, emerged inductively from this process of analysis. It is perhaps worth noting that Williamson had read English literature at Sussex, then later took an MA in film and television at the Royal College of Art. Both areas of study lie within the arts or humanities where, methodologically, the text tends to be

centralised. It is also worth noting the extent to which structuralism and semiology were fashionable, influential and central to debates within British academia at the time. A flick back through the pages of *Screen* magazine, or a glance at the renowned Open University course in *Popular Culture* which was initially conceived in the late 1970s, offers something in the way of evidence. Indeed, this was the era remembered for the Althusser versus Thompson conflict wherein Althusser attacked empiricism and Thompson argued the poverty of theory. It is difficult to describe retrospectively the sense of excitement, debate and challenge to academic traditions which formed the publishing context of the late 1970s. This may now seem a matter of academic history, but passions were aroused at the time. The British Sociological Association took the theme of 'Culture' for its 1978 annual conference held at Sussex University. As I remember it, a number of sessions overflowed the seating space as debates ran on and methodological tempers ran high!

This was also a time when feminism in Britain was strong: the women's movement was active in relation to a range of issues, and patriarchy in the ivory towers was under assault. The assault involved, among other things, reappraisal of the academic agenda. Art historians were starting to reclaim the work of women artists, the popularity of women's literature became seen as offering insights into female experience and romanticism, and films previously dismissed as 'matinée audience weepies' became objects of analysis. I think the impulse was twofold. On the one hand the academic agenda was being scrutinised and found wanting; that is, it was found consciously and unconsciously to be a patriarchal canon. On the other hand, as women (academics, students, activists, teachers, housewives) we were demanding respectability for studies of objects, experiences and images pertaining directly to our lives. This interest was not restricted to women but also typified a number of studies pursued, in particular, at the Centre for Contemporary Cultural Studies (CCCS) at Birmingham University. CCCS was founded in the mid-1960s very much within the (British) tradition of cultural studies associated with Richard Hoggart and Raymond Williams. This tradition was challenged in the late 1970s with a number of students registering research projects which emerged from fascination or personal obsession with particular popular cultural forms whether women's magazines, rock music, bikers, and so on. It is in the same spirit that Judith Williamson notes her teenage fascination with advertisements and a desire for magazine glamour which was uncomfortably at odds with her reading of Karl Marx and

her feeling of being somehow exploited. I am sure that I am not alone in sharing memories of the desirability of the fantasy worlds of magazines and novels (whose heroines were not only so much more attractive than me but also lived interestingly complex stories which culminated in happy heterosexual coupledom or romantic tragedy). The year 1978 predates the style magazines of the 1980s (*ID*, *The Face*, *GQ*). Aside from Sunday colour supplement advertising, mass-circulation magazine advertising was – and remains – particularly concentrated in women's magazines. Arguably women had then, and still have, a particular relationship with the world of desire on offer.

In summary, I am suggesting that the study emerged from a particular set of academic, political and personal circumstances which may be seen as both facilitating and limiting its particular nature.

FROM THE PARTICULAR TO THE GENERAL

The back cover of the original British edition of *Decoding Advertisements* tells us that the book intends 'not simply to criticize advertisements on the grounds of dishonesty and exploitation, but to examine in detail . . . their undoubted attractiveness and appeal'. The author continues: 'the overt economic function of this appeal is to make us buy things. Its ideological function, however, is to involve us as "individuals" in perpetuating the ideas which endorse the very economic basis of our society. If it is economic conditions which make ideology necessary, it is ideology which makes those conditions seem necessary.'

Williamson highlights her intention to steer a course between the academic and the popular and to effect a reconciliation of the two through her choice of two quotes as epigraphs: one is the extract from The Rolling Stones' song 'I can't get no satisfaction' in which we hear of 'useless information supposed to fire my imagination' and the man who, 'comes on to tell me how white my shirts can be'. The other quote is from Marx's *Critique of Political Economy* where he notes his deductive method of climbing 'from the particular up to the general'. These references sit together somewhat uneasily. The complexity of her objectives is implied in this disjunction.

The book is organised into two parts: in part one she analyses particular advertisements as texts, developing an emergent argument as to the processes whereby advertisements work. In part two she tackles the broader ideological referent systems within which advertisements function. When I first read the book, many years ago, it was the specific analyses in part one which seemed most pertinent. I had just

started teaching graphic design students and here was a handle for inviting them to think about their visualising and, indeed, about ways in which advertisements implicate us ideologically. As time has gone by, I now think that the second half of the book begs closer attention both because of political shifts of the last few years and because, in so far as we are being offered a model of understanding, it remains a starting point for further development.

Given how the book is organised I shall discuss each section separately before moving to an overview.

SATISFACTION

Williamson's starting point is Marx's discussion of commodity fetishism in *Grundrisse* and his distinction between use value and exchange value. She is interested in analysing the ideological processes whereby objects acquire culturally specific values over and above their fundamental use value(s). Economic exchange values are based not simply on use values but complexly on a combination of practical and symbolic usages and associations. Advertising is central to this process of commodification and exchange, operating at the fulcrum of production, pricing and exchange. Hence Williamson's fundamental investigation into first, how advertisements acquire meaning, and second, crucially, how this meaning relates to individual identity. Ultimately her interest lay not in the consumer goods themselves but in the images of ourselves that are 'sold' to us as an integral part of the process of commodification and acquisition of symbolic exchange value.

In part one of the book she analyses particular advertisements. She is concerned to address ways in which advertising works through the currency of signs, through how signs address somebody, and through how we decipher signs. Her examples are posters and magazine advertisements rather than television advertising which means that we are dealing in single images, or examples from a series, rather than time-based imagery. Williamson notes the apparent independence of the world of advertisements, but also acknowledges the continuity from page to screen, although ultimately there is little address to ways in which the interplay between different types and contexts of advertising influences how we read individual images. Her interest is in how what she describes as the ubiquitous quality of the world of advertisements functions to create structures of meaning both in terms of their obvious sales function and in terms of ideological discourses. Taking individual advertisements as 'case studies' she argues that

advertisements translate 'things' or descriptive statements of attributes of any particular commodity into human statements so that, for example, the high mileage per gallon of a car translates into thriftiness or clever saving. In other words, the image addresses us as a certain sort of person. Facts are given symbolic exchange values, translated in terms of human qualities. Are you the sort of person who . . .?

The notion of the 'language' of advertising is something of a commonplace referring to advertising conventions as well as to obvious clichés. Williamson rejects any idea of a single language, arguing that advertising cannot be reduced to a single, apparently coherent, grammar as the components are variable and are not necessarily a part of any one language or social discourse. In this she seems to move on from Barthes's position in *Mythologies* wherein he suggests that advertising can be reduced, in explanatory terms, to a cultural understanding of language (denotation) and myth (connotation). The implication at this stage in his writing is that unified explanations might be possible. Later, in 'The Rhetoric of the Image' Barthes clearly refutes any implication that a simple semiological model is adequate to the analysis of imagery. In this relatively brief essay he notes the complexity of signs and levels of signification implicated denotatively and connotatively in any single image and concludes that there is tension between the rich symbolism of connotation and the 'storyline' or imperative (why we should buy a product) denoted:

> in the total system of the image the structural functions are polarized: on the one hand there is a sort of paradigmatic condensation at the level of the connotators (that is, broadly speaking, of the symbols), which are strong signs, scattered, 'reified'; on the other a syntagmatic 'flow' at the level of the denotation . . . Without wishing to infer too quickly from the image to semiology in general, one can nevertheless venture that the world of total meaning is torn internally (structurally) between the system as culture and the syntagm as nature: the works of mass communications all combine, through diverse and diversely successful dialectics, the fascination of a nature, that of story, diegesis, syntagm, and the intelligibility of a culture, withdrawn into a few discontinuous symbols which men 'decline' in the shelter of their living speech.[1]

Simply quoting from Barthes's summary risks offering a position statement which is not easily understood. But the essay is marked by its clearly written examination of a number of questions of detail and its

careful appraisal of at what point and to what extent it is valid to draw back from the particular towards more general conclusions. In other words, one of the great strengths of the essay is the clear, coherent and specific focus.

Williamson is not so clear. Perhaps she took on too much, but the book is marked by a complexity of intentions – to use semiology, to challenge capitalism, to raise issues of gender, etc. – which together contribute a degree of confusion. While she pays attention to detail, she lacks the precision that characterises Barthes's work. For example, she proposes that advertisements offer a structure which 'is capable of transforming the language of objects to that of people and vice versa'.[2] She draws on the Saussurian distinction between *langue* (grammar or system) and *paroles* (speech or utterances). In other instances she uses the term *language* in a less specific way, for example to indicate that advertising sets up connections between people as consumers and products as commodities. However politely put, the book is a hard read. This is partly the nature of the academic endeavour but it is partly a consequence of complexity of purpose combined with a slightly cumbersome writing style.

Also Williamson's approach is premised on what appears as a degree of surprise that 'things' or objects become symbolic in that, 'supplanted from their usual places in our physical lives, from their material context, [they] take on new symbolic meanings on the hoardings or posters where they are no longer things but signs'.[3] In semiological terms surely any object or artefact has significance as well as function whatever its context? This is regardless of whether it appears as a material object or as a referent for a representation or image (a graphic representation or a more impressionistic or metaphoric image and reference). In other words, why the surprise?

But putting aside the confusion of objectives at a general level, it is clear that Williamson's central interest is in how advertisements mean. Part one on advertising-work draws upon psychoanalysis as well as semiology to explain interpretative processes. The notion of advertising-work specifically references Freud's emphasis on 'dream-work' as the system of creating meaning. Williamson is interested not in the obvious content of the advertisements, that is, the sales pitch, but in the significatory form of advertising. Using Saussure's distinction between the signifier (the thing) and the signified (concepts), she says she is concerned to emphasise the importance of the referent, that is, the actual thing in the real world with all that we associate with it. So yes, the material referent has associated meanings. My point is that

there is a degree of inconsistency. At first reading, many years ago, I felt that these were my misunderstandings; later I am not so sure.

DECODING AND DIFFERENTIATING

Williamson's argument is developed through analysis of selected advertisements. In chapter one she proposes that a key function of advertising is to differentiate between products in the same category of use-value. Thus, for example, perfumes are advertised through the creation of images since, she suggests, they can have no particular significance. Typographically there is a clear distinction between the developing line of argument and the discussion of individual examples which are presented in smaller type size. Each advertisement discussed is shown, although rather small-scale, in black and white only, and with relatively bad tonal definition. Obviously this results from the cheap production of the book; Williamson will not have had any choice or control here. But these design factors make it difficult to read the image let alone any integral written text. This renders the reader over-dependent on Williamson's own discussion of individual examples which I find irritating. But this irritation also reflects my view that colour imagery should be reproduced in colour since the language of colour is a component within communication. For Williamson this is not an issue. She views colour as merely a technique used primarily to make connections within the image which correlate a product and other things. One of the absences from this study is a proper address to the aesthetics question. Indeed, in the logic of this part, decisions involved in the selection and reproduction of particular images are not problematic since her point is that these are single examples from a whole range, ones chosen by her and her students, and sequenced as stepping stones in order to develop her explanatory argument. The argument is not intended to depend on the particular examples. Technically this means that, in empirical terms, we could find our own examples to read and 'test' in terms of her proposals.

Chapter two moves the argument on from questions of how advertisements differentiate between products to a discussion of ways in which signs mean something to us. Thus she discusses how we create meaning through recognition of signs, how we take meaning and are differentiated accordingly (Pepsi drinkers are not Coke drinkers). In chapter three she discusses ways in which we interpret or decipher signs. This leads directly into the second section of the book and into consideration of the limitations of her inductive proposals.

SYSTEMS AND REFERENCES

In this section Williamson is concerned to discuss ways in which images operate connotatively to reproduce particular ideological discourses. She is thus interested in systems of ideas and the bricoleur effect whereby advertisements reference 'odds and ends from ideological thought that already exists'.[4] She emphasises that these odds and ends exist through the appeal to the reader since ideology works through people.

Following Lévi-Strauss Williamson discusses the transformative processes whereby natural objects become located within cultural systems as cultural artefacts: for example, an image on a tin can come to stand for 'the Natural'. Nature becomes a referent which symbolises the romantic ideal of The Natural. She argues that exchange values are derived from the processes of transformation, from the fact of the insertion of the food or artefact within a cultural system. Developing from this, she suggests that references to the imaginery 'natural' also function to obscure the extent of the intervention of science and technology and, indeed, industrial production processes. Manufacture represents a way of controlling raw, untamed nature, and culture works to obscure the facts of control by reaffirming naturalness. As with the previous section, the argument is developed through detailed readings of specific examples and, at this level, seems convincing.

Lack of discussion of the reader and the possibilities of diverse responses according to social, regional, biographical difference limits the credibility of Williamson's conclusions. To take an obvious example, nature and The Natural must have different and diverse meanings for urban dwellers and for farmers, rural workers and, indeed, land-owners. Since ideology works through people, surely there must be points of tension between mythological systems and experienced realities which offer possibilities for resistance and change. If we cannot make acceptable sense of experience through the ideological discourses and political categories on offer, we may start to seek alternatives. Given Williamson's Marxist stance the lack of proper address to the reader as active, individualised subject located socially and culturally is one of the key weaknesses of the study.

Williamson goes on to suggest that advertisements, operating narratively both within history and drawing upon ideas of history as referent, are spells as they offer magical transformations, promises of changes in lifestyle or personal attractiveness premised on the acquisition of products. Raymond Williams has also referred to advertising as 'the Magic System' which he sees as 'a highly organized and profes-

sional system of magical inducements and satisfactions, functionally very similar to magical systems in simpler societies'.[5] While Williamson is using the term in rather similar spirit, Williams adopts a clear materialist analytic model:

> The essence of capitalism is that the basic means of production are not socially but privately owned and that decisions about production are therefore in the hands of a group occupying a minority position in the society and in no direct way responsible to it. Obviously, since the capitalist wishes to be successful, he is influenced in his decisions about production by what other members of the society need. But he is influenced also by considerations of industrial convenience and likely profit, and his decisions tend to be a balance of these varying factors. The challenge of socialism . . . is essentially that decisions about production should be in the hands of the society as a whole, in the sense that control of the means of production is made part of the general system of decision which the society as a whole creates. . . . The fundamental choice that emerges, in the problems set to us by modern industrial production is between man as consumer and man an user. The system of organized magic which is modern advertising is primarily important as a functional obscuring of this choice.[6]

Williamson does not refer to Williams's article (originally published in 1960). Ye he has a number of points to make which would, I think, have helped to anchor her semiological approach. In particular he engages with the position of the advertiser noting that advertisers are themselves imbued in the 'magic'.

> They may have a limited professional cynicism about it, from knowing how some of the tricks are done. But fundamentally they are involved, with the rest of the society, in the confusion to which the magical gestures are a response. Magic is always an unsuccessful attempt to provide meanings and values, but it is often very difficult to distinguish magic from genuine knowledge and from art.[7]

I make no apologies for quoting extensively from Williams as his work provides something of a corrective and complementary starting point for study within this field.

CRITICAL RESPONSES

In researching for this essay I was surprised to find that the original critical reception for *Decoding Advertisements* was relatively muted. A

library search threw up four reviews of interestingly diverse source and viewpoint. The *Christian Century* states that

> Williamson reproduces scores of illustrated advertisements and then decodes them. Her choices are apt, and they merit decoding and devastation. But she links her work to all the fashionable forms of structuralist hermeneutics (in a self-advertisement of elitist educationalism) and employs a mind-numbing kind of Marxism, thus obscuring the subtleties for sake of dogma.[8]

This brief comment tells us little about the book (although it did leave me speculating as to what kind of Marxism the *Christian Century* would find mind-expanding).

Gene Laczniak, writing for *The Library Journal*, is equally brief. The review is categorised under 'Business' which in itself has a certain paradoxical appeal since Williamson's fundamental intention is to challenge the tenets of capitalism on which business as we know it is founded. He notes that she 'thoughtfully points out how the security or sex appeal or sense of belongness conveyed by an ad is more persuasive than the product itself', but I am not certain whether this use of the term 'thoughtful' is intended to be appreciative or sardonic. He continues:

> Williamson's intimation that the use of such images may constitute a sly attempt by sellers to manipulate the consumer is both irritating and naive. Of course images are used to sell certain commodities! People do not fundamentally seek products: they want satisfaction and benefits: an adolescent buys 'social acceptance' more than a skin cleanser. An entertaining book, but Williamson's 'secret' insight is taught in any basic business course.[9]

Certainly, from the perspective of those concerned with psychology and marketing, Vance Packard's work from the 1950s must be among the texts that appear to show up the limitations of Williamson's enthusiasm, although her detailed attention to texts and to the processes involved in the decoding of single images could be seen as complementing and extending previously established advertising tenets.[10]

By contrast with these two brief reviews, John Sturrock, writing in *The New Statesman*, is lengthily antagonistic. He uses the publication as an excuse for a paragraph of memories of his life in advertising then moves on to comment on the book:

> The title was honest and attractive – the deceptions and mal-

practices of the admen were going to be laid cruelly bare. But if Ms Williamson means well, she writes uncommonly badly. She lays nothing bare, and anyone clever enough to understand what she is saying would undoubtedly be clever enough to decode even the most fiendishly subtle advertisement without her help. . . . Semioticians worth their salt are adept at reading between the lines; Ms Williamson manages actually to write between them, and there were occasions as I forced my way loyally through her pages when I felt I must be reading not an original English work but a translation from the French of some uncritical stooge of Louis Althusser.[11]

The point about writing style may be justifiable. But otherwise what we read here is an antithesis to French Marxist theory that reminds us again of the strength of feeling engendered in the then current debates on the left between empiricist and structuralist methodologies. Sturrock adds that:

The public . . . is not as gullible as she rather patronisingly implies; nor, for that matter, are the advertisers so desperately cunning. Advertisements are a byword for the incredible; people disbelieve them on principle, at any rate so long as they know that what they are faced with is an advertisement . . . Ms Williamson is a demonologist who would have us believe in those superannuated bogies, the Hidden Persuaders, tampering subliminally with our intimate selves. But advertising remains obstinately superficial. It may call in the Freudians, but they will find that the Admass has no tamperable Id.[12]

I think there are several points to be made in response to this critical comment. First, Sturrock implies that Williamson adheres to a sort of psychological conspiracy model in terms of understanding advertisers and their approach. This is not how I interpret her explanatory approach. Indeed, as I have suggested, in her focus on advertisements as texts, Williamson has more-or-less nothing to say about advertisers and their motives. Arguably this is one of the limitations of the book. Second, Sturrock asserts that people disbelieve advertisements on principle. How does he know? This type of comment refuses the significance of everyday experience and dismisses the relevance of debates as to the nature of ideological processes. Williamson's enterprise is clearly located within these debates. This type of comment is also blind to the study of everyday cultural experience (about which I need hardly comment since this reader is founded on the logic of the validity of cultural studies).

Third, and associated with the above points, Sturrock's observations on people's disbelief in advertising include the passing comment that this rests on them knowing that 'what they are faced with is an advertisement'. Again, in her focus on the advertising text and on interpellative processes, Williamson does not discuss recognition or, indeed, failure to respond. For her, if an advertisement fails to hail its reader it therefore is meaningless to the reader and consequently falls outside her terms of discussion. She does not address the question of how we recognise advertisements as what they are, how we categorise this genre of visual imagery. In her focus on texts, Williamson has very little to say about the contexts – and the implications of various contexts – in which images are encoded (by the producers) and decoded (by readers).

This latter point is taken up by Trevor Pateman in his discussion of understanding advertisements.[13] He argues that there is a need to complement theories of formal systems with a general theory of communication. He therefore wants to establish how we recognise advertisements as advertisements in the context within which they have been expected (for example, on television or in magazines). As he suggests, recognition logically precedes processes whereby advertisements as specific texts become meaningful. By implication, semiology is insufficient on its own.

Writing in 1989, Giuliana Muscio engages with the limitations of Williamson's study, likewise noting the problems of restricted methodology, and argues that *Decoding Advertisements* has not aged well and that 'its simplistic structuralist–semiotic approach appears dated, and therefore its utility as a "cultural handbook" has waned'.[14] She adds that the theoretical framework 'belongs to that kind of intellectual bricolage that makes "systematists" and theoreticians jump from their seats', meaning, with horror! As she points out, even if the book offered adequate explanation of the ideological function of advertising, would 'explanation' be enough to change the work of advertising and, indeed, the system which underpins it? Arguably the act of criticism and faith in intellectual achievement may, like the magic of advertising, obscure the need for real political action towards social change.

TO SUMMARISE

In her preface to the fourth impression in 1982 Williamson clearly acknowledges that both advertising and the theoretical debates of the late 1970s have moved on. But she restates her view that:

Marxists – and anyone who wants radically to change our world – cannot afford to reject some of the basic structuralist–semiotic theories. In emphasising how meaning is produced these theories move away from the old idealism of essential meanings, of fixed values taken for granted, of social phenomena seen (conveniently) in isolation, not as part of social systems. They stress that meanings are specific for particular societies, classes, periods of history: not God-given and immutable.[15]

Her fundamental interest is in the ideological processes whereby objects acquire culturally specific values over and above their use value(s), hence her analysis of the role of advertising in the process of commodification and exchange.

I think this restating of Williamson's political and academic starting point is useful in considering the limitations of the study both then, when originally published, and now. As I have suggested, the key limitations are the focus on textual analysis to the exclusion of contextual discussion, and the extent to which assumptions are made about readers of advertising texts. There is reference to issues of class, gender etc., but ultimately the analyses of the advertisements assume that the readers are people rather like Williamson and her students. This assumption is a consequence of the centrality of semiology as the explanatory approach and method. While I take her starting point that Marxists and other radical critics needed to take on board the potential of structuralist methodologies in terms of better understanding ideological processes, the focus on text and relative exclusion of contextual discussion is perhaps not the best method of persuasion. In attempting to do too much, the book achieves too little. There is still space for more comprehensive studies within this field.

That this study was not fully coherent and comprehensive is perhaps clearer with hindsight than it was on publication for a number of reasons. First, debates about the extent and limitations of structuralism within academia meant, I suspect, that the book was to some extent accepted or rejected out of positions on the left rather than in relation to its own value, insights and limitations. Second, as indicated in some of the reviews discussed above, while it challenged different aspects of the established order, the clear political stance and the academic limitations of the study left open possibilities for summary dismissal from a number of points of view. As it has become dated it has also become notable both as a record of the state of magazine advertising in

the mid-1970s and as a starting point for discussion of methods of analysis and methodological debate.

On a rather different note, the book loses some benefit of the doubt by being about visual texts yet eschewing some of the production values which might have made the analysis and argument clearer. Although there is the convention of different type point size for analysis of each text, on the one hand, and development of the overall line of argument, on the other, there are many other ways in which good graphic design could have helped readability. In particular, we are asked to take on board arguments about the language of colour in relation to advertisements which are presented to us in low quality reproduction in black and white only! I am not advocating coffee-table style uncritical glossy imagery, but imagine analysis of, say, literary texts with one dimension of language – perhaps metaphor – missing!

Debates have moved on from the 1970s as have advertising styles, motifs, and production considerations. In so far as Williamson focuses on British advertising and its influences, we would now look much more centrally at the implications of Europe in terms of global market systems, marketing strategies and contexts, and discussions or speculations as to how readers maker advertising meaningful. The book has not aged particularly well, but despite its limitations *Decoding Advertisements* may still prove useful in indicating one type of starting point, to be used in conjunction with other starting points, for these discussions.

NOTES

1 Barthes (1977), p. 5.
2 Williamson (1978), p. 12.
3 Ibid., p. 71.
4 Ibid., p. 101.
5 Williams (1980), p. 185.
6 Ibid., p. 186.
7 Ibid., p. 189.
8 *The Christian Century*, vol. 96 (25 April 1979), p. 476.
9 *Library Journal*, vol. 103 (15 December 1978), p. 2515.
10 *The Hidden Persuaders* was first published in 1957. Packard was concerned to explore ways in which 'American super-advertising-scientists' manipulate consumers through use of mass psychoanalysis.
11 *New Statesman*, 17 March 1978, p. 364.
12 Ibid.
13 Pateman (1983).
14 *Quarterly Review of Film and Video*, vol. 11, no. 1 (1989), p. 124.

15 Williamson, December 1982.

I should like to thank my colleagues Guy Julier and Derrick Price at Bristol Polytechnic for their helpful comments on this essay.

REFERENCES

Barthes, R., *Mythologies*, London: Granada 1973.
Barthes, R., 'The Rhetoric of the Image', in *Image-Music-Text*, London: Fontana 1977.
Betterton, R. (ed.), *Looking On* (section one), London: Pandora 1987.
Coward, R., *Female Desire*, London: Paladin 1984.
Dyer, G., *Advertising as Communication*, London: Methuen 1982.
Goffman, E., *Gender Advertisements*, London: Macmillan 1979.
Myers, K., *Understains*, London: Comedia 1986.
Packard, V., *The Hidden Persuaders*, London: Pelican 1962.
Pateman, T., 'How is Understanding an Advertisement Possible?', in H. Davis and P. Walton (eds), *Language, Image & Media*, Oxford: Blackwell 1983.
Williams, R., 'The Magic of Advertising', in *Problems in Materialism and Culture*, London: Verso 1980.
Williamson, J., *Decoding Advertisements: Ideology and Meaning in Advertising*, London: Marion Boyars 1978.
Williamson, J., *A Sign is a Fine Investment* (video), Arts Council.

Chapter 11

Paul Willis, *Learning to Labour*

Beverley Skeggs

When I first read *Learning to Labour* (*LTL*) in 1979 I felt I had been enlightened. It evoked, very powerfully, the dignity that is fought for by those experiencing oppression. For the first time the working class were presented as strong, defiant, belligerent in their creativity, and humorous. It was a change from all the passive-victim categorisations of compensatory social policies. It made a lot of sense. It showed how young working-class men wield power. It also showed how they contributed to their own subordination. It pointed out that there were few dignified alternatives to their action. It didn't blame them, or the working class in general. It demonstrated that young white working-class men made history but not in the conditions of their own choosing, and in so doing their oppression and that of others was ensured.

LTL is a study in the irony of human action.[1] It focuses on twelve boys – 'the lads' – in their last two years at 'Hammerton' school in the West Midlands through into the early months of their work. It explores their actions and responses to the school, their accounts of their escapades in their own culture and their responses and those of their family, particularly fathers, to the world of work. It is set in the early 1970s when unemployment was not a central issue. It asks why working-class boys take working-class jobs (which involves degradation of themselves) voluntarily, positing 'the difficult thing to explain about how middle-class kids get middle-class jobs is why others let them' (p. 1). Willis explores how the process of cultural and economic reproduction is made possible by 'the lads' ' celebration of the hard, macho world of work. He shows how the school system contributes to this process. For instance their resistance to the authority of the school system takes place in the context of and as a *result* of their future positioning in the labour market. It is their own (macho) culture and the organisation of the school which, Willis argues, determines their

responses to the institution of the school, and ultimately the labour market. The action and agency of the individual 'lads' is framed by the institutional location of the school and the structural organisation of the labour market. Willis shows how gender masculinity – articulates with class. The book is divided into two sections: the first is based on the research and is designed to be for practitioners (these are not defined). The second examines the research findings in more detail in relation to social theory. The research was collected from observation and participant observation in the school with pupils and teachers and during leisure activities. It develops from the anthropological ethnographic tradition in youth cultural studies in which observers enter into the culture of a specific group to understand and expose its workings. Willis added Marxist theoretical analysis to such methods.

SHIFTING PARADIGMS

In the 1970s the relationship between cultural studies and education was much closer than in 1992. Willis was part of an Educational Studies Group at the Centre for Contemporary Cultural Studies at Birmingham University (CCCS). The centre produced a substantive analysis of the development of the education system.[2] The Educational Studies Group was concerned to effect political change by locating the potential for it; there was a strong practical commitment to their work. This is demonstrated in the conclusion to Willis's work which makes suggestions for teachers and those involved in the other pedagogic and counselling practices. He notes that:

> If we have nothing to say about what to do on Monday morning everything is yielded to a purist structuralist immobilising reductionist tautology: nothing can be done until the basic structures of society are changed but the structures prevent us making any changes . . . To contract out of the messy business of day to day problems is to deny the active, contested nature of social and cultural reproduction: to condemn real people to the status of passive zombies, and actually cancel the future by default. To refuse the challenge of the day to day – because of the retrospective dead hand of structural constraint – is to deny the continuance of life and society themselves. It is a theoretical as well as a political failure. (p. 186)

This sentiment embodied the political paradigm shifts that were occurring within sociology. It represents an attempt to break free from

the immobilising shackles of the fatalistic analysis of the power of ideology present at the time, in order to challenge practically the continuance of inequality. Willis's work is thus contingent upon struggles over theoretical frameworks which attempted to explain and challenge inequality, notably the production of the 'New' sociologies of education and deviance.

New sociology of education (NSE)

In the early 1970s the sociology of education was experiencing a paradigm shift. This was partly in response to the changes in the discipline of sociology as a whole, i.e. a challenge to positivism and the impact of phenomenological sociology.[3] In 1971 Michael Young initiated the NSE by challenging the assumption that education in itself was a 'good thing'.[4] Previous theories drawing on a structuralist–functionalist epistemology located the reason for inequality directly in the culture of working-class pupils: hence the emphasis on compensatory education programmes. Using phenomenological theory Young made problematic what actually counted as education. This relativising of educational values led to the suggestion that inequality could be ameliorated through changes in the curriculum and in teachers' perceptions of pupils. There was no need to analyse the structural organisation of education: any change could be produced by consciousness-raising.

During this period other analyses were focusing on the role of the education system in *reproducing* the inequalities of capitalism: Bernstein (1971) and Bourdieu (1971) drew upon empirical evidence to substantiate their theories, Althusser (1971) emphasised the role of ideology in different sites of the state apparatus.

In the mid-1970s the emphasis returned to the structural. This was initiated by Bowles and Gintis (1976) who in a study of schooling in capitalist America returned to the structuralist–functionalist analysis that predated the NSE, yet this time the morality had changed: the system was bad rather than the participants. Bowles and Gintis argued that official school knowledge makes no difference to the overall reproduction of inequality. Rather it was the *correspondence* between the social relationships of work and the general structuring of the occupational system and its reproduction in the organisation and social relations of schooling.

Kuhn (1978) argues that correspondence theories made a selective interpretation of Althusserian theories of ideology. Althusser main-

tained that consciousness was not a reliable index of social reality but its distorted or false representation. Bowles and Gintis developed this by arguing that the main function of education was to inculcate students with the aptitudes and dispositions necessary to accept the social and economic imperatives of a capitalist economy. Willis reversed the emphasis. Rather than seeing wider cultural factors as making only a moderate impact into an all-encompassing educational system, he argued that it was education that participates in the cultural field of social groups, who choose and affirm their social membership and cultural identity. Willis challenged the view that schools were destined to resign youth to their fate. Incorporation into capitalist inequality was ultimately achieved by the participants themselves rather than any overpowering system. Politically this opened up the possibility of structural change from individual action.

The new sociology of deviance (NSD)

Willis also draws upon and challenges previous work on youth cultures and the sociology of deviance. For instance Miller (1958) argued that delinquency, although at odds with the values of the dominant society, was a result of conformity to the values of what he called the lower-class community. He believed that delinquency arose because young boys who are exposed to lower-class culture *over-conform* to its standards. Miller's work in the USA was followed by other theorists such as Cohen (1955) and Cloward and Ohlin (1960) who suggested that working-class youth form *reactive cultural formations* to the dominant middle-class culture. Cloward and Ohlin suggested that those who are denied access to the rewards of mainstream society can find illegitimate ways of having the same rewards. Cohen developed this analysis, arguing that the criminality of youth was not an attempt to gain the rewards of dominant society but an activity that was undertaken for the pleasure in itself: deviance was entertainment for those involved. Matza (1969) rejected the ideas of theorists who sought to define a *delinquent subculture*. Rather, he argued, there exists a subculture of delinquency in which delinquent behaviour is only one of many activities that the group may be involved in. Moreover, Matza argued that the youth involved may subscribe to the values of the dominant culture as well as holding values specific to their own local communities.

In 1975 the CCCS book *Working Papers in Cultural Studies*[5] (*WPCS*) initiated the framework from which Willis's work emerged (Willis

contributed a paper on the cultural meaning of drug use). The introduction refers to the importance of Howard Becker's *Outsiders* (1963) for signalling a paradigm shift in traditional sociological analysis on youth cultures. Becker viewed deviance as a social creation, a result of the power of some to label others.

In *WPCS*, Corrigan and Frith (1976) point out the lack of analysis of institutional location in previous studies of youth culture. They argue (using Gramsci) that working-class culture cannot be understood without reference to the history of the state and to the history of those institutions which function to maintain and reproduce the social relations of capitalism, in part precisely by seeking to incorporate the working class ideologically and institutionally.[6] Willis added the new ingredients of institutional setting and masculinity to previous studies of youth and working-classness.

Unlike Hebdige (1979) who chose to focus on symbolic systems, Willis was less interested in the flamboyant styles of subcultures and more in the class base from which subcultures emerge. Clarke et al. (1976) in *WPCS* had argued that there is no 'subcultural career' for the working-class lad, no 'solution' in the subcultural milieu, to the problems posed by the key structuring experiences of the class such as unemployment, educational disadvantage, compulsory miseducation, dead-end jobs, the routinisation and specialisation of labour, low-pay and the loss of skills. They proposed a *double articulation* of youth subcultures, first to their 'parent' culture, and second to the dominant culture, arguing that the young inherit a cultural orientation from their parents towards a 'problematic' common to the class as a whole. This then weighs, shapes and signifies the meanings they attach to different areas of their social life. Culture rather than youth became the determining feature of the *WPCS* analysis that was adopted by Willis:

> The term *youth culture* directs us to the *cultural* aspects of youth. We understand the word *culture* to refer to that level at which social groups develop distinct patterns of life and give *expressive form* to their social and material life-experience. Culture is the way, the forms, in which groups handle the raw material of their social and material existence.
>
> (Clarke et al. 1976, 10)

Thus, another paradigm shift: 'youth culture' moved from being delinquent to being the potential vanguard of political change, a metaphor for wider social change. *LTL* can be seen as a product of

these changing debates. It located the sites for the reproduction of inequality to be in the relationships both between the school and the labour market and between the parent culture and the labour market. It added masculinity into the analysis and focused attention on the actions of individuals who actually do the daily work of cultural and economic reproduction.

RHETORICAL DEVICES/SEDUCED BY THE TEXT?

Ethnographic accounts depend upon the plausibility of the representation. The narratives and descriptions, the examples and characters and the interpretative commentary are woven together in a highly contrived product.[7] In many ways *LTL* operates in the same way as a television series or film. It has enough believable accounts of dramatic incidents to do a soap opera proud. It provides vicarious access into a world which the majority of readers would be unlikely to inhabit. It also fits into a discursive framework of established codes and conventions which celebrate the anti-authoritarianism of working-class masculinity: just think of the Angry Young Misogynists of the 1950s, Bleasdale's *Boys from the Blackstuff* or the more recent romantic celebrations of the glamorised and dangerous working-class men in *The Krays* and *Goodfellas*. Hebdige (1976) is aware of this when he makes the links between the mods and the 1960s depictions of gangsterism which operates as a form of popular fantasy '. . . in a word, living cinema' (p. 95).

Edmondson (1984) argues that splitting *LTL* into two parts involves the reader who 'believes' in the first part (the supposedly non-theoretical section) in finding the analyses of the second half more plausible:

> The most striking feature of the order of Paul Willis's book is that it enables the reader to evolve a certain personal response to its subjects *before* the author advances a detailed sociological account of their situation. The response which the first part of the book is clearly intended to evoke is one of sympathy: sympathy not just in the sense of particular feelings towards Willis's subjects, but also in the sense of a preparedness to consider their points of view and to refrain from the dismissive evaluations of their conduct which are usually (the book makes clear) from people outside their own class and group.
>
> (Edmondson 1984, 42)

It is possible that readers of the first half of *LTL* 'recognise' the situations it describes. I certainly did. In particular the anti-authoritarian statements by the 'lads' which articulate the pettiness and injustices of the educational system are likely to produce recognitions from readers. In a similar way it would be difficult not to be seduced into sympathetic laughter at the accounts of assembly behaviour, museum visits and street re-organisations by 'the lads'. The account of how the 'lads' are able to subvert the teacher's information on Picasso and mopeds into a news commentary intervention into an advertising jingle certainly wins admiration for their creativity (p. 80). The comment by Joey 'even Communists laff' (p. 29) momentarily creates a link between the reader and the speaker. We all are, at some time, involved in 'having a laff'; we understand. The resistances to any empathy or sympathy with the 'lads' because of their sexist, racist and homophobic comments is partially ameliorated through the dignity and creative insubordination that they maintain in their dealings with the injustices they face.

In fact, *LTL* attempts to win our sympathy right at the beginning:

> I argue that it is their own culture which most effectively prepares some working class lads for the manual giving of their labour power. We may say that there is an element of *self-damnation* in the taking on of subordinate roles in Western capitalism. (p. 3)

> The *tragedy* and the contradiction is that these forms of 'penetration' are limited, distorted and turned back on themselves, often unintentionally. (p. 3)

Can we resist? The cover of the second edition of the book, with its black and white grim social realist photographs of wasteland and heavy industry, prepares us for the inside content.

McRobbie (1980) has criticised male subcultural theorists, Willis included, for their lack of presence in the narrative. But Willis does use rhetorical devices such as the associative 'we': 'Just because *we* have looked at the "richness" of the cultural response of "the lads" *we* should not forget what that response is to' (p. 77).

The political commitment of Willis is also seductive. This was particularly refreshing in 1977 when the majority of left theorists only offered fatalistic despair in the face of the all pervasive effects of ideology. Willis argues that the cultural reproductions of working class boys contains the possibility of radicalness. He also argues:

The identification and understanding of the cultural level is an action to bring it closer to self-awareness and therefore to the political, to recognise in the materiality of its outcomes the possibility of the cultural becoming a material force. Such a politicisation of culture is actually one of the pre-conditions for, and an organic element of, longer-term structural change. (p. 192)

This optimism led to many researchers at the time (myself included) searching for, and actually believing in, the radical potential in every cultural action.[8] Resistance was, for a time, to be found almost everywhere. It was not until the mid-1980s that people began to ask why all this resistance was remaining as just that.

So, *LTL* was a culmination of several paradigm shifts which provided the possibility for theorising political change at the level of individual action which would also transform structural relations as a result. Not only did this theorising hold out something to grasp on to, it also seduced us into this belief – not difficult if you were desperate for some hope of political transformation – by its dramatic account of dignity under degradation. For those who came from the working class there was the confirmation of what we already knew: that the working class never take it sitting down (is this the Gracie Fields of sociological theorising?) and were always far more sussed than the theorists who portended to explain our lives away as problems and delinquents. Conceivably, for middle-class socialists it enabled a reconfirmation of beliefs in the revolutionary potential of the working class – if only they weren't so sexist and racist.

What, then, can we now say of the balance-sheet of the legacy of *LTL*?

Legacies, achievements and changes

First, one of the problems in trying to outline these facets of *LTL* is that many of them have become incorporated into our theoretical common sense. It is difficult to stress the originality with which they first appeared.

LTL attempted to understand subjectivity in relation to structure:

Settling for manual work is not an experience of absolute incoher-ence walled from enlightenment by perverse cultural influences, nor is it that of activistic innocence deeply inscribed upon by pre-given ideologies. It has the profane nature of itself, neither without meaning nor with the other's meaning. It can only be lived because

it is internally authentic and self made. It is felt, subjectively, as a profound process of learning: it is the organisation of the self in relation to the future. (p. 172)

While this now reads as naïve in relation to theories on the multiplicitousness of subjectivity, and whilst the profundity of the experience was not demonstrated, it did constitute a shift from theoretical frameworks which examined the labour market, the education system or 'the self' as separate entities. The attempt to show how structure was lived and reproduced within labour and education was relatively new.

Second, *LTL* gave dignity back to the working-class responses to education. Willis challenged the deficiency views of working-class culture and the vulgar reductionism of Althusser which insisted that pupils were empty vessels being filled up with ideology. *LTL* demonstrated that the 'lads' did not occupy an imagined relation to their real conditions of their existence but were acutely aware of and able to articulate their real conditions. Using the rather unfortunate term 'penetrations' to describe this awareness, Willis argues that it was limited by blocks, diversions and ideological effects which confuse and impede full development and expression. Willis demonstrated that the working class is the only class in the capitalist social formation which does not have a structurally-based vested interest in mystifying itself. Only the bourgeoisie have to believe in the legitimations of capitalism. The indifference of 'the lads' to work and their knowledge of its inherent meaninglessness are a measure of the cultural penetration of their real conditions of existence.

Third and similarly, 'the lads' just do not believe that qualifications have any value: for what they want to do, they do not. Like Bourdieu and Passeron (1977) and other social theorists they know that certificates obscure the meaningless nature of work. They know that qualifications lead to social exclusion. For them it would mean social exclusion from their own culture and friends. Willis argues that conformism to the culture of certificates only holds logic for individuals, not for the class as a whole – if it did there would be massive social transformation as the entire working class achieved social mobility.

Fourth, Willis also showed how the 'lads' were able to differentiate themselves from other groups. They not only wanted to evade the control of others but also the control of time. They were able to set up distinctions, rather than having them imposed through the bourgeois

workings of 'taste'.[9] Willis shows how control and creativity are exercised from within subordinate class positions.

There are, however, problems with *LTL*. First, Willis shifts between different definitions of ideology. He maintains that ideology is separated from the cultural: 'ideology works on and in, produces and is partly produced by, the cultural' (p. 160). He does not specify how. Within this he also wants to retain a concept of ruling ideas and dominant ideology. And whilst claiming not to use the concept 'hegemony' because the meaning of it is uncertain, he does refer to the hegemony of common sense which is also partly produced from above and below: the downward vertical implants of ideology on the counter-school culture are those of confirmation and dislocation (p. 161). This is called having-your-cake-and-eating-it analysis. Willis argues that the reason why the insightful penetrations do not lead to political action is their partialness. Gender, race and the mental/manual division stop the full potential being reached. This recreates the very problems that Willis was trying to escape. Penetrations are made possible by 'the lads' ' investment in their masculine superiority through manual labour. This reproduces their racism and sexism, and thus the penetrations work against each other: many men/racists have insights/penetrations into the benefits that sexism/racism brings. This does not necessarily lead them into wanting to give up those benefits.

Second, one crucial theoretical pivot for the analysis is the assumed existence of a mental/manual division of labour. Willis is not alone in this: Browne (1981) maintains that such a division is the central structural constraint and organising principle of institutional education. Traditionally the mental/manual division is located directly in production rewarding those who conceive, control, plan and manage as against those who merely execute tasks.[10] Willis shows how the 'lads' are able to invert this division through the subjective creation of identities in manual labour. They are able to do this by associating anything connected with mental labour as feminine. Thus the negative qualities that the 'lads' associate with femininity can be used to dismiss the value of mental labour.

However, this analysis can only be sustained for the male sexual division of labour. For even though the majority of women are to be found in the non-manual sector, this has little to do with the conception, planning and managing of work tasks. There is no way that working-class girls can invert the status of mental and manual labour to confirm the value of their future in unskilled work.[11] There can be no wholehearted endorsement of manual labour because it is considered to

be masculine and dirty; it does not have any of the connotations of glamour found to be important in girls' occupational aspirations.[12]

Third, Willis also introduced masculinity into the equation between education and work. Tolson (1977) provided the basis for this analysis; Willis showed how it was an integral part of everyday social relations. Masculinity was used as a defence for dealing with the powerlessness 'the lads' faced. This use was less of a penetration, more of a way of creating distinctions in a hierarchy of oppression. In the everyday guerrilla war they conducted in the classroom, no quarter was given to a weak opponent. They were continually having to prove themselves against each other. This was consolidated in the school where 'grassing' is a major offence. There was no respite from masculinity, its achievement was relentless. Willis argues that work represents a place of masculine safety where they can continue to be 'the lads'. Willis does not differentiate between the coping strategies used to overcome powerlessness, and the exercise of power.

Fourth, although they are left untheorised, Willis provides descriptions of how sexuality pervades the power structure of the classroom: the 'lads' fake masturbation, they continually recite chat-up lines, accusations of homosexuality are frequently invoked to win points in a competitive conversation, they call a female teacher 'a cunt' to undermine her authority, they are admired by teachers for their sexual prowess. The language they use is brutal, violent and misogynist; women are there to be used, they are defined, labelled and categorised in ways that 'the lads' themselves fiercely resist. They speak of rape: 'you know, you're struggling with her, fighting, to do it, and you've got her knickers down' (p. 43) which is theorised by Willis as a complex of emotion. Yet even the fear of women, noted by McRobbie (1980), articulated through their frequent references to menstruation, is seen as a product of their resistance, rather than as a legitimation and articulation of power and domination.

McRobbie notes how studies of 'youth' are central to the development of cultural studies, but also how these studies, based on men, conducted by male researchers, only serve to consolidate the association that youth equals male. Willis's study is part of this process. By representing these racist, sexist and homophobic 'lads' as dignified in their degradation, he perpetuates not only the close relationship between education and the labour market, thereby excluding the family, but also reproduces and legitimates the equation that youth equals 'the lads'. Willis re-presents 'the lads' as if they were *the* working class. *LTL* operates on the implicit acceptance of 'the lads''

definitions: these are not questioned, enabling Willis to incorporate their frameworks into his analysis uncritically.

Fifth, Willis makes extensive use of transcripts, yet the conditions for their production are not very clear. It seems apparent that data were selected on the basis of 'dramatic indicators', similar to the selection of the best photograph.[13] The lack of voice given to the 'earoles' (the conformist boys) does suggest that the boring everyday mundane might not make such a good story. It may also suggest over-identification with one group,[14] in particular over-identification with one 'lad', namely Joey, whose insightful comments dominate the book. Does he speak for the rest?

There is also a problem of validity when generalising from just twelve boys. He says the 'lads' were selected on the basis of 'some kind of oppositional culture' (p. 4), and that a comparable 'conformist' group were also selected. If accounts were chosen for their explanatory power in relation to the theoretical framework, and for their ability to exemplify the structural relations as they were lived at the level of everydayness, this should have been specified. We gain no sense of whether the research fits the theories or vice versa. In this sense the theoretical analysis was not a discrete event but an integral part of the research process. The lack of accounting for the actual production of knowledge means that Willis puts his own intentions and action under less scrutiny than that of 'the lads'.

Willis makes theoretical interpretations of the comments made by the 'lads'. It is a useful theoretical and methodological exercise to construct possible alternative interpretations, and unpack the assumptions that underlie these alternative explanations. For instance, Meighan (1978) notes how Willis perceives acts of violence, vandalism and sexism to be part of the 'lads'' feelings of superiority. He suggests it may be more a product of alienation, resentment or frustration.

CONCLUSIONS

LTL appeared at (if there can ever be one) the right historical moment. Willis fed into the transformations of both the theoretical and methodological premises of the disciplines of sociology of education and sociology of deviance. In so doing he carved out a niche for cultural studies. He suggested that it was possible to find the potential for transformative cultural-political change whilst also including structure in his analysis of interaction. He even showed how central gender was to this process. If this was not enough, he was able to use seductive

rhetorical techniques on the reader; it is difficult to resist the poignancy and acuteness of the accounts. And although there were major flaws in the analysis he did move the debate into a different political terrain. It was no longer about equality of opportunity in schools, for what difference would that make according to his analysis? It was about culture. It was no longer about problem children but about problematic structures.

The important legacies of his analysis – institutional responses, the labour market and the state – have now been clouded by the multifarious attempts to take up his legacy of resistance, now often uncritically reworked (as the concept of pleasure). In making possible the consolidation of a political paradigm shift Willis paved the way for optimism and hope. When I began this analysis I could see only problems and lacks (race/gender; sexuality/power). Now I'd feel grateful if many other cultural theorists were able to theorise structure and agency in relation to institutional frameworks. The political and theoretical integrity has been lost in much of the game-playing of postmodern discourse[15] while others search for resistance/pleasure in anything they can find. On a final, more hopeful note, the limits to Willis's analysis have now been surpassed, interestingly not by himself in his recent work, but by feminist scholars such as McRobbie (1991) and Walkerdine (1990).

NOTES

1 Paul Willis, *Learning to Labour: how Working-class Boys get Working-class Jobs*, London: Saxon House 1977.

2 D. Finn, N. Grant and R. Johnson, *Unpopular Education: Schooling and Social Democracy in England since 1944*, London: Hutchinson 1981.

3 R. Moore, 'The Correspondence Principle and Marxist Sociology of Education', in D. Gleeson (ed.), *Bowles and Gintis Revisited*, Lewes: The Falmer Press 1988.

4 M. F. D. Young, *Knowledge and Control: New Directions for the Sociology of Education*, London: Collier-Macmillan 1971.

5 Reprinted as *Resistance Through Rituals* in 1976.

6 A. Gramsci, *Selections from the Prison Notebooks of Antonio Gramsci*, eds Q. Hoare and G. Nowell-Smith, London: Lawrence & Wishart 1971.

7 P. Atkinson, *The Ethnographic Imagination: Textual Constructions of Reality*, London: Routledge 1990.

8 Even though much of the analysis was inappropriate for understanding the 'resistances' of young women whose cultural location vis-à-vis femininity and the family produced very different responses (McRobbie 1978, Griffin 1980, Skeggs 1986).

9 P. Bourdieu, *Distinction: a Social Critique of the Judgement of Taste*, London: Routledge 1986.
10 H. Braverman, *Labour and Monopoly Capital*, New York: Monthly Review Press 1974. See also S. Marglin, 'What Do Bosses Do? The Origins and Functions of Hierarchy in Capitalist Production', *Review of Radical Political Economics*, vol. 6 (1974), pp. 60–112; and K. Browne, 'Schooling, Capitalism and the Mental/Manual Division of Labour', *Sociological Review*, vol. 29, no. 3 (1981), pp. 445–73.
11 A. Pollert, *Girls, Wives and Factory Lives*, London: Macmillan 1981.
12 N. Sherratt, 'Girls, Jobs and Glamour', *Feminist Review*, vol. 15 (1983), pp. 47–62.
13 H. M. Collins, 'The Meaning of Lies: Accounts of Action in Participatory Research', in G. Nigel Gilbert and P. Abel (eds), *Accounts and Action*, Aldershot: Gower 1983.
14 M. Hammersley and P. Atkinson, *Ethnography: Principles and Practice*, London: Tavistock 1983.
15 A. Callinicos, *Against Postmodernism*, Cambridge: Polity Press 1980. See also B. Skeggs, 'Postmodernism: What is all the Fuss about?', *British Journal of Sociology of Education*, vol. 12, no. 2 (1991), pp. 255–67.

REFERENCES

Althusser, L. (1971) *Lenin and Philosophy and Other Essays*, London: New Left Books.
Ang, I. (1985) *Watching Dallas: Soap Opera and the Melodramatic Imagination*, London: Methuen.
Ball, S. (1983) 'Case Study Research in Education', in M. Hammersley (ed.), *The Ethnography of Schooling*, Driffield: Nafferton.
Becker, H. (1963) *Outsiders: Studies in the Sociology of Deviance*, Glencoe: Free Press.
Bernstein, B. (1971) *Class, Codes and Control, vol. 1*, London: Routledge.
Boudon, R. (1974) *Education, Opportunity and Social Inequality*, London: John Wiley.
Bourdieu, P. (1971) 'Systems of Education and Systems of Thought', in M. Young (ed.) *Knowledge and Control*, London: Collier-Macmillan.
Bourdieu, P. and Passeron, J.-C. (1977) *Reproduction in Education, Society and Culture*, London: Sage.
Bowles, S. and Gintis, H. (1976) *Schooling in Capitalist America*, London: Routledge.
Clarke, J., Hall, S., Jefferson, T. and Roberts, B. (1976) 'Subcultures, Cultures and Class', in S. Hall and T. Jefferson (eds), *Resistance Through Rituals: Youth Subcultures in Post-War Britain*, London: Hutchinson.
Cloward, R. and Ohlin, L. (1960) *Delinquency and Opportunity: a Theory of Delinquent Gangs*, Chicago: Free Press.
Cohen, A. (1955) *Delinquent Boys: the Culture of the Gang*, Chicago: Free Press.
Cohen, P. (1972) 'Sub-Cultural Conflict and Working Class Community', *Working Papers in Cultural Studies 2*, Birmingham: CCCS.
Cole, M. (1988) (ed.), *Bowles and Gintis Revisited: Correspondence and Contradiction in Educational Theory*, London: The Falmer Press.

Corrigan, P. and Frith, S. (1976) 'The Politics of Youth Culture', in S. Hall and T. Jefferson (eds), *Resistance Through Rituals: Youth Subcultures in Post-War Britain*, London: Hutchinson.

Edmondson, R. (1984) *Rhetoric in Sociology*, London: Macmillan.

Garnsey, E. (1978) 'Women's Work and Theories of Class Stratification', *Sociology*, vol. 12, pp. 223–43.

Griffin, C. et al. (1980) 'Women and Leisure', paper given at the 'Leisure and Social Control' Conference, Centre for Contemporary Cultural Studies, University of Birmingham.

Griffin, C. (1985a) 'Qualitative Methods and Cultural Analysis: Young Women and the Transition from School to Un/Employment', in B. Burgess (ed.), *Field Methods in the Study of Education London*, Lewes: The Falmer Press.

Griffin, C. (1985b) *Typical Girls*, London: Routledge.

Hebdige, D. (1976) 'The Meaning of Mod', in S. Hall and T. Jefferson (eds), *Resistance Through Rituals: Youth Subcultures in Post-War Britain*, London: Hutchinson.

Hebdige, D. (1979) *Subculture: the Meaning of Style*, London: Methuen.

Holland, D. and Eisenhart, M. (1990) *Educated in Romance: Women, Achievement and College Culture*, Chicago: University of Chicago Press.

Kuhn, A. (1978) 'Structures of Patriarchy and Capital in the Family', in A. Kuhn and A.-M. Wolpe (eds), *Feminism and Materialism*, London: Routledge & Kegan Paul.

McRobbie, A. (1978) 'Working Class Girls and the Culture of Femininity', in Women's Studies Group (eds), *Women Take Issue*, London: Hutchinson.

McRobbie, A. (1980) 'Settling Accounts with Subcultures: a Feminist Critique', *Screen Education*, vol. 34, pp. 37–49.

McRobbie, A. (1991) *Feminism and Youth Culture*, London: Macmillan.

Matza, D. (1969) *Becoming Deviant*, New York: Prentice Hall.

Meighan, R. (1978) 'Learning to Labour', review in *Educational Review*, vol. 30, no. 2, pp. 183–5.

Miller, W. (1958) 'Lower Class Culture as a Generating Milieu of Gang Delinquency', *Journal of Social Issues*, vol. 14, pp. 5–19.

Moore, R. (1983) 'Pedagogy, Production and Further Education', in D.Gleeson (ed.), *Youth Training and the Search for Work*, London: Routledge.

Roberts, B. (1976) 'Naturalistic Research into Subcultures and Deviance', in S. Hall and T. Jefferson (eds), *Resistance Through Rituals: Youth Subcultures in Post-War Britain*, London: Hutchinson..

Shepherd, J. and Vulliamy, G. (1983) 'A Comparative Sociology of School Knowledge', *British Journal of Sociology of Education*, vol. 4, no. 1, pp. 3–18.

Skeggs, B. (1986) 'Young Women and Further Education', unpublished Ph.D. thesis, University of Keele.

Stanley, L. (1990) *Feminist Praxis: Research, Theory and Epistemology in Feminist Sociology*, London: Routledge.

Thompson, E. P. (1965) 'The Peculiarities of the English', in R. Miliband and J. Saville (eds), *The Socialist Register*, London: The Merlin Press.

Tolson, A. (1977) *The Limits of Masculinity*, London: Tavistock.

Walkerdine, V. (1981) 'Sex, Power and Pedagogies', *Screen Education*, vol. 38, pp. 14–26.

Walkerdine, V. (1990) *Schoolgirl Fictions*, London: Verso.

Whitty, G. (1977) 'Sociology and the Problems of Radical Education', in M. F. D. Young and G. Whitty (eds), *Society, State and Schooling*, Lewes: The Falmer Press.

Whyte, F. W. (1955) *Street Corner Society*, Chicago: Chicago University Press.

Williams, R. (1973) 'Base and Superstructure in Marxist Cultural Theory', *New Left Review*, no. 82, pp. 3–16.

Willis, P. (1979) 'Shop Floor Culture, Masculinity and the Wage Form', in J. Clarke, C. Critcher and R. Johnson (eds), *Working Class Culture*, London: Hutchinson.

FURTHER READING

Connell, R. W. (1987) *Gender and Power*, Cambridge: Polity Press.

Jones, S. (1988) *Black Culture, White Youth: the Reggae Tradition from JA to UK*, London: Macmillan

McRobbie, A. and Nava, M. (1984) (eds), *Gender and Generation*, London: Macmillan.

McRobbie, A. (1990) *Feminism and Youth Culture: from Jackie to Just Seventeen*, London: Macmillan.

Segal, L. (1990) *Slow Motion: Changing Masculinities Changing Men*, London: Verso.

Walkerdine, V. and Lucey, H. (1988) *Democracy in the Kitchen: Regulating Mothers and Socialising Daughters*, London: Virago.

Wallace, M. (1979) *Black Macho and the Myth of the Superwoman*, London: John Calder.

West, W. G. (1984) 'Phenomenon and Form in Interactionist and Neo-Marxist Qualitative Educational Research', in L. Barton and S. Walker (eds), *Social Crisis and Educational Research*, Lewes: The Falmer Press.

Whitty, G. (1985) *Sociology and School Knowledge: Curriculum Theory, Research and Politics*, London: Methuen.

Index